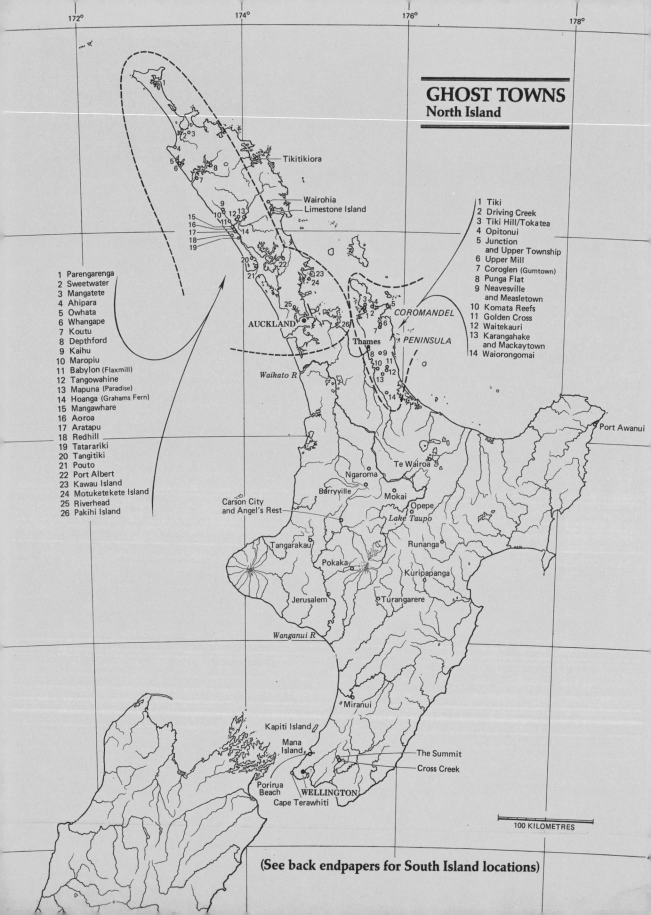

GHOST TOWNS
North Island

1 Tiki
2 Driving Creek
3 Tiki Hill/Tokatea
4 Opitonui
5 Junction
 and Upper Township
6 Upper Mill
7 Coroglen (Gumtown)
8 Punga Flat
9 Neavesville
 and Measletown
10 Komata Reefs
11 Golden Cross
12 Waitekauri
13 Karangahake
 and Mackaytown
14 Waiorongomai

1 Parengarenga
2 Sweetwater
3 Mangatete
4 Ahipara
5 Owhata
6 Whangape
7 Koutu
8 Depthford
9 Kaihu
10 Maropiu
11 Babylon (Flaxmill)
12 Tangowahine
13 Mapuna (Paradise)
14 Hoanga (Grahams Fern)
15 Mangawhare
16 Aoroa
17 Aratapu
18 Redhill
19 Tatarariki
20 Tangitiki
21 Pouto
22 Port Albert
23 Kawau Island
24 Motuketekete Island
25 Riverhead
26 Pakihi Island

Tikitikiora

Wairohia
Limestone Island

COROMANDEL
PENINSULA

AUCKLAND

Thames

Waikato R

Port Awanui

Te Wairoa

Ngaroma
Barryville
Mokai
Opepe
Lake Taupo

Carson City
and Angel's Rest

Runanga

Tangarakau
Pokaka
Kuripapanga

Jerusalem
Turangarere

Wanganui R

Miranui

Kapiti Island

Mana
Island

The Summit
Cross Creek

Porirua
Beach
WELLINGTON
Cape Terawhiti

100 KILOMETRES

(See back endpapers for South Island locations)

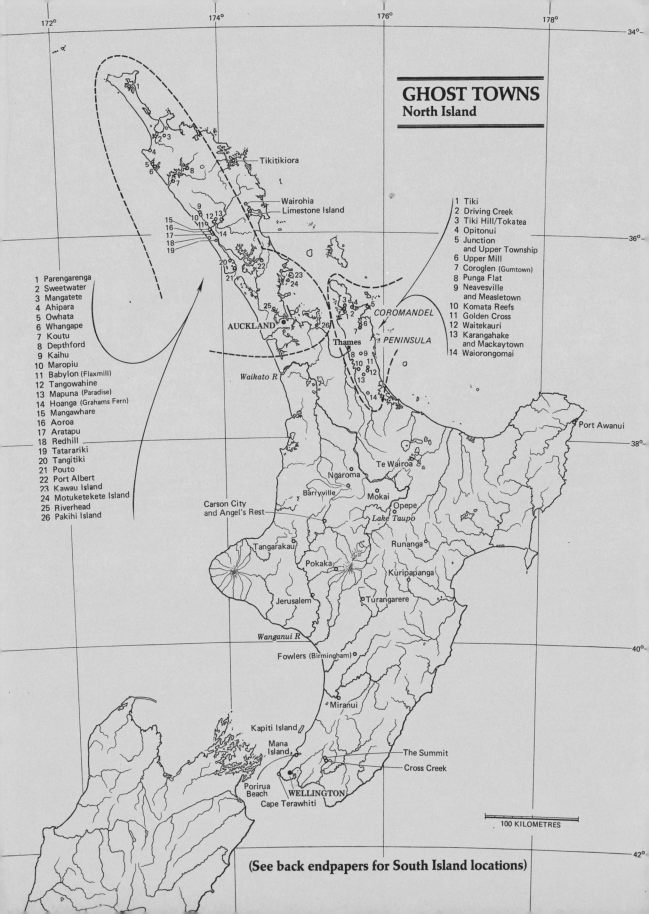

GHOST TOWNS
North Island

1 Tiki
2 Driving Creek
3 Tiki Hill/Tokatea
4 Opitonui
5 Junction
 and Upper Township
6 Upper Mill
7 Coroglen (Gumtown)
8 Punga Flat
9 Neavesville
 and Measletown
10 Komata Reefs
11 Golden Cross
12 Waitekauri
13 Karangahake
 and Mackaytown
14 Waiorongomai

1 Parengarenga
2 Sweetwater
3 Mangatete
4 Ahipara
5 Owhata
6 Whangape
7 Koutu
8 Depthford
9 Kaihu
10 Maropiu
11 Babylon (Flaxmill)
12 Tangowahine
13 Mapuna (Paradise)
14 Hoanga (Grahams Fern)
15 Mangawhare
16 Aoroa
17 Aratapu
18 Redhill
19 Tatarariki
20 Tangitiki
21 Pouto
22 Port Albert
23 Kawau Island
24 Motuketekete Island
25 Riverhead
26 Pakihi Island

Tikitikiora

Wairohia
Limestone Island

AUCKLAND

Thames

COROMANDEL

PENINSULA

Waikato R

Port Awanui

Te Wairoa

Ngaroma

Barryville

Mokai

Opepe

Carson City
and Angel's Rest

Lake Taupo

Tangarakau

Runanga

Pokaka

Kuripapanga

Jerusalem

Turangarere

Wanganui R

Fowlers (Birmingham)

Miranui

Kapiti Island

Mana
Island

The Summit

Cross Creek

Porirua
Beach

WELLINGTON

Cape Terawhiti

100 KILOMETRES

(See back endpapers for South Island locations)

GHOST TOWNS
Of New Zealand

GHOST TOWNS
of New Zealand

REED

Published by Reed Books, a division of Reed Publishing (NZ) Ltd,
39 Rawene Rd, Birkenhead, Auckland. Associated companies,
branches and representatives throughout the world.

ISBN 0 7900 0537 9

First published 1980
Reprinted 1983, 1997

Printed in Singapore

Photograph of Welshmans above Bendigo in Central Otago courtesy of Grant Sheehan.
Back cover photograph of Omoto cycling road race, Wallsend
courtesy of the Alexander Turnbull Library, Ref. F 12637 1/2.

To my parents, my Rover 95,
the Ring Cycle and so many New Zealanders,
all of whom helped make this book possible.

Acknowledgements

My thanks to Dale Williams for suggesting the book, to Bill Beavis for his flattering processing of my photographs, to Mike Bennett for an inspirational rap, to Denise and Cappy Harris for so much assistance and hospitality, to Jack and Eva Wilson for such a pleasant afternoon, likewise Tony Yelash. Also to Phil Barton of the Alexander Turnbull Library map room for digging out so many obscure references, ditto the librarians there and in the photo section and in so many other libraries, Fred Smith for loaning his brother's notes, Alistair Isdale for allowing me to peruse his voluminous notes, Riverton Museum's young lady and old man for being so nice with their photographs and time, Neville Ritchie for the most comprehensive list of possible ghost towns I could imagine, Mr Gillespie for subsidiary suggestions, the secretaries of most of the Historic Places Trust branches and all the other folk who so kindly answered my letters.

Contents

Introduction

Webster's defines a ghost town as an abandoned town or village that is at least in part still standing.

It is fitting that an American dictionary should define a ghost town, for I believe that most of us associate such places with the sagging wooden main streets of the American Wild West, with the inevitable tumbleweed blown along the thoroughfare by the invisible wind that also stirs up dust, causes the saloon doors to creak and half suggests the scrape of a hoof or the easing of a Colt 45 in its holster, just off-screen.

My grandmother developed my deep boyhood craving for the fictional Wild West with my eleventh birthday present of a Buffalo Bill Annual, from which comes this quintessential quote:

The main street showed nothing but broken buildings and the paint peeling off in strips, a signboard hanging drunkenly from one chain and proclaiming: 'THE SUNSET SALOON', a store with broken windows, sand silted right up to the counters visible through the broken door, a once garish dance-hall with the tin roof fallen in, and every other sign of ruin and utter desolation.

I still think that is not half bad. It is this romantically-blinkered view of early days that is part of the Pakeha heritage. Maoris hold no such truck with Pakeha guilt and fear of once-violent settlements and that is one of the reasons why I have avoided former Maori villages. There are other reasons, too, such as tapu, respect for the dead, reverence for their ghosts and their much more sacred and serious appreciation of the past. In time the Pakeha may come to share this view.

Ghost towns — faint monuments to our forefathers' greed and mismanagement and rapacity? True. As well, foundation stones. Without the mutual pursuit of whales the races may not have got into the habit of mixing so readily in positions the missionaries did not approve of but which were nonetheless harmonious. Without gold, Otago and points north were on the way to bankruptcy and

1

oblivion. The ruthless exploitation of timber gave us more houses per family than other countries and may have reinforced an egalitarian viewpoint; we have still not set our houses in order over the ruthless plunder of precious native forests. It is undoubtedly true that the more careful husbanding of the first settlers would have left us with more to be going on with. In this respect ghost towns may serve to reinforce the folly of mindless mining of natural resources; even our farmers have yet to fully appreciate this point.

The ghost towns in this book suggest a Pakeha migration from south to north, from top to bottom as the Maoris see it. The Savage South, the Crazy Central, the Crazier West Coast — these were our Wild Wests. The move stopped at Auckland below a No-hoper North — but perhaps that is unkind. This is largely the story of the gold, timber and gum that made and then unmade the first Pakeha settlers, of a century of colonisation; the Maori millennium deserves a much more scholarly account.

Today we are a quiet bunch of outdoor urbanites living off the land. We are not too keen on any more exotics coming here. A visiting Canadian ecologist arrived as I was writing this book. He said he had walked through over 100 countries and this one was the most violent. He said this was the only country he knew where fathers taught their sons to shoot all exotic animals, forgetting that they too came into this category.

A century or so ago we roared in and grabbed all that glittered to our way of thinking, mostly the yellow stuff, as the Maoris called it. Ghost towns are the endpapers of our beginnings as New Zealanders; their inhabitants appeared a more vigorous and optimistic lot, despite failures and false hopes, than the Kiwis of these nervy, electronically-soporific times.

This book proposes to link then and now. It is very much a broadbrush survey of most of the ghost towns of New Zealand. Subjectivity has certainly crept in. An awareness of how careful I had to be came from a newspaper, which shall be nameless, carrying a story in 1960 headed "Ghost Town Gets a New Post Office." The story was slightly more tactful in saying of Orepuki, population 250: "Although not quite a 'ghost town' it is the next thing to it." Among the letters that poured in was this: "As a resident of Orepuki for many years I resent the term of 'Ghost Town' or the next thing to it. Granted there are not the shops and hotels that there used to be, but that is no reason to call it a 'Ghost Town' . . . Today it is a prosperous farming area and has well supported branches of Federated Farmers, WDFF, Plunket Society, and several other organisations. There is some form of entertainment on every Saturday night of the week during the winter months." The letter is signed "Two Eyes".

This is surely an awful warning to any writer rash enough to

attempt to classify living settlements as ghost towns! I fortunately only made such a blunder verbally in Puhoi, but it was suggested that I leave town before I found out just how alive and kicking its citizens could be.

Nevertheless, I have taken the plunge in several marginal settlements. At other times, I have not. Alfredtonians can rest in peace, at least a little longer. And that goes for most declining farming settlements. Their chapter has yet to be written and, at present, is a trifle premature, I feel.

I tried to follow the definition of the census department official who told me that a town was characterised as a place with a school, store, post office, and maybe a hall, while a "location" was beyond this pale. I shall not point to the inconsistencies of such a definition. I beg the reader's indulgence for the liberties I have taken with his or her favourite town. I trust that my 16,000-kilometre trek around the country's lesser roads has not caused me to stray too far from the beaten track. I plead innocent to malice aforethought. In so many ways this book is just a beginning.

David McGill

We have burnt our history with the same blind stupidity as we have burned our forests.
— Professor J. C. Beaglehole in a Canterbury University lecture.

Those who do not remember the past, are condemned to relive it.
— George Santayana.

Our imagination craves to behold our ancestors as they really were, going about their daily business and daily pleasure.
— G. M. Trevelyan.

Dryasdust.
— Carlyle on historical researchers.

1

Half-heroes, half-ruffians
The whalers

Come all of you whalemen who are cruising for Sperm,
Come all of you seamen who have rounded Cape Horn,
For our captain has told us, and he says out of hand,
There's a thousand whales off the coast of New Zealand.

NZ Whales, Songs of the Whalemen. The Song Spinners.

Jacky Guard established the first permanent European settlement in
New Zealand in 1827 with the shore whaling station of **Te Awaiti** in
the Sounds. He left it a few years later in the hands of Dicky Barrett,
moving across and south to Kakapo Bay, **Port Underwood,** where
his grandson and great-grandsons farm, where grandson Albert
Guard is the closest link to our Pakeha roots.

"This here's the cutlass Jacky Guard defied Te Rauparaha with,"
says Albert Guard, lifting a huge, brass-handled sword out of an old
chest. "Jacky made his mark on the sand and said, 'No further!' Te
Rauparaha came no further."

Nor me. Watching the massive Albert Guard draw out this
cutlass, and then two flintlocks in quick measure, is a convinc-
ing sight. He looked as tough as his grandad was said to be, and
among the many exploits of Jacky Guard passed down was the pick-
ing up of two mutinous sailors, one in each hand, and tossing
them overboard. It was supposed to be the Cornish wrestler in
him.

Back in Picton they told me the Guards had mellowed a bit, but
Picton is bone-jolting hours away and around here they are not only
massive but also passive, not given to smiling much at strangers.
Once this was the only European civilisation New Zealand knew.

The cannon behind still looks in trim, but in fact there was little
use for it after the Wairau Massacre, when the Maoris scarpered, in
expectation of utu. Uncle John, they tell you, fired it ceremoniously
on Christmas and other big days, just to let the neighbourhood

5

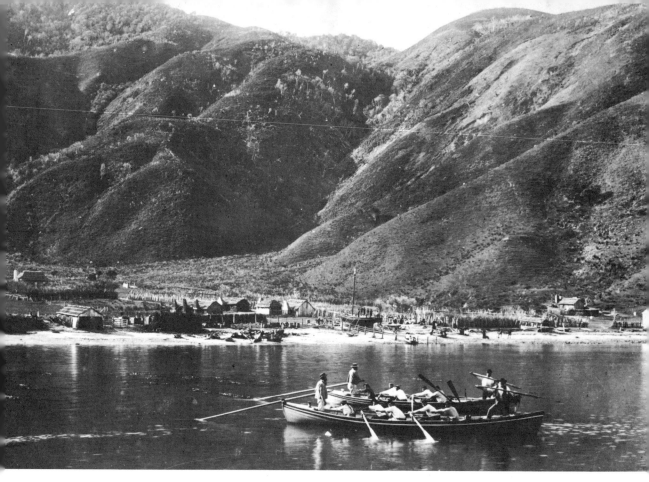

Te Awaiti. *Alexander Turnbull Library.*

recall who was who; John was in fact the first white child born in the South Island.

It was a miracle he survived. Another of Albert's treasures from the chest is the tortoiseshell comb which saved Betty Guard's life and that of her two young children, for when they were captured by Taranaki Maoris the comb played a crucial part.

"The comb," says Albert Guard, "was struck by a tomahawk and that saved her. She was knocked unconscious and a Maori woman threw a mat over her and then she was tapu. They brought a lump of her brother for her to eat."

Albert tells the story succinctly. There are longer versions on record of a most harrowing period for Betty Guard and her children. She seems to have survived it well. Edward Jerningham Wakefield describes her as a "fine, buxom-looking Englishwoman".

There are portraits around to support his description, but precious little evidence left to back up New Zealand Company naturalist, Dieffenbach, in his description of Port Underwood as looking "like the Golgotha of the whale, so many remains of that animal are lying on the beach". Two try pots next to the cannon and a few rusty bits and pieces around the beach are all that is left of the

6

fifteen-year slaughter of the leviathans of the deep. Guard had sent the try pots to Picton Museum, but reclaimed them when he saw they were being used as rubbish bins.

Jacky Guard bought Kakapo Bay from the Maoris for rather more than the going price of the day. He paid a cask of tobacco worth £50 then, five pieces of print, ten oxen, eight iron pots and twenty blankets.

At about this time Port Underwood was being proposed as a colony in Tasmania, encouraged by the ship, the *Marian*, returning there after seven months with a clear profit of £4,500 from whaling and tales of whales for the taking; this was quite true, for the whales came there to give birth, and the cow's habit of refusing to leave her calf made easy harpooning. Dieffenbach challenged the suitability of bays masked by cloud with high hills keeping the sun at bay. Sydney merchant Underwood got the point named after him, and eventually this became Port Underwood, but the colony never got off the sea; by 1836 the surviving whales had got the message and taken off, hotly pursued by dozens of ruthless boats.

Kakapo Bay, or Guard's Bay as it was also known, was one of six in the Port Underwood harbour where whaling settlements were established, the average a handful of Europeans and fifty or so Maoris. There was a station at **Mana Island,** two at **Porirua** and three at **Kapiti,** the last-named having eighty Europeans and no Maoris, and strict naval discipline. Te Awaiti was a compromise, forty Europeans and several hundred Maoris. In 1837 missionaries counted 1,500 Maoris in the Cook Strait area, a total three times the

Albert Guard, grandson of this country's original coloniser. *David McGill.*

Kapiti, before the birds took over. From a watercolour by John Alexander Gilfillan of Gillett's whaling station, 1844. *Alexander Turnbull Library Collection.*

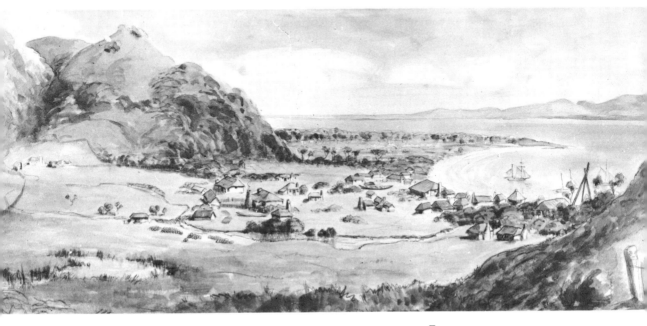

entire European population of the country at the time. The Cook Strait stations represented the only large whaling settlements in New Zealand.

Vivid and detailed accounts from E. J. Wakefield, James Coutts Crawford and James Heberley tell us more of life in these Maori/Pakeha bridging settlements than many a subsequent European settlement. Wakefield was not disapproving of these rough, hard-drinking whalers the way the missionaries were, but he did report that when he asked one at Port Underwood if he always worked on Sundays, the reply was, "Oh! Sunday never comes into this bay!" Wakefield noted the inevitable quarrelling following Maori women from different tribes living with the whalers. Wakefield defined the offspring as a blend of the "frankness and manly courage of the sailor" and the "cunning and reckless daring of the convict", as if these "currency lads" were born of sailor and convict! He did add that they were distinguished for great physical beauty and strength, a diplomatic tribute to the success of miscegenic love.

Wakefield admired the whalers' courage, and also their perspicacity in identifying quacks and hypocrites among the doctors and missionaries. He noted their slang names, Flash Bill and Gipsey (sic) Smith, and their preference for calling a spade by any other name, for a pig was a grunter, a gun a shootstick, a potato a spud, a blanket a spreader, a pipe a steamer, tobacco was weed, a woman was a heifer, a girl a titter and a child a squeaker. Maori chiefs were known as Satan, the Sneak, the Long-un, the Badger, the Greybeard and the Wild Fellow. Some of the argot survives, and may explain the Australasian taste for nicknames and the Bazza McKenzie type of nonsense.

Crawford was taken by the whalers' leisure hours, observing that they were "generally more or less drunk". Te Awaiti whaling leader Joseph Toms (or Thoms) took his fancy, especially with his explanation of how his rum barrel went so far: "Why, when I takes out a glass of rum, I puts in a glass of water; when it gets too strong of water, I puts in turps, and when it gets too strong of turps, I puts in bluestone."

Toms was ambitious to see European civilisation take hold, and applied for pub licences on his whaling stations at Te Awaiti, Port Underwood and Porirua. He also ran a flock of about fifty goats and tended a garden grown from seeds off the *Tory*. He ran Te Awaiti with Dicky Barrett, whom Wakefield described as a jovial, rotund man with twinkling eyes, well decked out in round straw hat, white jacket and blue dungarees, though he was too fat to go whaling. Wakefield also met Captain Hayter Jackson at Jackson Bay station in Port Underwood, a man who admired Bonaparte and liked to quote Scripture and Guthrie's Geography. Captain James Heberley (or

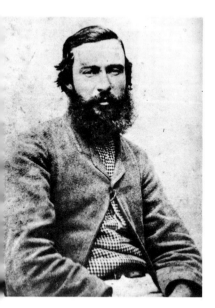

Joseph Toms, 1842-1909, the second white child born at Te Awaiti. *Alexander Turnbull Library.*

8

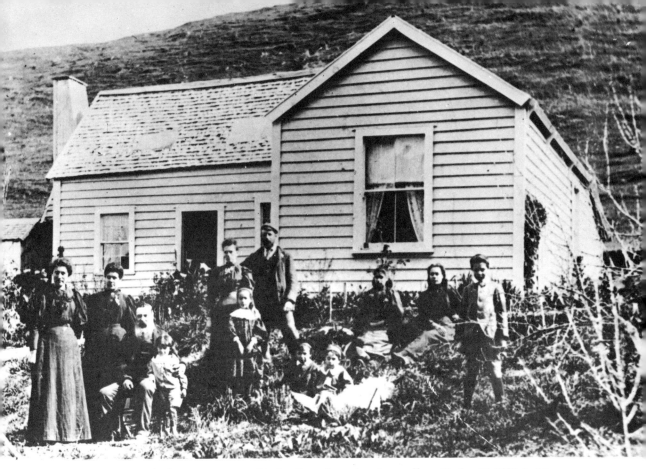

Te Awaiti, 1896. Left to right: Annie Toms, Gertrude Toms, Mr Toms, Sid Toms (youngest son), Mr and Mrs Walker (English whaler), Minnie Toms, Edith Clarke, Nellie Toms, Willie Toms. Front: Tommie and Eddie Toms. *Boulton Collection, Alexander Turnbull Library.*

Heberly) was a protégé at Te Awaiti of Jacky Guard, and universally known as Worser, a corruption of whata, or food, given him by a Maori woman and the cause of much amusement among the Maoris. Heberley bought a Maori wife for a blanket, as was the custom, but he was one of several hundred whom the Reverend Ironside later married to his "wahine". Whalers' "wives" rose before them to prepare breakfast and gear, and were commended by several commentators for maintaining high standards of cleanliness and discouraging drunken orgies.

Stations were manned by sailors who had deserted ship for the attractions of shore life, runaway convicts and currency lads. At the start of the season they were given their jobs, the smithy's top pay at ten shillings a day, with cooper, carpenter, painter, tonguer, cook, steward, headman, steersman, and assorted crew in descending order, shore jobs apparently the white collar employment of the day. Few left with any money, the fare of £60 to Sydney intended to discourage such an event. In today's argot they were ripped off, paying 5s or more for a pound of tobacco that cost 1s in England, sugar 1s a pound, a bar of soap 5s, moleskin trousers £1. Pay was often in rum, doled out after a kill in celebration and on shore to protect owners' profits.

9

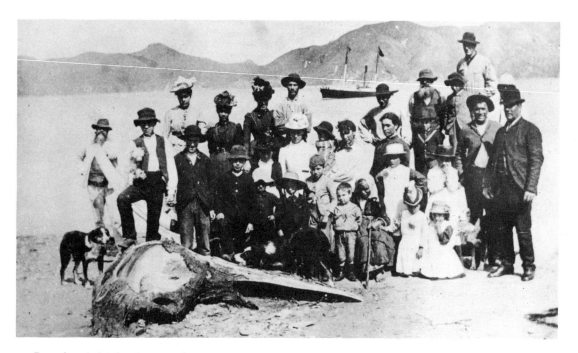

Barrett was one of the few who did do well, as seen even there in his floored and lined house with a verandah. The usual accommodation was thatched clay, which was no worse than that which most of Europe lived in at the time. These one-room houses were dominated by the chimney, from which hung iron pots, kettles, dogs and, up it, smoking hams, bacon and fish. A whale's vertebra served as a stool, benches and a deal table took the middle ground, bunks were curtained off to the side, the rafters were packed with rope, oars, masts, sails, lances, spades, harpoons and brightly-polished oil lamps. Two square holes in the walls served as windows which were shuttered for bad weather. A sickeningly-sweet smell of arrack rum impressed visitors. Fixtures and fittings included a salt meat cask, flour keg and water butt, a dresser with bright tin dishes, glasses and crockery. The immediate environs usually featured a scarred mongrel, a tame sow, goats, fowls, pigeons, an oily beach and Maori relations dozing in blankets against the sunny side. Wakefield thought the houses as clean as a Dutch coaster.

The boats themselves were fancifully painted but spartan to an extreme. Seafood was a box of biscuits, washed down with water or grog.

Captain Heberley has described the dangers of the trade, which often took them on to the very back of their prey, where they heard barnacles scrunching against the boat as they prepared for its death, or theirs. He wrote of a wounded whale towing them across the

10

Strait, then twenty hours of rowing the carcass back from the Brothers: "You haven't got such men now! Bad men. Hardy men. It was nothing to them to take their lives in their hands and, with nothing better than an open boat, an iron harpoon and a tub line, hunt the great whales themselves down the terrible valleys of the seas."

There were contemporary judgements of these first Pakeha exploiters which were as relevant as any that come from today's paperback pontificators. Dieffenbach thought the indiscriminate hunting of an animal in season was like felling a tree to obtain its fruit. They took "the most certain means of destroying an otherwise profitable and important trade", a lesson we have still not learned — only the victims have changed.

Buick has written simply of strong men "who lived hard, worked hard, and died hard".

Reeves called them "half-heroes, half-ruffians", who "did their work and unconsciously brought the islands a stage nearer civilisation".

"Oh, women!" declared Dr Felix Maynard, "How dearly are the bones of your corsets paid for!"

The missionaries saw souls plunging to perdition. To Missionary Bumby, Tar White (for that was what the crude and careless whalers made of Te Awaiti) was a Sodom and Gomorrah rolled into one, on view "every species of iniquity without restraint and without concealment. The very sense of decency seems to be extinct. The very soil is polluted. The very atmosphere is tainted." Archdeacon Henry Williams: "Their nourishment is liquor and their language is blasphemy."

In a curious turnaround the missionaries saw the Maoris as the good and innocent victims of the drunken and corrupt whalers, while Wakefield saw the "native women" as trouble stirrers and Te Rauparaha and Te Rangihaeata as "drunken travelling disturbers of the peace".

The Reverend Samuel Ironside rose above judgements and ministered magnificently to the Maoris throughout the South Island from his base in Ngakuta Bay, just around from Kakapo Bay. The Maoris returned his care, building his churches for no material gain, so that he achieved the remarkable feat of raising sixteen chapels as far down as Oamaru during the period from 1840 to 1843. He could do nothing about the treachery of the Pakeha — most generally in land encroachments, most particularly in the despicable murder of a Maori chieftainess married to a Dutchman, James Wynen; her murderer was shamefully acquitted by a settler jury, which led directly to the Wairau Massacre. A white stone monument at Ngakuta Bay is all that is left of the work of this great Methodist missionary.

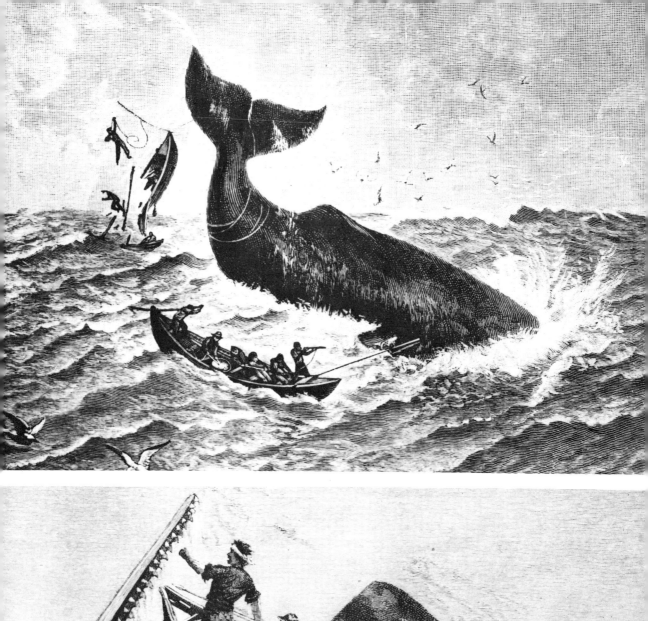
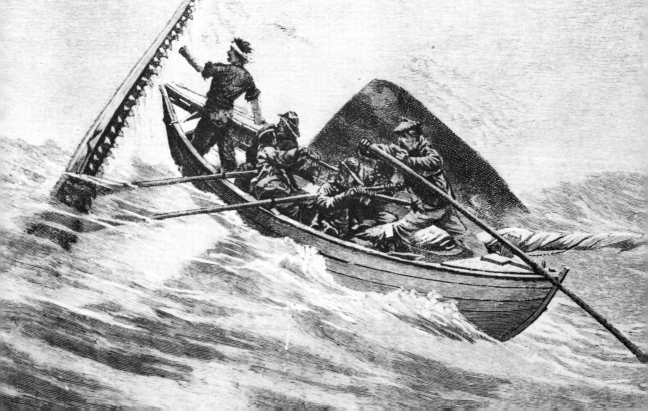

Whaling might well have been the wildest and most dangerous industry that man has put his hand to — certainly it was for the whales. These illustrations are taken from Bullen's *The Cruise of the Cachalot*, London, 1898. Shore whaling concentrated on different breeds, but the techniques and risks were much the same. *Alexander Turnbull Library.*

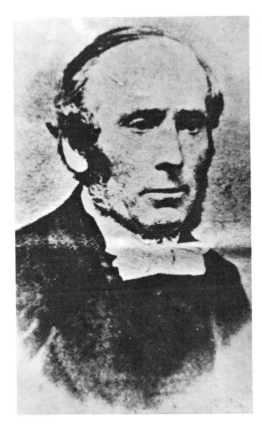

The pioneering missionary who administered to several thousand Maoris and several hundred whalers around Port Underwood in the early 1840s. The Wairau Massacre terminated his good work. A small white memorial is all that is left at Ngakuta Bay, Port Underwood, to mark the base of his zealous South Island campaign. *F. W. Smith Collection, Alexander Turnbull Library.*

The memorial to the Reverend Samuel Ironside at Ngakuta Bay, Port Underwood. *David McGill.*

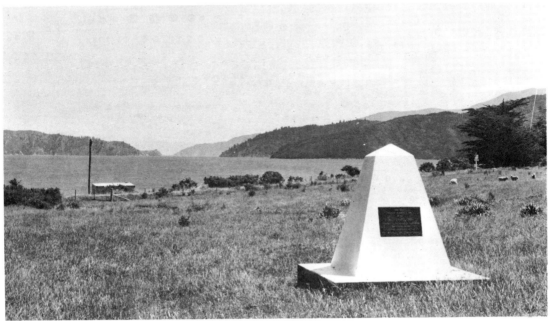

Joe Timms, the last man in New Zealand to go whaling in a row boat. *Picton Museum.*

"Porerua Bay", a steel engraving by Henry Melville, after an original by S. C. Brees, from *Pictorial Illustrations of New Zealand,* London, 1847. Already, the whaling establishment on the left had been replaced by cattle, whose continued presence in this country suggests that herding is more sensible than hunting.

Te Awaiti was followed by thirty more whaling stations up and down the country in the next thirteen years. Second to Port Underwood in size and establishment was **Preservation Inlet,** operating by 1829 (some claim it was of the same 1827 vintage as Te Awaiti). It was probably a port of call early on, as indeed Codfish Island had been in the 1820s for the sealers sheltering from the Maoris or the food depots for whalers in the Bay of Islands as early as 1794. Preservation Inlet had four good years, landing over 100 tons a year. Peter Williams bought the Inlet from the Maoris for sixty muskets, 1,000 pounds of gunpowder and 1,000 musket balls, which were understandably the major factor in the halting of Te Rauparaha's Viking-like sweep southwards. Williams had a large house and his staff of fifty lived in six other houses opposite Te Oneroa in Cuttle Cove. Remains there include a whale pot, whale bone and barrel bands marking the site of the storehouse, where it is recorded 300 tons of goods were landed.

Whaling, of course, continued from Picton up to the 1930s, and in Picton lives Joe Timms, now in his nineties, the last man in New Zealand to go whaling in a row boat. He came from Austria at ten years of age to be the companion and eyes for a blind lighthouse-man on the other side of Te Awaiti. He went to school there, although there was precious little schoolwork done, he recalls, when a whale was sighted. They were tough lads, too tough for the teacher, who once had to lock the door on a lad wielding an axe who objected to being told what to do by any myopic landlubber. Joe was in the boats at fifteen years of age, and has tales to match Heberley's, like the whale that stood on its tail, then crashed down on the boat and took its bow off.

At Te Awaiti today there are graves and whale bone and vestiges of the whale bone picket fences which once surrounded the houses. There is a plaque and fading memories of New Zealand's first shore whaling station, and a painting held in Sydney that may or may not depict New Zealand's first European-style permanent settlement.

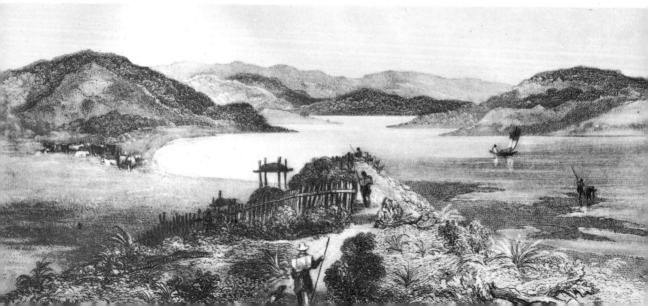

2

Gold, gold, gold
The Tuapeka goldfields

Diggers smoking, new chums joking;
Come, my hearty, join our party.

Joe Small, 1866.

Gabriels Gully is as silent today as any plundered cemetery. Except, of course, for the increasing numbers of tourists trekking up this empty valley situated a few kilometres behind Lawrence.

Pick and poke as they may, they will find no relics of New Zealand's first great goldtown. You'd be hard put to fill your teeth now from the goldfall town that put New Zealand on the international map. Today it is a torn valley healing over with manuka and broom, and with only the inevitable plaque as testimony to that furious year, 1861, when gold fever infected all five kilometres of length and several hundred metres breadth of the valley, as 10,000 men turned it over like gardeners possessed.

Photographs of Gabriels Gully are like the aftermath of a mole convention. Lawrence, with its graceful avenue of silver birches and fledgling museum, is a more fitting modern gateway to Central Otago's clean, clear air and old goldfields. Gabriels had its fast, fierce hour, and today scarcely offers the glimmer of a ghost town.

Young Charles Money passed through Gabriels in its heyday. He had a photographer's eye for detail. He has described (in *Knocking About in New Zealand*) the canvas and galvanised iron public houses, restaurants, stores and shanties, and everywhere the advertisements for "nigger minstrels" and best gold prices. A calico store had for a counter old gin or brandy boxwood laid across saplings. On display were "sides of bacon, a tub or so of butter, one or two dry cheeses, sardines, lobster, salmon and other potted fishes and meats, bread, tobacco, clay pipes and piled-up boxes of Letchford vesta matches . . . the whole of this extensive warehouse was about as large as a reasonably-sized dog-kennel".

15

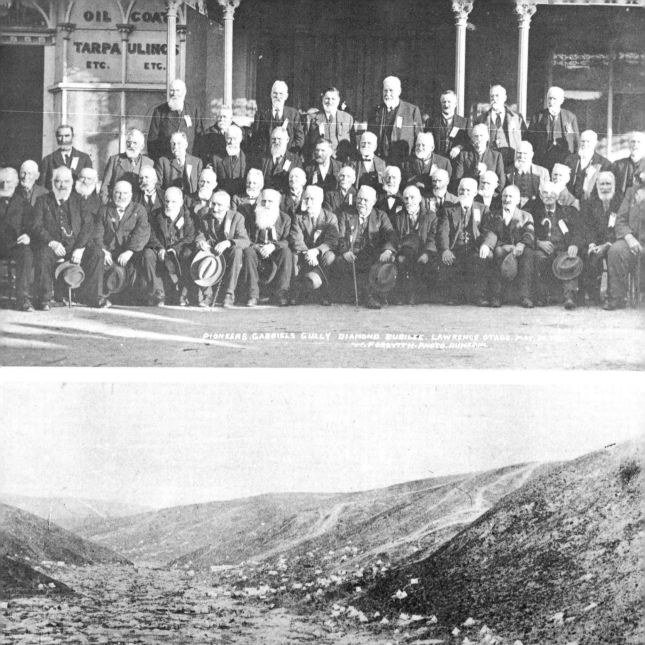

PIONEERS GABRIELS GULLY DIAMOND JUBILEE LAWRENCE OTAGO MAY 1921 C.G. FORSYTH PHOTO DUNEDIN

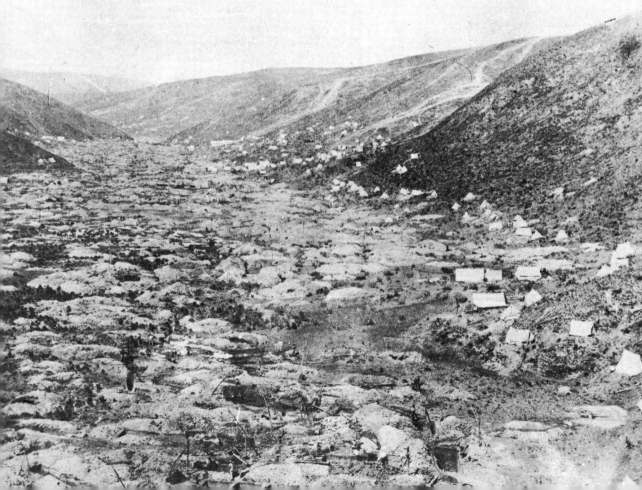

The size of the dwellings, especially public houses, often seemed decidedly small, as if folk then were smaller than modern man, the way we thought of the Japanese after the war. As for the food, Money does give an image of plenty. One miner who had seen it all summed up his experience as "plenty of gold and not much tucker".

Money observed six men "deep in unlimited loo", for cards were one of the popular pastimes. The players proved to be two old Harrovians, the son of a wealthy wine merchant (whose father kept him in tawny port and golden sherry, which kept him in friends), a government clerk, a doctor and a trooper from a police camp — the untypically typical cross-section to be found at this crossroads of society.

Gabriels may have launched and certainly reinforced New Zealand's egalitarian ways, for there a cook's son and duke's son both wore the same blue shirt and off-white moleskin trousers. Charles Thatcher sang to the miners:

On the diggings we're all on a level, you know,
The poor out here ain't oppressed by the rich
But, dressed in blue shirts, you can't tell which is which.

George Hassing, the Dane, thought the sympathetic brotherhood of the miners surpassed "even the bonds of Freemasonry", of whom there were a good few on the goldfields. One newspaper observer, anonymous as was the custom of the day, spoke of a "free and careless bluffness which is a great relief from the reserve and formality that prevail among all classes in the Old Country."

Alas, this first flush of goldfields life was a brief step forward in the history of our gold communities. . . .

Perhaps the sweet reasonableness of the discoverer, Gabriel Read, had some influence. James Robertson, Lawrence's mayor at the Jubilee functions in 1911, spoke of Read as a perfect gentleman who placed no value on money. Read himself is on record as holding the miners in the highest regard, but then he did not hang around to be disappointed; he was always off prospecting and even refused a government job so he could remain free. He had his freedom, and died penniless in a Tasmanian asylum.

Read's dutiful note informing the authorities that he felt bound to share his good fortune found a modest bottom corner in the *Otago Witness* of 4 June, 1861. It was placed next to an advertisement for Holloway's Pills, which persisted in providing "health for a shilling" long after the goldfields had done their dash.

There had already been the disappointing rush of hundreds of men to the Lindis and other reports of gold strikes, so Read was initially treated with caution. James M'Indoe responded to Read's letter in the *Witness* with his doubts that seven ounces of gold extracted in ten hours using a butcher's knife could be anything but

Perhaps our most famous collection of old-timers, a regular gaggle of gold, worth their weight in the yellow stuff. *Southland Museum.*

The classic, most-frequently reproduced and, undoubtedly, most dull scene depicting gold fever ever recorded — Gabriels Gully in 1862. *Hocken Library.*

the result of a sinister motive or a compositor's error, but now he had been and seen for himself. A clever man, M'Indoe opened Gabriels' first store in the September, reaping even richer rewards while others did the dirty work.

Read's news took a month to bite. On 6 July came the *Witness's* famous editorial, beginning: "Gold, gold, gold, is the universal subject of conversation. The fever is running to such a height that, if it continues, there will scarcely be a man left in town."

Scarcely has an editorial been so often quoted. Its opening three words dominated advertising of the day.

And it wasn't far from the mark. By September there were 4,000 at Gabriels, all well-behaved, said "Our Correspondent" for the *Witness.* By the following July Dunedin's population was 5,850 and that of the Tuapeka goldfields double that. It was reported that a Dunedin minister had only his precentor left to preach to.

The first and biggest Gabriels was halfway up the valley and the second at the foot of the Blue Spur, later to ascend and inherit its name when hydraulic sluicing washed out its beginnings.

It is hard to separate life at Gabriels from the townships nearby, all of which developed in the following few months. **Munros Gully** next door resulted from a shepherd's wife of that name following in Read's handsteps with a butcher's knife and pannikin. Wetherstones was christened after two brothers of that name who discovered gold when out pig-shooting for much-needed tucker, and Tuapeka Flat, Tuapeka Mouth, Tuapeka West and Evans Flat or Gully came soon after that.

The Thistle Hotel, Evans Flat. This was probably taken after 1908 when prohibition came in, for there are no signs indicating a bar. It is situated at the Evans Flat Bridge over the Tuapeka River. The road formerly passed in front of the hotel, but is now at its rear. *Gabriels Gully Centennial* booklet says the hotel and store were owned by Jas Hopkins, who came from Bendigo in 1862. Later proprietors were Hugh Craig and John Munro. W. J. Munro of Lawrence owns the original photograph. *Lawrence Museum Collection, Hocken Library.*

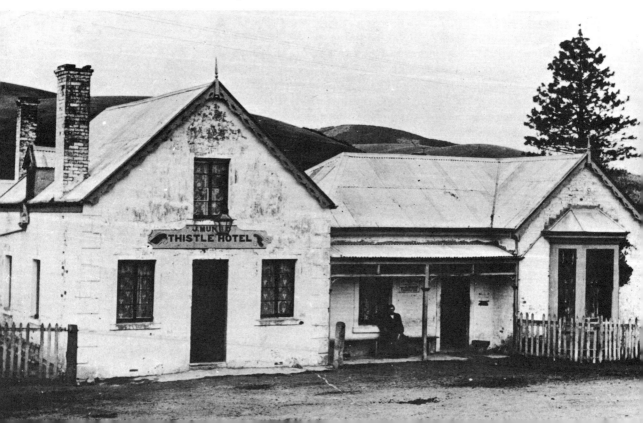

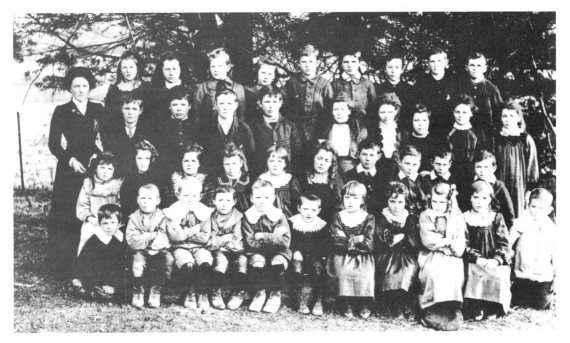

Evans Flat School, about 1904. *Lawrence Museum Collection, Hocken Library.*

In 1862, 500 signatures were collected at Munros for a post office, but the men did not hang around to push their case. Munros was noted for its Cornishmen, who made decisions in truly democratic full-and-free discussions, but who fought like champions all. Their alarming style of wrestling, known as catch-as-catch-can or collar-and-elbow, often resulted in broken limbs.

Evans Flat, named after the veteran bullock driver, William Evans, drew off the population of Munros that did not go the Tuapeka way, but like all the gold towns, lost out to Lawrence. The Hindu Black Peter, Edward Peters, had found gold before Read in what became the schoolgrounds there, and eventually received some monetary recognition from the government for his find. Evans Flat did better at a later stage from coal, flax and flour.

"Gold! Gold! Gold!" was the heading of an advertisement for the Diggers' Mart in Princes Street, Dunedin, followed by such seductive stanzas as:

Hurrah my merry diggers, before you make a start,
I would recommend you all to call at the Diggers' Mart.

The ad appeared religiously in every edition of the *Times* and *Witness,* an early example of saturation promotion.

The ad also peddled Winceys (just arrived) suitable for the winter, for the Diggers' Mart was "creditably informed" that ladies were planning to attend their husbands on the diggings.

The unseasonal delay of winter and the unrepeated arrival of

19

respectable ladies were unique and soothing factors for the Tuapeka goldtowns. So much so that Pedestrian reported in the *Witness* of 3 August, 1861, that he heard no oaths or jokes, but anxious, earnest diggers for whom work was the order of the day; night was a knapsack for a pillow, the branches of the kilmog or manuka for a mattress and a share of a chum's kangaroo (or possum) rug for a coverlet. That month, lay Methodist and Presbyterian preachers were heard on the diggings. For the first religious service there the Reverend Donald Stuart took the text: "And now the men see not the bright light which is in the clouds", which was by way of being the first joke cracked on the diggings.

When winter finally came the canvas Presbyterian church was cracked and rent by winds and blown over. In 1864 a wooden one was erected.

In August Pedestrian was finally able to report snow six to eight inches deep, not to mention the twenty degree frosts. Boots had to be thawed by body and blanket heat. Tents became saturated by a composition of clay and water, inspiring Pedestrian to quote:

"Pale as a parsnip, bolt upright,
Sat on your heads antipodes in bed,"
And tried to stop their tents blowing away.

Diggers were reported griping about queuing all day for mail and bogging down in atrocious roads. Mid-morning was a time of water disputes, as damming would dry up the neighbour below and flood the neighbour above. The rest of the day was hard yakker, punctuated by the occasional cry of "Joe", a warning imported from the Victorian fields of policemen on the way after licence-dodgers. The local licence was a mere £1, so the cry served to signal the unusual, like a pretty woman or a bell-top. For some reason such hats were red rags to the miners, perhaps because they suggested a superior air. A Canadian won applause for crushing one down on its owner's head; the owner took the joke well, so a whip-round provided him with enough for a dozen more.

The usual meal was damper (flour and water), boiled bacon and tea. Night was a curious time, according to the *Witness* correspondent: "A perfect medley of strange sounds until about midnight, the firing of revolvers from one end of the gully to the next, imitation cock-crowing, London cries, all's well, flutes, fiddles, concertinas, sentimental, comic and nigger songs, which latter usually have an accompaniment, *a la tambourine* on a tin dish, and frequently there is another and rival performance upon that melodious instrument hard at work beating the devil's tattoo in a neighbouring tent. These and other sounds (in the language of advertisements) 'too numerous to mention' create, as you may well suppose, a perfect discord."

20

The revolvers were apparently used to warn off would-be robbers. As for the rest, give or take a few instruments, it is probably not so different from Saturday night at the footy club.

On 21 September, 1861, 2,500 miners were issued with licences and fifty business licences were approved. A few drunks and stick-ups were reported.

At the end of 1861 Mr Wheeler filed his reports on the Tuapeka goldfields back to the Melbourne *Argus*. He did not care for the rancid, unsalted butter — it came from Ireland! He observed that everything was "mixed with what you find wherever Scotsmen have been principal occupants, whiskey (sic) which is de rigueur".

Of the weather:

First it blew,
Then it snew,
And then it friz horrid.

The wind lifted him out of his saddle, and only his reins saved him from a wintry variation on the Icarus dilemma.

He thought Victorian miners could take a lesson from the serenity of a night at Gabriels, disturbed only by a popular Negro song, something about du da, and a cornet-a-piston in difficulties.

Evans Flat, about 1870.
Lawrence Museum Collection,
Hocken Library.

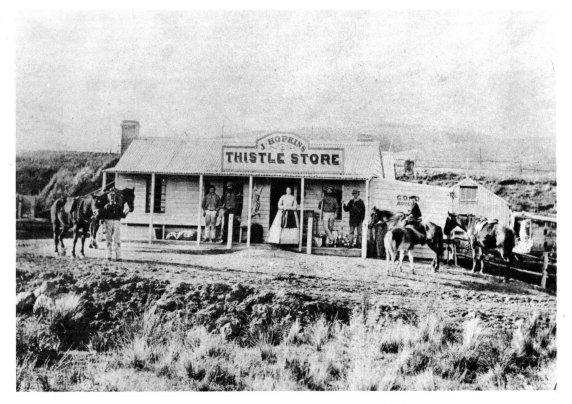

21

The stores sold brandy at 15s a bottle and 1s 6d a nobbler, whiskey 12s 6d and 1s. By the pound flour was 11d, beef 1s 4d, mutton 1s 2d, potatoes 8d, salt 1s 6d, sugar (coarse) 1s 6d to 1s 9d, butter 3s 6d to 4s, tea 6s 6d, coffee 3s 6d (ground, in tins) and bread 5s a four pound loaf. Canvas was 2s 6d a yard, common lace-up boots £2 to £2 10s, American pegged boots £3 10s, rough Napoleons £5 to £6, coarse thin blankets £1 13s 6d, monkey jackets £3 3s, moleskin trousers 16s, buckets 18s, blue shirts 5s, sawn timber 2s 6d per lineal foot, shovels and picks £1 a piece; porter and ale were scarce and 5s a bottle.

Wheeler was assured by storekeeper M'Cluskey that traders made small profits and carriers big ones, charging 1s per pound for cartage.

Wheeler saw fifty Maoris; he said they were well-behaved, unlike those up north, from whom they also differed in appearance.

He saw many starving people numbed with cold and moving on because they couldn't afford firewood. The field could not support the weight of population.

Indeed the *Witness* had warned repeatedly of the high cost of living on the goldfields, and recommended that nobody should start without a stake of £30 for six weeks to two months of living.

However, both Mr Wheeler and the *Witness* accused each other of bias. The London *Times* of December, 1861, judged Wheeler to be "reasonably faithful but with decided color (sic) against the prospects of the New Zealand Goldfields".

In those days newspapers had little hesitation about adopting a partisan position. Otago wanted the immigrants and Melbourne did not want to lose its immigrants, some of whom had rushed there from Otago.

The rush to the pleasure pots and the attendant pain are presented in the next chapter.

3

Games, groans and gangsters
Playtime at Wetherstones

My father a sign painter was
And sometimes draw'd in chalk, sir;
But the drawing that his son likes best
Is the drawing of a cork, sir.

Be Kind To Thy Father, contemporary pop song.

Wetherstones was where most of the miners eventually congregated, and it became the biggest and most boisterous goldtown on the Tuapeka fields. (The current spelling is favoured, but you will find it spelt Weatherstons, and variations in between, just as Munro's often becomes Monroe's.)

The 1976 census says there are eighteen people in the location, but you would be hard put to find them. Now it is merely a dead-end track off from Lawrence, with big old redwoods and other exotic trees and a few old wooden buildings. If you are there in spring, you will see a host of golden daffodils.

The daffodils are a pretty memorial to Wetherstones' brief flowering as the fun capital of the goldfields, the Las Vegas of its time. It had less than its share of the brawling and skullduggery that soon became a feature of the goldfields, but few goldtowns had more fun.

By November, 1861, 5,000 had packed into the place, with fourteen hotels and as many drinking saloons, gambling dens and billiard parlours. Billiards, or bagatelle, was as popular as cards, and bets were often as high, from £10 up to £1,000. It became so popular at one time that the "Mothers of Daughters" wrote to the *Tuapeka Times* complaining of the lack of young fellows making social calls.

William O'Leary, Arawata Bill, was born there in 1864. The poet Denis Glover immortalised him for new generations in the Pegasus Press collection *Enter without Knocking*:

23

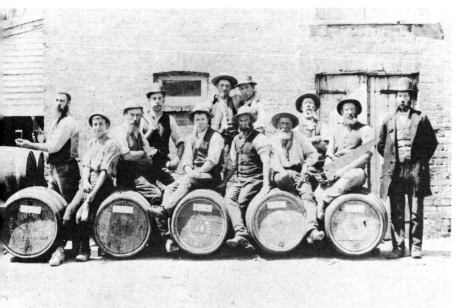

Simpson and Hart Brewery, Wetherstones, 1894. From left: J. Munro, E. Hart, G. Coxon, A. Hart, D. Coxon, J. Murray, F. Swannick, J. Sutherland, S. Gare, J. Forman, M. Coxon, J. K. Simpson. *Lawrence Museum Collection, Hocken Library.*

Wetherstones' pretty legacy — a host of golden daffodils being plucked *circa* 1910 in aid of Dr Barnado's Homes. *Lawrence Museum Collection, Hocken Library.*

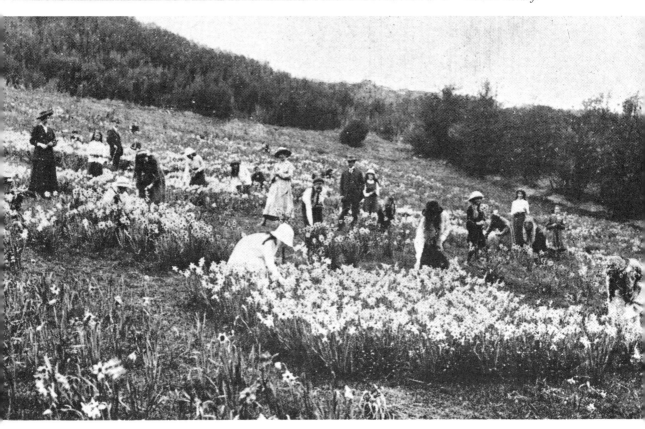

Wouldn't you like to know what it tasted like?! *Lawrence Museum Collection, David McGill.*

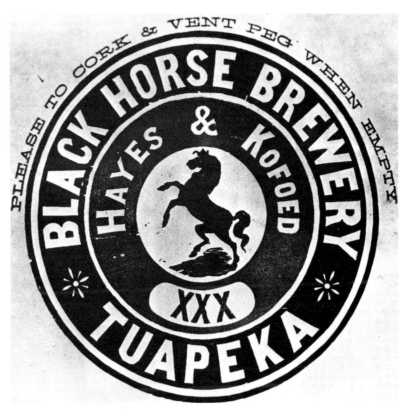

Black Horse Brewery, Wetherstones, about 1900. *Lawrence Museum Collection, Hocken Library.*

The fools! There's more gold beneath
these rivers and mountains
than in all their clattering teeth.

In 1865 the town was surveyed into Burke, Wills and Speke Streets, but that was of no concern to the miners who stuck to their imported Melbourne streetnames — Bourke, Elizabeth and Collins. Noah's Ark was their name for the store that had at least two of everything, and it further lived up to its name by surviving, in shell at least, up to modern times.

Games of chance included monte, euchre, faro and poker. There were shooting galleries and fighting and wrestling rings. Caledonian sports were inaugurated at the first Christmas, with running, jumping, pole-jumping, quoits, tossing the caber, sword dancing and prizes such as £3 and £6 for throwing the light and the heavy hammers.

Sometimes the entire goldfields would take a day off in search of the curious and the exciting. There were cheap jacks, thimble riggers, skittle alleys and all manner of side shows. Dancing girls always seemed to be called Ballarat Sal, Melbourne Liz and Sydney Kate, always gay in their furs and feathers and satins and silks.

Children got on with their own games of skill — shinty (a Scottish variation on hockey), cockfights, duckstone, tiggy touchwood, kiss-in-the-ring, marbles, leapfrog and fly the garter.

Charles Money procured a job for a fastidious German classical musician as piano man at the Ballarat in Wetherstones, where often an excited Irish boy would do a little roaring on his own account. Money relished the moment when the poor German was clapped on the back and commanded to play *The Rattling Boys*, which was then

Black Horse Brewery, Wetherstones, about 1910. The Hart house is on the right. *Lawrence Museum Collection, Hocken Library.*

26

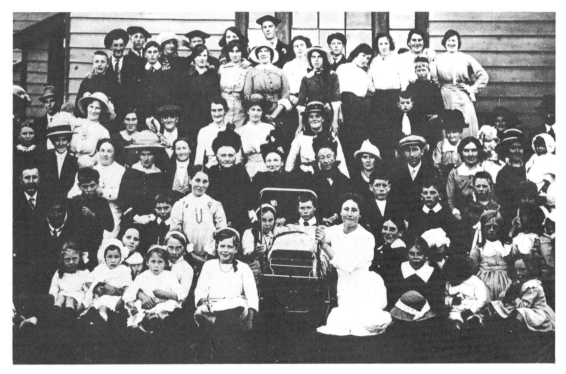

followed by a wild Irish whoop. Money thought the look on the German's face could not have been more pathetic than that "a beautiful danseuse bestowed on the ruffian mob who forced her to execute one pas seul before her own execution". However, the German acquitted himself well enough to hold down his 50s a week plus bed and board.

Money's sense of humour was in keeping with the times, certainly with the *Tuapeka Times*, the *Tuapeka Press and Goldfields Gazette* — both newspapers ran a Facetiae column, of which a few samples:

A pair of tights – two drunks.
How to get along well. Dig it deep.
A newspaper advertisement calls for a plain cook, able to dress a little boy five years old.
Which is the best – the song of the nightingale or the lay of the barn door fowl? – Shut up, and pass the egg spoon.
Does it hurt a joke to crack it?

Such jokes nowadays are more likely to earn the recipient a crack. We are not as facetious as we once were, and this seemed to go for the subsequent goldfield newspapers, with the partial exception of the *Arrow Observer*.

Of course, the inevitable result of all this carousing was a call for

Wetherstones school picnic, about 1910. *Lawrence Museum Collection, Hocken Library.*

a doctor, which often came too late to save some unfortunate, over-burdened with red-eye, from falling in a gully or creek and being frozen to death.

The doctor most often involved was Ebenezer Halley, who made as great an impact as Read in his time. He burned himself out like the comet his granduncle discovered. His practice ranged from Mt Benger near Beaumont down to Waikaia (called Switzers then) and over the Tuapeka fields to Tokomairiro, Waipori and the Lammerlaws. The practice was big and bad enough to kill him. He died of pleurisy contracted from one too many crossings of a swollen river on his faithful horse, Smuggler (the mount which only ever let him down outside pubs, in memory of its previous owner, a commercial traveller).

Robert Fulton, in his excellent book on early Otago and Southland medical practices, has identified some of the areas where a goldfields doctor was needed: "Foreigners from all parts of the world flashed their knives, and stabbed where they chose; bullies and prizefighters battered their victims into insensibility; sluice boxes suddenly overloaded by a freshet gave way, pinning the worker at an awkward moment, smashing wrist or ankle; bullocks kicked out unexpectedly, one perchance catching some poor new chum in the ribs, staving in his side; poisonous liquor, yclept (called) whiskey, poured down thirsty throats, at one and sixpence a shot, soon bringing blue devils in its train. . . ."

Then there were babies to be delivered, the victims of landslides, frostbite, dysentery, pneumonia and pleurisy to be attended to, and so on. Not forgetting rotten teeth; one miner rewarded a doctor with a bag of gold dust for the pulling of such offenders.

And bad doctors. One insensible victim was treated with cold water to the head, mustard plasters to the feet and legs, cold cloths to the back of the neck, friction and hot brandy to the chest and arms, vinegar and brandy upon the forehead and hot water to the feet, and then had 227 millilitres of blood drawn from the arm. The patient's death was diagnosed as congestion of the brain.

Halley was worth 100 quacks. Once he got stage fright at a Wetherstones reading, and managed to blurt out: "I have done my best. Mortal man can do no more." It was a fitting epitaph to his premature death at thirty-nine years of age.

Those who wilfully inflicted the damage which doctors had to clean up were themselves at first given summary street justice. Stick-up bandits at Gabriels were tied to trees and whipped. Two fighters were tried where they fought.

"How do you plead?" asked the magistrate.

"Not guilty."

"You're a liar," said the magistrate. "I saw you hit him. Fined 10s. The magistrate's court is now closed."

28

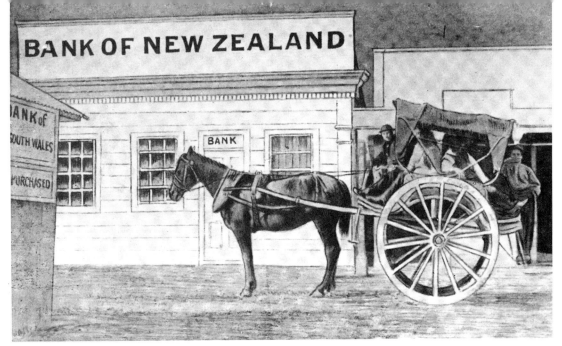

BANK OF NEW ZEALAND

Tuapeka had a great discoverer, a great doctor, and a great bushranger. Garrett was all he was ever referred to as, but he had some of the dash and redeeming qualities of a Butch Cassidy and a Robin Hood. In Fulton's book on the early doctors, Mrs James Fulton describes him as a fine-looking man. His *modus operandi* was as pretty as you please. Henry Beresford Garrett, the alias of Henry Rouse, organised the first major stickup on the New Zealand gold-fields, heading a gang of four masked men who waylaid 15 miners midway between Gabriel's Gully and Dunedin on the Maungatua range of 18 October 1861. The miners could not know the former convict employed unloaded revolvers. Garrett did not drink or smoke but he served his victims gin and lit their pipes, leaving them tied to trees and lighter by 400 pounds and their fob watches.

Garrett took the first ship to Sydney, where he was involved in a bungled bank robbery, again with unloaded revolvers. His description was by now in circulation both as being illegally at large from Victoria and as Otago's first bushranger. Being over six feet in an age when most men were considerably shorter, with the gaunt appearance and slouching gait of a survivor of two decades on the Norfolk Island and Tasmanian penal settlements and the hell hulks of Melbourne, he was recognised along with a stolen watch and shipped back to Dunedin for trial. The press identified him as the most notorious highwayman since Dick Turpin. Mr Justice Gresson reduced his sentence to eight years because of his humane treatment of his victims. Soon after an early release in 1868 he was arrested for stealing goods worth four pounds. Having made threats against a magistrate, he was sentenced to 20 years. He died in gaol aged 67 having spent most of his life in prison following his sentence of 10 years aged 27 for stealing some cloth.

The Wetherstones Bank of New Zealand consisted of two canvas rooms, according to N. M. Chappell in his history of the bank. The outer room contained the coin with which business was transacted, and the inner compartment consisted of a living room for the manager and his assistant. Wetherstones was more notable before its bank was established for the high-risk initiative of young Falconer Larkworthy, who set up the first bank agency there on behalf of the Bank of New Zealand with notes he had printed himself, using the local store and the help of the storekeeper. When the Union Bank at Waitahuna refused to accept one of Larkworthy's home-made notes, the storekeeper ended up in jail and Larkworthy had to call on all the spare sovereigns in Dunedin to restore diggers' confidence in him and his bank. He survived in those free and easy times when it was accepted practice for bank agents to stimulate custom with the aid of a little alcohol. *Lawrence Museum Collection, Hocken Library.*

A less savoury villain was Sam Perkins. He had one grand day when he helped ninety-five-kilo Jock Graham, the colourful postmaster to the diggings, who wore scarlet and a cocked hat with a white feather in it to match his white horse, and who announced himself with a bugle. Rats and mice were the curse of the diggers, and Jock had the bright idea of auctioning a wagonload of cats. Sam served as his barker.

"I have, gentlemen, to offer you," pronounced Sam, "the striped tiger . . . three times removed to the celebrated Kilkenny cats that fought at the Battle of the Boyne until nothing was left but the tails. If you doubt my word, gentlemen, take a look at this tail, and you will find abundant evidence of the fierceness of the conflict in which his ancestors were engaged."

Jock reckoned he had never done better business, topping the 2s 6d he charged per letter for delivery with 30 bob a cat thrown.

Sam Perkins was small, grizzly of beard, and furtive. But the miners believed him again when he reported gold up in them thar Blue Mountains, near Tapanui. Sam was in the pay of a storekeeper who needed custom up that way, and he very nearly paid with his life when the hundreds who tramped there discovered it was a duffer. He was sentenced to death, but the first attempt at hanging broke the branch. While a suitable tree was being searched out, the troopers arrived and released him. It was later rumoured that he was involved in a blackmail scandal in Invercargill, so his disappearance could have been the result of any number of people.

Tent-slitting was a favoured method of robbery. One such effort at Wetherstones led to a determined pursuit by Sergeant-Major Hugh Bracken and Sergeant Trimbill. The pursuers dodged the robbers' fire and tracked them down. They surprised them at night with their own tent-slitting approach, challenging them not to move or their brains would be blown out. The robbers froze, their loaded guns a hand's length away.

Later their leader, Sprotty Gallaghan the Victorian convict, defended himself in court with a string of questions which the reporter blithely dismissed as "trifling and irrelevant".

Much later, Bracken turned in his rank to take up serving drink, attracting Charles Thatcher's satirical song of a man who once collared drunks, who now winks and supplies their drinks.

The old Easter hawker's rhyme "One-a-penny, two-a-penny, Hot Cross Buns" was adapted locally to "One-a-pecker, two-a-pecker", and this should serve as well as anything to introduce the next chapter on the revival and extension of the Tuapeka goldfields, in some cases after the development of other goldfields.

4

Two-a-pecker
Tuapeka the second time around

Gold, gold, gold, bright fine gold!
Wangapeka, Tuapeka, gold, gold, gold!

Otago nurses' variant on old rhyme.

Waipori is today full fathomed under Lake Mahinerangi, for the sake of hydro power. The cemetery is the sole dry reminder of the 3,000 or so miners who rushed there in April, 1862, pausing on the way to dredge out the little settlement of **Bungtown.**

Paddys Point, below Lawrence, developed at the same time, as thousands headed for the Waitahuna fields, which included German Flat, Nuggety Gully, Waitahuna Gully, M'Gregors Gully, Irishtown Gully, Mt Poverty (because it was so cold and bleak), Cockney Point, Maori Gully, Butcher Gully, Tucker Gully and Sailor Gully. In the month of May there was even a rush over to Waikouaiti, which was better known as the end of the ferry ride from Dunedin; Maori women piggy-backed miners to shore, where they set off over the Pigroot trail to the Dunstan.

The *Witness* said Waipori was a wild place where a party of Irishmen, "who seem to take advantage because there is no police force, were fighting for two or three hours". A respectable miner tried to separate them, but got his face slashed and his thumb almost severed. A blacksmith was stunned from behind by a pick handle aimed by a ruffian, who ran off.

A Victorian miner said it was so cold there that the skin peeled off the nose and the back of the hand, giving the victim the appearance of being addicted to "potations deep".

It was a grim place, with credit for one of the first Irish jokes on record here: An Irishman is told of the fall of the price of bread. "That is the first time," he says, "I ever rejoiced at the fall of my best friend."

To begin with, about 1,000 settled at Waipori, served by five

31

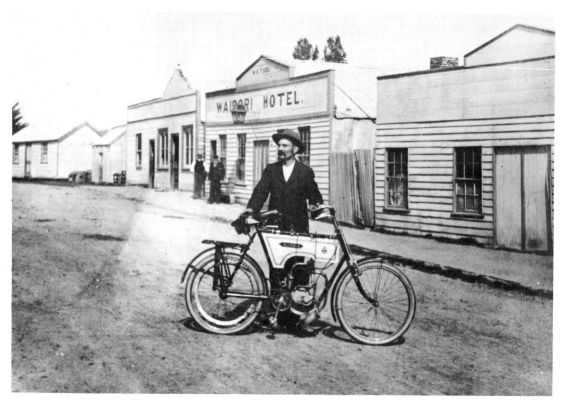

William Wilson poses with the first motorcycle brought to Waipori, in 1906. To the left of the hotel is his shop. All of it is now under water in the interests of hydro-electricity. *Alexander Turnbull Library.*

stores, a butcher, two bakers and an accommodation house run in absentia by the Otago Provincial Council. Some idea of how badly the accommodation house was managed comes from the *Otago Daily Times* refusing to print a miner's letter on the subject because "the tone . . . is too bitter for our columns".

Even the medical treatment there seemed to reach a new low. The victim of a knifing was injected with camphor and turpentine, and that finished him.

On a slightly happier note, a woman charged with "wilfully attempting to destroy herself" was rescued by a young man promising to marry her, which the magistrate held him to there and then.

The bad weather and the drownings drove away all but a few hundred, though quartz mining revived Waipori in 1865. It couldn't have been all bad, for Henry Blackmore had come over from Melbourne to Gabriels, drifted on to Waikouaiti, the Dunstan, Kawarau, Foxs, Shotover, Wakamarina in Marlborough, Mataura, Pomahaka, Nevis, Hills Creek, Hogburn, Hamiltons, Lowburn, Hyde — gasp! — and finally decided to settle at Waipori!

Now it lies submerged, an Antipodean Atlantis, finally resting in peace.

Waipori, 1897. *Southland Museum.*

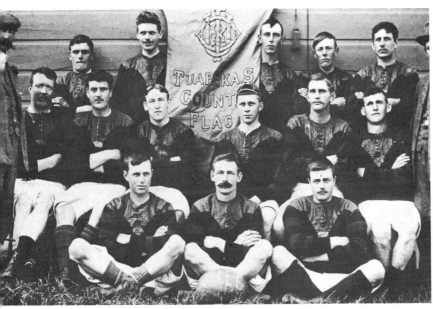

Waipori Representative Team, 1908. *Lawrence Museum Collection, Hocken Library.*

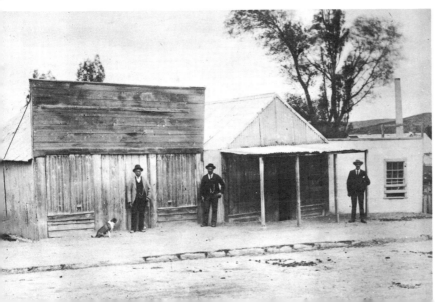

Waipori before the flood. *Ng Collection, Alexander Turnbull Library.*

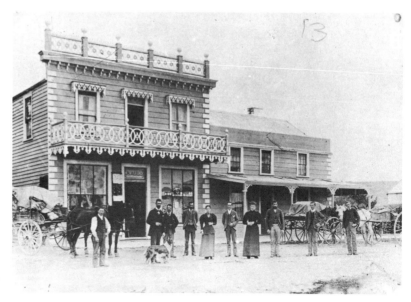

Auld's Store, Waitahuna. *Lawrence Museum Collection, Hocken Library.*

Alex Garden's store, Waitahuna. *Lawrence Museum Collection, Hocken Library.*

The present Waitahuna was Havelock, which did not develop until the 1870s, by which time the goldfields nearby were well dug over. But there are still the remnants today of the athenaeum built at **Waitahuna Gully** in 1870, and precious little else from the thousands who flocked there following the discovery of gold in July, 1862, by Gabriel Read and Captain Baldwin. For many years the citizens of Waitahuna reinforced their misplaced faith in the future of the Waitahuna Gully township by walking the three kilometres there to change their library books.

34

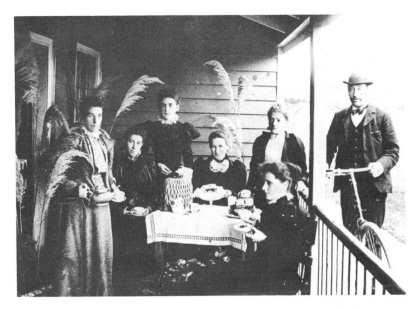

Tea Party at the Bridge Hotel, Waitahuna, about 1900. *Lawrence Museum Collection, Hocken Library.*

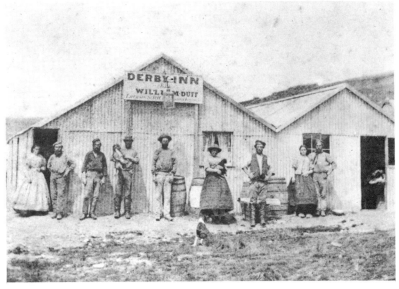

Derby Inn, Waitahuna Valley, in the 1860s. The innkeeper and his wife are standing in the doorway to the left. *Alexander Turnbull Library.*

Waitahuna Gully once had five hotels and the usual stores, butchers and bakers. Some miners had up to £20,000 to throw around, although most, of course, settled for considerably less. The miners at Tuapeka did have the general effect of bumping up shepherds' salaries, which ranged from £45 to £50, to £90 a year.

Favourite pastimes at Waitahuna Gully included shooting pigs, ducks and native pigeon for prize money of £50. The *Tuapeka Times* said it was "good practice for service at the front", which meant the Maori Wars. Bowling, tennis, swimming, cycling, gymnastics,

35

Chinese greengrocer selling vegetables in Waitahuna, about 1910. *Lawrence Museum Collection, Hocken Library.*

Cranky Joe, a familiar sight for so many years on the outskirts of Lawrence in sackcloth and gold-ashes. *Lawrence Museum Collection, Hocken Library.*

rugby, hockey and cricket were played. The *Tuapeka Times* recorded that one match was lost to Tokomairiro by the latter's superb underarm bowling, but that the entire team was lost to the less noble game of cray fishing.

There were ploughing matches from 1868 onwards, readings to raise money for the athenaeum, a local fife and drum band, the Waitahuna Christy Minstrels and even a quadrille association.

The children were not neglected. Inspector John Hislop reported in 1872 that the Waitahuna Gully school had sixty-two boys and sixty-seven girls and that "reading is correct and distinct. Arithmetic is most successfully taught. Home exercises are well done. Singing from notes is taught very efficiently. The results in other subjects are very satisfactory."

The more fickle society of Wetherstones had actually split over the desirability of a school with the progressives eventually winning one.

Chinaman Flat was spawned on the very boundary above Lawrence out of the bigotry of its white citizens. An 1867 bylaw was passed to keep the Chinese out of the town environs, and 600 eventually settled just outside, forming the biggest concentration of Chinese in New Zealand. There were never more than 3,000 in Otago, but that did not stop provincial parliamentary debate on the threat they represented.

The Chinese first arrived on 19 February, 1866, at Waitahuna and Lawrence. The *Tuapeka Recorder* reassured its readers that they "seemed to be a quiet, peacably disposed class of man . . . and although their language sounds a little strange, there was nothing in their general demeanour that could be called downright repulsive". Why on earth should there have been?

The *Tuapeka Times* dared a sneak survey of Chinatown Flat late in the piece and observed sixty to seventy habitations "narrow, dark and dingy, constructed of boards, kerosene tins, and sugar bags".

There the Chinese had their stores, hotels, gambling dens, ashpits, pig sties, cesspools, fowl houses and wells. Their head man, Old Mousey, took vegetables to Lawrence and the citizens of Lawrence came to gape at their feasts of pork, fowl and brandy.

Efforts to convert them to Christanity did not amuse the Chinese, although the sending of a minister to Canton to learn the language was to pay dividends for the missionaries who later went there.

The single remnant of Chinaman Flat is the brick Chinese Empire Hotel, built in 1890 by Sam Chew Lain; the josshouse has been moved up the hill to serve as a crib, the fate of many a piece of Otago's history.

Sam Chew Lain was an exception to the rules. It was his own rule not to serve youth, the test being whether they had any whiskers. He stopped serving those he felt had had enough, telling them to

36

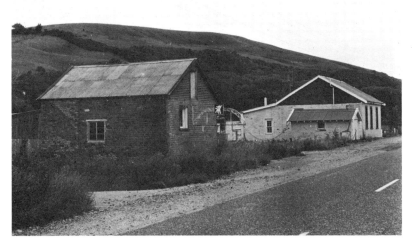

Sam Chew Lain's redbrick Chinese Empire Hotel is the last building left in what was once Chinaman Flat, outside Lawrence. *David McGill.*

go home and dig the garden. He was well regarded by the citizens of Lawrence and became a member of its Masonic Lodge. When this tall, striking figure died in 1903, he was buried in the local cemetery, under the most imposing tombstone there. That was perhaps most exceptional of all, for the Chinese were almost invariably sent home to be interred in the only place of celestial peace.

Among the minor rush towns of the Tuapeka fields **The Woolshed** below Waitahuna deserves a mention, largely for its optimistic renaming as **Glenore.** Another is **Horseshoe Bend** on the way to Miller's Flat, renamed **Rigney** after the principal in a touching incident. In late '64, an ex-Dublin theology student, William Rigney, discovered a shivering dog standing guard over a dead young man. Rigney got permission to bury him there and placed a cross on his grave with the following epitaph burned into it: "Somebody's Darling Lies Buried Here."

In 1912 this good Samaritan was buried beside the young man.

Manuka Creek was always modest but persistent. In 1875 it still had a teacher, butcher, post office/store and hotel. A century later thirty people still live there.

The end of the Tuapeka fields was an overnight affair, as word came in April, '62, that Hartley and Reilly (or Riley) had struck gold on the Dunstan. In September, 1862 Read reported his old diggings almost deserted.

"We left gold," said one miner, "to find more gold".

In 1864 many returned to work for wages in the new era of mechanised mining. Then the **Blue Spur** township developed two of everything — two hotels, two stores, two bakers, two boot-makers and two butchers.

37

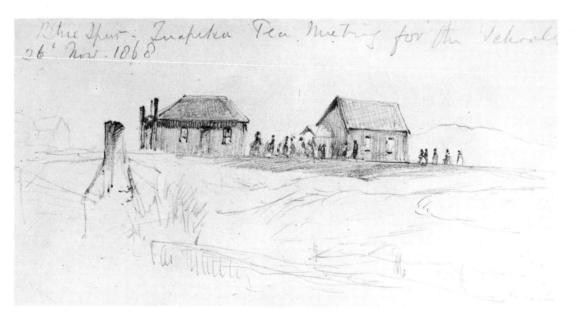

Blue Spur township, Tuapeka, sketched by Andrew Hamilton. Photographs from the original. *Lakes District Centennial Museum, Arrowtown.*

John Mouat returned from there to his cosy life as a Dunedin barrister, and brought back gloomy memories of the grim search for manuka firewood. The only relief was reading the *Australasian* or the *Witness* at 2s 6d a copy, or a Saturday night in a public house "cowering over the miserable shadow of warmth diffused by a stove fuelled with bad lignite, emitting a most disagreeable sulphurous stench".

In 1867, the Blue Spur Mutual Improvement Society ran a winter course of essays, readings and debates. President McLelland, the teacher there, read a paper on music, followed by a debate, "Horses versus Cattle: Which are of the greatest service to mankind?" The poor attendance may have been owing to the discouraging fee of 2s 6d, or, more likely, according to the Blue Spur correspondent: "It makes one's blood run cold to think that young men prefer the billiard table or the dance."

On the first Arbor Day, 1892, 300 trees were planted at Blue Spur and sixty at Wetherstones, for which pray thanks. Blue Spur is today heavy with old trees and rotund hedges, like Wetherstones with a few old residences, although no population is listed there. The Blue Spur House of Treasures is open occasionally, most easily on request.

In 1902 Blue Spur was down to a population of 200, yet these included three Supreme Court judges — Christie, Tyndall and Hay.

Miners kept coming back in the '70s and '80s to pick over the remains or work with machinery. The Fultons opened a New Golden Age pub at Wetherstones in the '80s. Coverlid had first brewed beer there in his shaving saloon in 1863, and three years

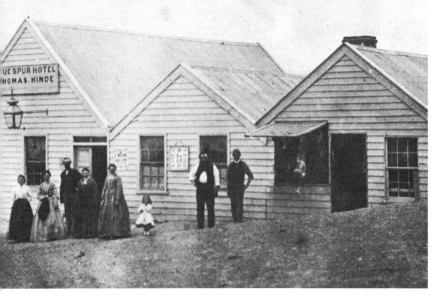

Blue Spur Hotel and butcher shop, about 1870. *Lawrence Museum Collection, Hocken Library.*

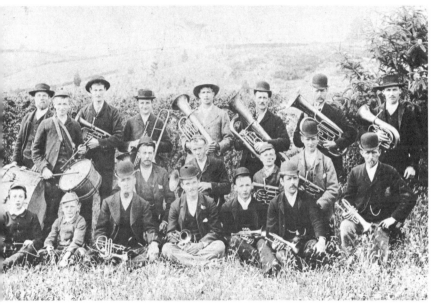

Blue Spur band, about 1890. *Lawrence Museum Collection, Hocken Library.*

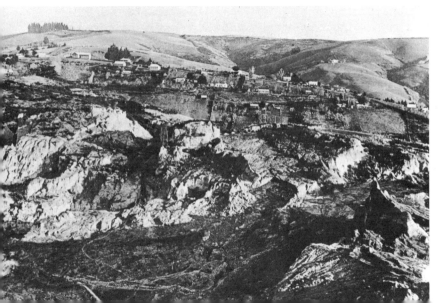

Blue Spur near Lawrence after the goldrush, 1885. *Lawrence Museum Collection, Hocken Library.*

Blue Spur, Tuapeka, today.
David McGill.

later began the Black Horse brew which was famous from Bluff to Christchurch, the pure water being part of the secret of success. It even survived the area going dry in 1908, by which time the great goldfields thirst was over. In 1872 there had been 220 hotels and twice as many sly-grog shanties on the goldfields.

Only Lawrence grew. It is appropriate that the manager of a Lawrence bank should be leading the collecting of photographs and relics of the goldfields. After all, it was that enterprising manager of the Bank of New Zealand in Dunedin, Falconer Larkworthy, who capitalised on the fact that the New South Wales and Union banks had run out of notes for the miners and printed his own. Police Chief St John Branigan reassured the miners of the legality of the notes, the Bank of New Zealand was established among its Australian rivals, and Falconer Larkworthy went on to fame and fortune in London.

That was the story of the goldfields. They had trebled Otago's income in one year from £83,000 to £280,000 and quadrupled the number of ships calling to over 200. Dunedin was turned from a declining town into the nation's leader, its newspapers loftily complaining of the cost to the leading province of the wars and of the possibility of secession from the North Island. Dunedin's solid image was built on the backs of the goldfields. Yet all the petitioning by the goldminers for better roads and services was spurned by the *nouveau riche* Dunedin mandarins.

The Tuapeka fields perhaps did not have time to turn sour. That came in the wake of the Dunstan rush.

40

5

Coals! Coals!! Coals!!
The Dunstan

And the digger came here in misfortune or luck
 with his tent and his swag on his back.
But his bottle is all that is left of him now at the
 foot of the old Dunstan track.

David McKee Wright, 1897.

"Coals! Coals!! Coals!!" was a familiar advertisement in the
Dunstan Times during the 1860s, some indication of improved
attention to creature comforts. But the free, unfettered spirit that
Charles Thatcher and Joe Small, the Irish comedian, sang of was
beginning to sour under the pressures of the insatiable lust for gold.

Muttontown Gully was a case in point. This was where the first
few thousands pitched their tents in August, '62, in pursuit of
Hartley and Reilly's (or Riley's) strike. It was at a stream crossing
nearly two kilometres below Clyde, and handy to the only available
food, the mutton of a local runholder; most of the miners had lost
their provisions crossing swollen rivers, or had an inedible tack
formed from a watery mix of flour, salt and sugar. It seemed an ill
omen that the first storekeeper there was Philip Levy, who later
turned to more violent means of divesting miners of their money,
and was finally hanged as one of the Burgess, Sullivan gang; Levy
was perhaps symptomatic of the riff-raff that were coming onto the
goldfields in greater numbers, just as M'Indoe, the first Tuapeka
storekeeper, was typical of the respectable Dunedin men on that
field.

By Christmas, '62, there were 5,000 men staked along the Clutha
(or Molyneux) from Clyde (or Dunstan) to Roxburgh. Most of these
calico and sod settlements were as temporary as Muttontown Gully,
which soon gave way to Dunstan. Dunstan became the capital of the
fields, something of a champagne centre, as Wetherstones before
it. Evidence of its heyday is in the infamous sly-grog shanty, The

Dunstan Dairy, named after the milk in which the vile alcohol was served and situated two kilometres above Clyde.

Conroys Gully, with Butchers and Blackmans Gullies alongside it, was one of the richest on this stretch of the Clutha, and a substantial settlement was formed there. The cob house built by Richard Dawson in 1864 is still in use within one of the district's orchards. At the lower end of the gully by the road fork is a stone cottage built by a young man for his bride, before he returned to class-conscious England to inherit the title of Lord Locke.

Fruitlands is sadly misnamed, for frequent severe frosts ensure that it is one of the few areas in Central where fruit does not flourish. (There was at the time, a cockeyed notion that altitude was always good for fruit.) It did better as Bald Hill Flat (the name made sense in that the hilly part was flattened in the pursuit of gold.) This location was also known as Limerick for no known reason, and Speargrass Flat after the cutty grass that was used to light fires with the root that was once tried as a vegetable.

Name changes are a feature of much of New Zealand history, and a confusing one at that. Vincent Pyke, who became Superintendent of the goldfields, wrote in his novel *Wild Bill Enderby* of the gestation of goldfields names. The miner gives the place a name "more significant than classical". He is followed by the storekeeper and the "purveyor of strong drink", who form a street "more or less crooked, and assign a more speakable appellation". Then comes some official, "policeman or what not — who, as of use and wont,

Fruitlands in 1874. *Dunedin Evening Star Collection, Alexander Turnbull Library.*

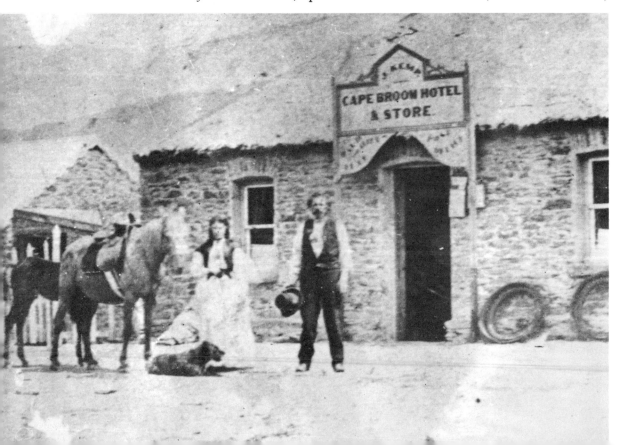

makes a point of renaming the place". The surveyor is last on the scene. He lays out the street "trigonometrically exact but very aggravatingly arranged in connection with the convenience of the residents, whose dwellings are intersected by lines at acute or obtuse angles, cutting off a corner here, running a street through a bedroom there, and generally making everybody angry and uncomfortable. But with the advent of the theodolite arrives the era of order; and the variously-mapped-out township . . . is forthwith known only by its authorised name."

Such was the Milligan-esque fate of many an Otago town, some of which never got past being surveyed.

Fruitlands could probably use another name change and a preservation order, for there cannot be a better line-up of ghostly remnants of cob cottages anywhere in the country. The most notable structure is the stone shell of the Cape Broome Hotel, which causes many a tourist, previously speeding along the straight main road, to screech to a stop for a better look. This was where novelist, Anthony Trollope, found that he couldn't get a meal during his travels in 1872. But what disturbed Trollope's sensibilities most was that "the owners of these iron domiciles seem never to be aware of the fact" that every word can be heard through the walls. He seemed unaware, from his comfortable position, that niceties tend to be forgotten after a day spent digging in water and then having to come home and cook your own miserable meal of damper, boiled bacon and tea, maybe a weka if your dog is doing its job.

The Cape Broom Hotel, Fruitlands. It is sound enough to be resuscitated for the tourist trade and the nation's knowledge of its past. *David McGill.*

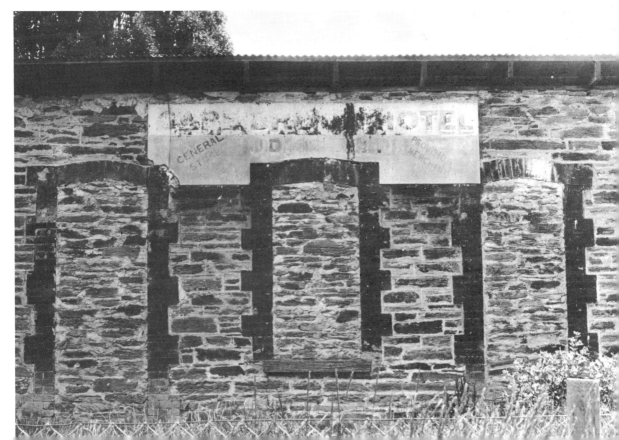

Gorge Creek with a listed population of five in the 1976 Census, was previously **Chamonix**, a packers' town of stores, shanties and accommodation houses. It has a monument to the men who perished over 1,700 metres above it at Campbells Gully in the great snow storm of 1863. There were about 500 up on the Campbells and Potters diggings. (Not to be confused with the diggings of the same name serviced by **Switzers,** with a population of 2,000, but now resited and renamed Waikaia.) Of the 200 who tried the trek out, thirty did not make it. One man slept through the snowstorm and could not get his door open. He was in luck, for he had put a dish over the chimney top in case it snowed, and was therefore able to get out onto the roof.

By the end of '62, Cromwell and **Cornish Point** across the river were vying for dominance. Cornish Point lost because it never got the bridge it petitioned for; its children went off to school by punt. Soon the children of Cromwell will have to come up to school by scuba gear.

Bannockburn, at the end of 1862, was situated on a different site from its present one. It was then located on the flat at the mouth of Bannockburn Creek, where John Richards built his first hotel. The township was named after and gained its fame from a successful miner who built his hut there and passed his easy-gotten gains straight on to the hotelkeepers, with the result that he began seeing the Blue Devils. He constructed a sod wall around his hut to ward them off and, from behind this wall, he hurled stones at them. As the story goes, he chased the last of them into the Kawarau River.

By 1866 Bannockburn was an established township, numbering among its businessmen that baking tyro, James Lawrence, who had bakeries at Nokomai, Nevis, Kawarau (Cromwell's first name), Foxs (Arrowtown later), Arthurs Point, Cardrona and Bendigo. The four-pound loaf inflated from 1s 6d locally to 4s at Nevis, 7s at Arthur's Point and a high of 11s when the rush was on at Foxs. Lawrence also diversified into hotels at **Carricktown** and **Quartzville** above Bannockburn.

In 1867 Richards moved his hotel to Doctors Flat, where it has remained. That year the Foresters' Lodge from Clyde opened a branch in Bannockburn.

The most celebrated sly-grog shanty in the area was run by a woman, who threw out the empties into the road to attract custom and to discourage her legal competitor, Halliday — it was said, perhaps by Halliday, that they were the same empties every day.

Bannockburn's population peaked at 2,000 in 1868. They were an independent, socialist-minded lot, and defended a teacher when he was censured by the Otago Education Board for speaking out on local affairs. A co-op store/butchery/bakery was set up there. A cricket match played in 1895 between men and women indicates

44

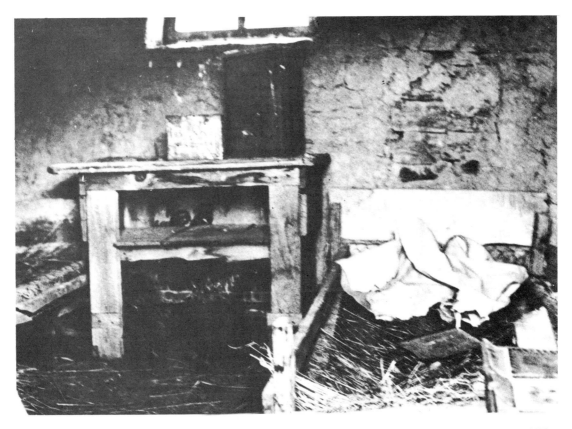

Carricktown, January, 1972.
A. B. Devereux, Hocken Library.

that, socially, they were ahead of the present liberated times. The women won by fifty-five runs, largely due to the deadly bowling of Miss Crombie (five wickets) and Miss Hancock (four).

Carricktown and Quartzville did not develop until the end of 1870, and failed to see out two decades. The harshness of the environment saw some support in the names of some of the thirty-eight mines there — names like Nil Desperandum, Frying Pan and Last Hope.

James Cossar and Gilbert Staite started Quartzville in October, 1870, when they built a store and butchery at the foot of the Carrick spur, near the Royal Standard battery. The *Cromwell Argus* suggested the town's name.

In May, 1871, John McCormick set up the Carrick Range Hotel and, in September, William Sutherland moved his smithy from Bendigo, with stables and other businesses following. The McCormicks celebrated the new township in October, '72 with a free ball and supper. By then there was another butcher and hotel, a drapery and Reuben Isaacs' fancy-goods shop. Huts were built of stone morticed with mud. A confectionery, restaurant and public hall were built and, in April, 1874, a sports meeting was held, consisting

45

of races from one pub to the next. By 1876 the decline was obvious. (Quartzville should not be confused with the diggings at Quartz Reef Point, opposite Lowburn.)

Carricktown, above Quartzville, grew up at the same time and came down sooner. The mine was stoutly named Heart of Oak, although Heart of Stone would have been more relevant. By the end of '71 there was a butcher, a baker and three hotels — Star of the West, Golden Link and All Nations. The following April one hotel had been blown down and another was up for sale. Only Louis the Frenchman was faithful to this grim town. Louis Jean Hubert from Alsace Lorraine had been a Californian Forty-niner. He came to Carricktown in 1871 and worked on the reefs there until his death in 1892, aged sixty-eight. Joseph Berry wrote in the *Cromwell Argus*:

> *Gone is the old 'forty-niner',*
> *Gone, like the days that are past,*
> *Gone is the sturdy old reefer,*
> *Gone to his haven at last!*

Bendigo, the place where businessmen left to go to Carrick and returned to later, is probably everybody's image of a ghost town. A flat, dusty road leads to a crossroads, where the wind whistles through a few tumbledown stone cottages that are little more than walls, outlines, like film sets.

"Site of Bendigo", says the AA sign. Behind is the yellow tussock, the line of pines and poplars and the backdrop of craggy hills, way up where **Logantown** and **Welshtown** once were.

One good remaining cottage is a crib. It was vacated a few years ago by a veteran miner; some say he is over in the Lindis Valley prospecting, some say he is up in that goldmine in the sky.

The emptiness in Bendigo is potent. You keep waiting to hear a sound, you catch a movement out of the corner of your eye, to your relief just some ol' tumbleweed rolling down the main street — except there's no tumbleweed in Otago, that's the Wild West you're thinking of. Too much telly. Blue Devils of another kind.

Bendigo was where the goldfields most elaborate joke was devised. John Magnus and two companions spent a month dressing a sheep to make it look like the missing Ah Fook Hu. They arranged for the "body" to be washed ashore. Ah Fook's brother was called. He declared it was not Ah Fook. "But me savee allasame," said Ah Fook's brother. "Him come from Queenstown." The joke was revealed and Bendigo had an all-night booze-up to celebrate.

The rush there had begun in September, 1862, but only about 500 stayed on. The tough Cornishman, Sam Box, and his captivating Irish wife, Maggie, set up store and saloon the next year, and were followed in the drinking business by the Hares, the Joe Smiths and Mrs Wilson, wife of Jack the Drummer.

46

Bendigo today, the bleak aftermath of a Central Otago goldtown. *David McGill.*

Box's store was the centre of Bendigo life in many ways. Saturday was wash-up day, then sell your gold at Box's, buy next week's tucker, have a few drinks, carry back a few, which went into the pool and then the fun started. The level of singing rose as the liquor level fell, "till it became," said witness George Hassing, "a hideous, maniacal yelling that entirely overpowered and drowned every sound within a radius of a mile or so".

Saturday night fever became so important to these brawny lads that when a flood took off the week's takings of 700 or so grams from the upper reaches, they took to theft. A diversionary cry of fire lured the Box family away while Harry the Slogger nipped into the store and raided the till. Later that night they were able to fill it again in exchange for the makings of the Saturday shindig. The upper area thereafter was called Swipers' Row.

When Mary Ann was jilted on her wedding day in Cromwell, she raffled off the wedding cake and accepted the Box's offer of a job as barmaid, becoming the first single woman behind a bar there. The Box's recouped any previous losses when the bar was drunk out in two hours flat by miners who were curious to see a barmaid in a bridal gown with orange blossoms on top. Hassing reports no ruffianism.

From 1863 to 1869 Thomas Logan persevered in getting quartz mining established in Bendigo, his success leading to a new rush of 400 men to the area named after him nearly two kilometres above the township. Stores and restaurants followed and the Logantown Hotel celebrated the opening of the battery in February, 1870, with a ball on a dance floor, which the local reporter thought "a week's blasting operations would have vastly improved".

47

Logantown increased its business to five hotels, three stores and three butchers, a clothiers, two restaurants, a billiard saloon and two blacksmiths.

Welshtown, which developed three kilometres further up was named after its inhabitants. The Bendigo township site was chosen by Superintendent of Otago, James Macandrew, on a visit in 1869. York Street was the main thoroughfare, lined with wood, iron and cob or pug establishments, including a bootmaker, baker, restaurant, five hotels, three stores, a clothiers, Isaac the Jew, three butchers, and a Miners' Temperance Restaurant Hotel, which sounds like a queer mix, if not a contradiction in terms.

After Goodalls' Hotel was burned down, while the proprietor was in bed and his wife was still below serving the midnight crowd, a meeting house was built on the site. A planned church came to nothing, but a school was established in 1878. Bendigo shakily survived into the new century.

The *Cromwell Argus* wrote a thoughtful piece in 1876 on the subject of why mining centres decline, suggesting that in the fourteen years Bendigo had been going, the miners had looked upon it solely as a place of work, not as a place to bring wives or to bring up children. Miners would not spend a farthing on the town. The proof was apparent when a visiting preacher chose wisely, but not well, the text: "If, O Lord, there are any here who are bowing down to the mammon of unrighteousness, put a hook in their nose as Thou didst to Sennacherib of old and turn them into the right path."

"Amen," said the miners, but they did not put their money where their mouths were, so the preacher received little recompense in this life for his well-meaning efforts.

All the miners' greedily-gargantuan efforts count for naught now, like sounding brass and tinkling cymbals. Bendigo, Logantown and Welshtown are as effectively ruins as any old Biblical city, with the dangerous disadvantage that the two upper sites are riddled with mine shafts fifty-five metres deep as common and as well-concealed as rabbit holes.

In January, 1865, Mr Cope, secretary of a mining company, declared that he expected the Dunstan to become the metropolitan goldfield of the province. More realistic was the 30 December report in the *Witness* that there was insufficient population in the Dunstan to permit storekeepers to pursue a divided trade, but that they must needs stock everything. The centre of goldfield gravity had moved on to the Arrow and beyond, which makes the advertisement Dunedin woodturner F. Jones placed in the *Dunstan Times* for 15 February, 1867, all the more curious: "Billiard balls, accurately returned."

6

A waist of time
The Arrow

Oh, the days when the shanty was here, boys,
* the rollicking days of old,*
The days when the luck was near, boys,
* the days of the first of the gold!*

David McKee Wright, 1897.

David McKee Wright looked back with lively land-shanties, shot through with sad hindsight. But of course it was nothing like that really, if the *Arrow Observer and Lakes District Chronicle* for Friday, 5 January, 1872, was anything to go by: to the *Arrow Observer* a waist of time was a stout old lady's legs. Those were the days of the uninhibited male chauvinist, and newspapers too; at least thirty were published in the province.

The gold was to thank, or to blame, for it. Alec Miller can remember a dredge every 1,500 metres along the turbulent Kawarau; a rash youngster proved the very day I was there with Alec that you can still drown trying to swim it. Alec has a gold ring fashioned out of local gold by his maternal grandfather Charles O'Fee in the shape of the clasped hands of international brotherhood. He has one, too, from the fruits of the adjoining Arrow River, but the metal is less pure.

Miller is a farmer at **Gibbston,** which you can pass in two blinks of an eye. First blink and you miss the adzed furniture sign, which used to be Gibbston Post Office in the house behind and was run by the Kinrosses, big landowners in the area.

Second blink and you pass a rest area, which was where the pub and the other half of Gibbston used to be. The hotel has gone now (it was burnt down in 1912), but Mrs Sanders lives in a new house on the site and will show you a photo of the old pub. She was born up the road where they later mined coal, but she always had a yen to live down here next to the old stone ruins of the store and stables.

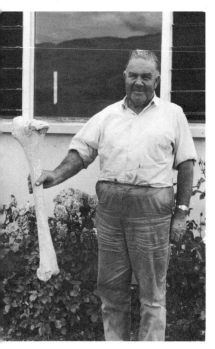

Alec Miller displays the bone of an original inhabitant of Gibbston, situated between Cromwell and Queenstown. He also has gold rings fashioned from his grandfather's sluicing of local rivers, and grand tales of the area's gold days.
David McGill.

The stone Gibbston School was replaced a few years ago, after surviving eighty-seven years; Queenstown Museum and Alec Miller put in bids for the original. The bids happened both to be $120, but the museum got the nod in the interests of cultural history; Alec had planned to replace the roof and use the building where it belonged.

He has a photo of the old school when it had forty-six pupils in 1892. The new school will seat under twenty, reflecting the population decline from over 200 to under fifty, not counting the Chinese.

Mrs Sanders and Alec Miller can remember the Chinese shuffling past in single file, always with a sow behind. The animal would farrow and keep them in bacon. Contrary to their usual practice, they did leave some gold behind. A local rabbiter went down in a scuba suit and brought up 311 grams recently.

The river is still where the gold is but there were several attempts to mine the bald hills above. Some Welshmen put in twenty-two kilometres of water races across those hills.

"People ask how they checked their levels," says Alec. "Well, they got the castor oil bottle and checked the bubble in the top for the level. Then they drank the castor oil and away they ran."

Alec laughs fit to split that gold-ring handshake. He's a genial, roly-poly fellow with a face thrashed from all seasons.

Arrowtown is the thriving epicentre of gold memorabilia, which is deposited in the display cases and the vaults of its excellent museum. Ex-deerstalker, Mike Bennett, runs it with a great passion for improving our picture of the past and a dire dislike of those cultural vandals who unthinkingly destroy it.

Above Arrowtown are the two quintessential ghost towns, **Macetown** and **Cardrona.**

Macetown is at the end of a twelve-and-a-half-kilometre walking track. For many years those tramping in would pass its unofficial mayor, William Jenkins, walking out for his provisions, which he did into his eighties. It is only in the last decade that we have lost these tough old turkeys and, with them, the last direct link with the days of gold fever.

Today Macetown is a pretty flat, shaded by serene old English trees. The days are numbered for Needham's stone hut there, since it lost its roof in the centennial year, 1962. (It was probably taken for a pigsty.) The last Chinese shanties have been bowled over by the yahoos. Smith's bakehouse, a wooden house and a few stone chimneys are all that is left.

Lake Hayes farmer Keith Grant, talked about his days as a lad there over his breakfast consisting of porridge, eggs, bacon, tea and plenty of toast. His grandfather mined at Macetown in the rush, and later his mother worked for the Tipperary Mine at Scanlons Gully. He grew up riding over its decline.

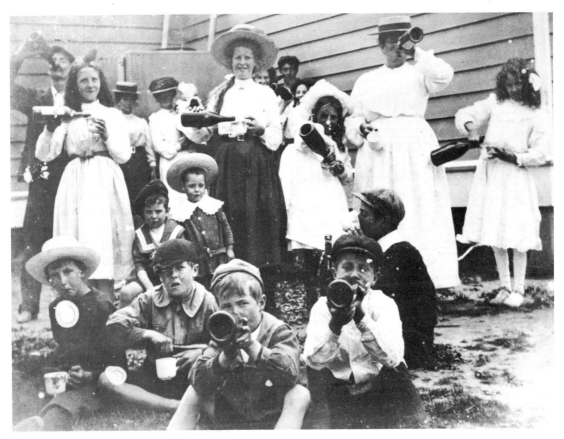

There is a 2,000 metre rim above Scanlons and Sawyers Gullies and Sylvia Creek which stretched down into Macetown. This settlement was named after the three brothers Mace — John, Charles and Harry, who struck gold there at the same time as the brothers, Joe and John Beale. Most goldtown names are disputed, but the most far-fetched belongs surely to Macetown which, according to a rival account, comes from a previous publican called Mason Melody, thus Mason's Town, contracting to Mase's Town and, finally — Eureka! — Macetown. Anyway the five who found it settled for calling it Twelve Mile, because it was that distance from Foxs — the towns of the time often received a mileage nomenclature to begin with. That's not the end of it, for Macetown was also called Goldburn.

Macetown was built in a hurry to accommodate several thousand miners. Only the chimneys were stone, and river stone at that, not quarried. Walls at first were sod or calico, later wood, iron and stone.

There were only four hotels; Macetown was never as debauched as Foxs. The chimney of the last hotel, the Alpine, only came down

Macetown, 1902; celebrations in those indulgent days when children were allowed their own bottles of beer. Would Dr Spock have approved? *Alexander Turnbull Library*.

51

in recent years. There were four stores, one run by bachelor, W. T. Smith, who was famed for his plum puddings. The butcher had his own slaughteryard and the bootmakers was known as The Knob Shop.

Perhaps it was by contrast with the rest of the citizens that the twelve Apostles became so famous. They were bachelors gay, in the innocent meaning of the day. Some would call them wastrels, rascals, drunkards even. But they all lived to sturdy old ages, no doubt attributing their good health and longevity to their daily intake of booze. One of them, Doc McKenzie, decorated the walls with copies of the *Illustrated London News.* In his more temperate declining years, he tended a garden of roses and geraniums and invited a round dozen — but, of course — of the Macetown ladies to afternoon teas.

The twelve Apostles lived down on the river embankment, handy to the Montezuma gambling den. The Chinese were further down still, at Hood's Gully, rock bottom.

Macetown was one of the few places where the Chinese worked new as well as old seams, but not underground — they were superstitious of that. Their herbal remedies were often sought when the universal panacea, Painkiller, failed to do any more than get the sufferer tipsy.

The healthy local lads were as merciless as any on the Chinese. They threw stones at them, fired their straw beds, painted their windows black so they would think it still night and blocked their urine bottles with mud. Even the girls stoned the Chinese for which, it is recorded, the teacher gave them six cuts each — for playing hookey.

For all that, the children did not prove averse to Chinese nut and treacle cakes, and seemed trusting enough in Chinese goodwill not to expect toads' eyes or some other retaliatory morsel folded into the food.

E. H. Wilmot surveyed Macetown in January, 1878, just as it had begun to decline. The main street was to be High Street and across it, Navan, Nore, Mayo, Lee and Boyne Streets. Few sections were taken up.

Some years ago the habitable buildings were sold for $10 each, dismantled and carted off, the kind of benign destruction that prevailed unchallenged in the pre-Bennett era.

Now Macetown must be regarded largely as a ghost park.

High up on the Crown Road **Cardrona** is showing signs of life as the Cardrona Hotel once again opens its doors — for the sale of craftwork, homespun woollen garments (while you wait and watch), Sunday painters and pottery. The proprietors plan to do it up, but that is quite a job. There is a quaint rippled effect to the old exterior which it would be a shame to fix. Most of the inside is in a

Macetown was surveyed by E. H. Wilmot in January, 1878. *Alexander Turnbull Library.*

52

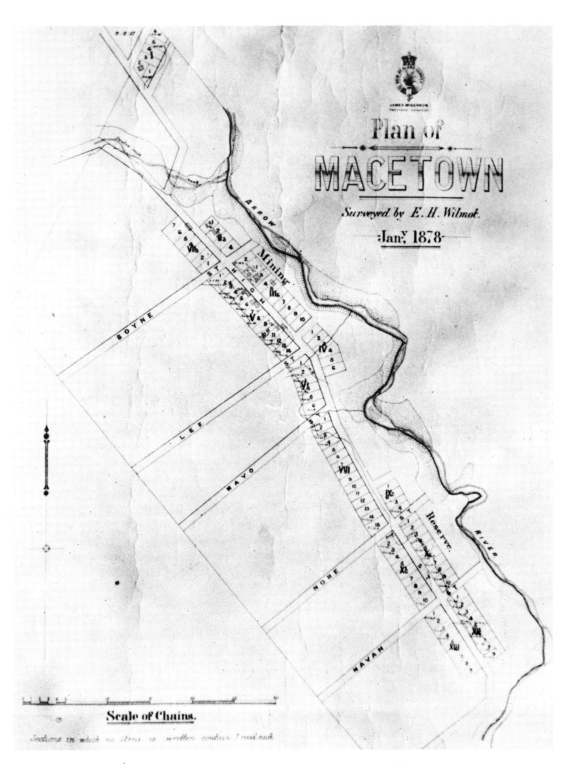

Plan of

MACETOWN

Surveyed by E. H. Wilmot.

Jan.ʸ 1878

Scale of Chains.

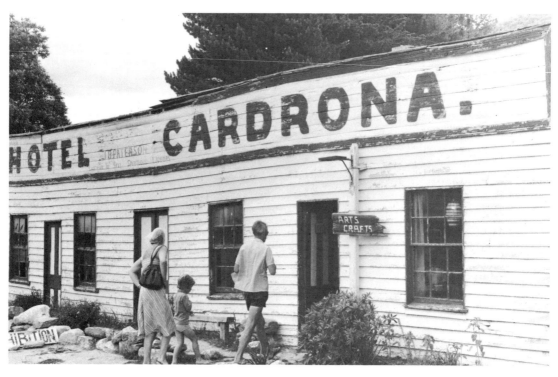

A new role for an old goldtown hotel. *David McGill.*

rotted, disembowelled state, especially the billiard room where the popular Paddy Galvin once danced reels to his own accompaniment on the fiddle. He was supposed to have resigned a publicanship because the licence allowed no music after ten at night.

It is not long since Cardrona Hotel was closed, and many well remember the difficulty of getting a beer out of James Paterson, its last publican. Cardrona is halfway between Albert Town and Arrowtown, on the highest if not the most rattly road in New Zealand. Paterson had too much respect for the road to allow more than a small beer, and lukewarm at that.

McDougall's store is still there next to the pub, quite possibly playing a mutual propping role, although the pitch is definitely not in its favour. Back the other way, the old school looks hale, but is barricaded up by the local recluse, who wants no truck with townies.

About five kilometres down the road towards Albert Town was **Lower Cardrona,** which boasts no residents whatsoever and was much the smaller settlement, contrary to the usual upper/lower syndrome. An hotel, stores and houses were built around the Banner of War and Empire claims. Little remains but the memory of the Christmas day when Dinah arrived fresh from Ballarat to the Empire pub. Lanky Jim grabbed the first dance and held on. At midnight the traditional pronouncement was made that single

54

women were reminded that leap year would soon be over. She proposed, Lanky was disposed, and they allegedly lived happily ever after in a cabin in the pines.

Alfred La Franchi opened an hotel at Cardrona in 1873, and ended up buried in the cemetery there. All told, there were four hotels and seven stores (four of which were run by Chinese), a post office, butcher, baker, blacksmith, bank, school, police headquarters and jail. There was also the McDougall post office/store/boarding house, although goodness knows, it is hardly big enough for one single function.

The school opened in 1870, and its first teacher was G. S. Pope. He was paid £130 per annum and may have the distinction of launching both adult education and night school in this country, with classes attended by six Chinese and four Europeans. The subject was one still popular in some quarters, the Three Rs.

Across the road from the Cardrona Hotel was the cricket pitch. From 1870 there were races on a course with a natural grandstand. In the mid-'70s athletics were the most popular. Even some of the Chinese entered. Their unusual running style provoked amusement, but was effective for the winner, Ah Goon.

Towards the end of the '70s the decline began. Locals began complaining that the clergy were never to be seen; they had not complained of lack of clergy in better days.

The carping increased. Drama and quadrille had been a popular way of whiling away winter evenings in this temperate town. Yet still a correspondent of a righteous turn complained that Mammon and Bacchus ruled the roost. Not to be outdone in the guardianship of Cardrona morals, the forty members of the Good Templars Lodge declared the Quadrille Assembly an immoral pastime. They scored on that count, and naturally extended their condemnation to the Progress Committee Dramatic Club and the Miners' Association. All three were closed down. Hallelujah!

Bitterness gripped the community. They objected to the taxes of £800 for a claimed £145 spent there. They wanted to be in Vincent County, not Lake County.

A mounted trooper visited a miner. Soon there was a rumour that he had inherited £500. The rumour picked up steam, and eventually it was declared that the miner had inherited £500,000. He did not deny the rumours when he found that the hotel accepted drinks on tick. He and his many new friends drank the pubs dry. On polling day the reason for the trooper's visit became clear when the subject of rumour emerged as deputy returning officer.

Cardrona's population dwindled from 1,000 to fifty Europeans and 150 Chinese. The 1878 flood was a deathblow to the town.

Albert Town is doing well today as a holiday crib spillover from Wanaka, but in the old days it dominated the area, absorbing

Cardrona's last licensee, Jim Paterson, at eighty-nine years of age, two years before his death in 1961. *Alexander Turnbull Library.*

55

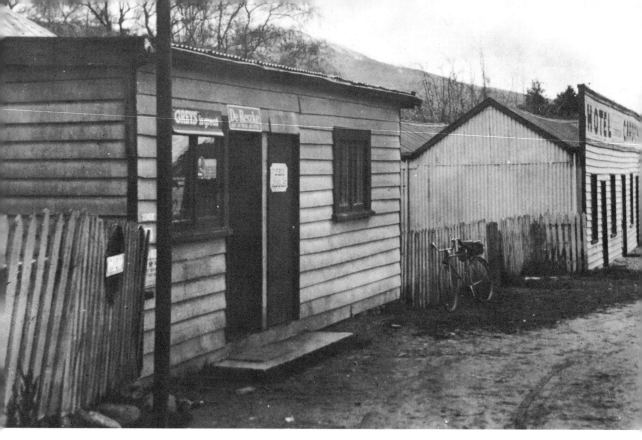

Newcastle. It was known as Alberts Ferry in reference to its role in keeping miners on the move.

Nevis and **Nokomai** may perhaps fit at the tail of the Arrow, for in a general geographical manner that is where they are.

Gold was discovered at Nevis in October, '62. A store was established in the New Year and steady growth reached a peak population of 600 in 1866. A newspaper was an imperative, and the *Nevis Buster* came out in handwritten form and was posted up for perusal. Presumably there were always enough literate men around to pass on the news. In those days a newspaper was called a buster, but the reason for this is not known any longer.

The next step for Nevis readers was a library in 1870. The following year its Progress Committee was pushing for a bridle track to Upper Nevis and a footbridge to the settlement known as The Crossing, where those coming over the Carrick Range crossed the Nevis River. There was a store/hotel there. At Lower Nevis there was a Potters No. 1, to distinguish it from Potters at Waikaia and Potters on Old Man Range.

Upper and Lower Nevis managed their one and only cricket match in 1891, and four years later Nevis beat Bannockburn. But by then, although gold had been followed by coal-mining, the place was in decline. This did not stop the horse races that began in 1866 and continued until 1912, however.

56

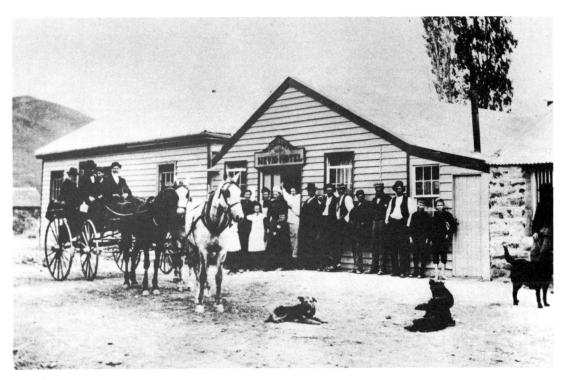

Nevis Hotel. *Hocken Library*.

Proud Nevis wowsers, about 1908. *F. Pyle Collection, Hocken Library*.

In 1901 the determined folk remaining formed an Endeavour Club, in 1906 rifle and tennis clubs and in 1912 the first Nevis Collie Dog Club. Weeks cut off in snow blizzards did not dampen their spirits.

Time finally crushed Nevis, and now it has no life.

Nokomai still does, and it was alive not long after Gabriels. Yet it was 11 November, 1871, before it finally got its community status symbol, the *Nokomai Herald*. This was published by local entrepreneur Henry Evans and handwritten by local schoolteacher Grant, its tone Victorian paternal. The Hurdle Race, it condescendingly announced, would be directed through the town "in deference to the ladies . . . it being a well-ascertained fact that for Love, Money and Steeplechasing the dear creatures will do anything".

The dear creatures did not do their duty well enough to keep Nokomai a going concern.

Nokomai demonstrated the typical struggle between rowdy diggers and an emerging bourgeoisie bent on gentility. The 30 December, 1871, issue announced a Tea Meeting and Ball the following Tuesday, yet this entry was surrounded by hotel ads in Mr Grant's best hand.

Perhaps the *Arrow Observer* deserves, in a rather male chauvinist chapter, the last as well as the first words from the same issue: "Fishes out of water — muscels (sic) in a lady's neck."

Nokomai, sketched by Andrew Hamilton, about 1869. Photograph of the original. *Lakes District Centennial Museum, Arrowtown.*

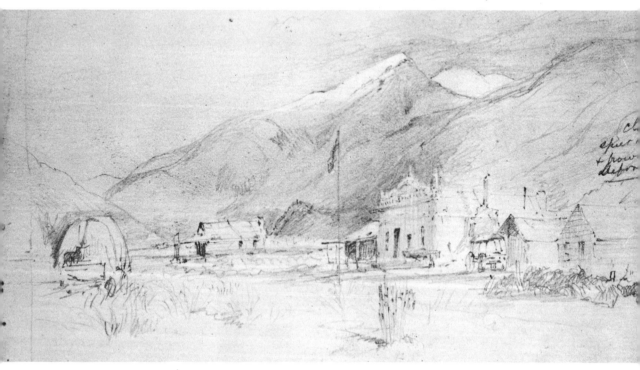

7

Boots! Boots! Boots!
The Lake goldfields

Then the loud, hearty voices of men came and
went in the rude iron walls that are gone,
And the crack of the whip was the music to hear
on the steeps where the waggons were drawn.

David McKee Wright, 1897.

"Boots! Boots! Boots!" was an advertisement in the *Lake County Press* in 1884. By then a better class of Napoleon was available for sale, but it was two decades too late for the intrepid tramper in search of ever-more fabulous goldfields.

In 1862 the Shotover was known as the richest river in the world. Men were dipping in shovels and lifting out 155 grams of gold at a time!

The trouble was that the river was ferociously cold and swift and its near-vertical banks were given to massive slips which took all before them. Horses were often obliged to slide down tracks on their tails. The conditions tended to make more than usual numbers of ghost towns in the Lake Wakatipu district, with less to them.

Arthurs Point was where gold was struck by Thomas Arthur and Henry Redfern on 16 November, 1862. They took over 6,000 grams in eight days with a value of £4,000. Now Arthurs Point is represented by one modern hotel; in its heyday it had a racecourse with a natural amphitheatre.

Julian Bourdeau from Montreal was storekeeper/packer on the track up to Skippers from 1862 to 1911. He feared that a road would put him out of business. It was the lack of a road that almost put runholder, Rees, out of business when one of his cattle leapt over the Devil's Staircase and took thirty-two of its kine down with it. Anybody who has spent three or four hours negotiating the thirty-two harassing kilometres to Skipper's Point can only wonder at Bourdeau's fears.

Perhaps the greatest wonder of it all is how they ever got a road around the precipices which occur at every turn above the viscous turquoise tumult. The road was not finished until 1890, a seven-year job, and long after the thousands of miners had swarmed up the length of the Shotover to its source. At Hell's Gates there are still the drill holes from the rock cutting in 1889, when John Maher and Sons of Kew, Invercargill, made a futile effort to cut a side road through to Pincher's Bluff. "Watch out for Old Man Maher" is the inscription on the rock. The Maher family have a traditional tale that there were three gangs on the road — one coming, one going, one quitting.

Nothing, of course, stopped the miners, not even their high casualty rate. The chimneys of the Long Gully Hotel are still there, but the first Shotover goldtown was **Maori Point,** or Charlestown, where there was a settlement on both sides of the river. At first the miners baulked at crossing the river, but Dan Erihana and Hakaria Haeroa showed the way. Their dog was swept away and, in rescuing it, they stumbled on a fortune. By nightfall they were rich.

The townships developed there in 1863. On the eastern side where the road was, were two butchers, the Diggers' Rest Hotel, a bakery, five general stores, a dozen grog shanties and a library. The western side had the police camp, court house, Bank of New Zealand, a bakery and three stores.

Now there is nothing left of the townships but a stone cairn.

The *Lake Wakatip Mail* for 6 June, 1863, regretted that there were only 200 police for the entire province and that the Skippers area, with a population of 2,000, had to make do with two policemen at Maori Point. Not every miner had the extended family reinforcements that the Maori chief, Patu, was able to return with when dispossessed of his claim. What got on the *Wakatip Mail's* quill was the £5,000 "wasted" on a warden's camp at Queenstown, while the Shotover endured poor policing and bad roads. Often the sick could not be taken out, and then it was hell on the poor blighter strapped up in splints.

For all that, Maori Point had its days at the races. In May, 1864, the *Mail* covered the Maori Point races; on the card the Maiden Plate, Upper Shotover Cup Hurdles and the Miners' and Packers' Purse. "Bob Apples," reported the *Mail*, "got the lead and kept it throughout the race. He was pushed hard by Scrubber when about two miles round but the Riverton nag was too good. Karkaway never had a show in the race. The betting was Bob Apples against the field, two to one against Scrubber."

"Wakatip", Trollope observed, was the habitual spelling, but a final "u" was the correct one.

The *Mail* reported two prosecutions that carry some of the feisty flavour of the times. Warden Charles Worthington was prosecuted

for assault on Miss Pocock, would-be licensee of one of the twelve sly-grog shanties. Worthington was acquitted because of Miss Pocock's reputation. The second prosecution was on the other foot, or everything but, when Bull Pup, nickname for Maryanne Anderson, an associate of Bully Hayes the pirate, was charged by a baker with assault, during which he claimed she hurled stones, cakes and oranges at him. He sought £20 damages, but did not get them.

The worst threat to shanty-owners, butchers, bakers and all, was the weather. One torrential burst of fifteen solid hours of rain brought the river up nearly fifteen metres and washed away or buried alive men and materials from Maori Point up to Skippers. Deadman's Terrace at Skippers is named after a dozen men who died in a landslide there.

A single family, three generations of Scheibs, lives at the bottom end of Maori Point Flat. The remnants of the settlement are chimneys and the bottles that they find where the hotels and drinking dens were.

Further up Maori Point, Wong Gong had a store and a market garden. He was one of the Cantonese who followed, as always, in the wake of the Europeans. One of them, Hoy Yow, has a headstone in the **Skippers Point** cemetery — like Sam Chew Lain in Lawrence, an exception to the rule.

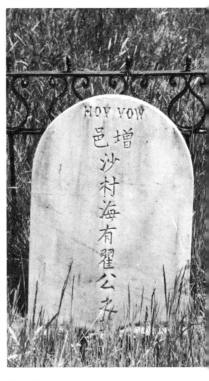

Hoy Yow's gravestone at Skippers Point. *David McGill.*

A man who had lived locally for many years suggested that despite the headstone, Hoy Yow's remains may well have been transported back home. The live Chinese, he told me, could return home rich with £1,000, half the European notion of a fortune. Often the Chinese dead, rumoured this local wiseacre, had their innards cleaned out and gold sewn into the corpses to benefit their relations. Margaret Glennie of Bullendale, further up the Shotover, has added support to this notion by recalling that a dead Chinaman was carried from there to Arrowtown. On arrival it was noticed how light the body was, and investigation showed that his "internity" had been removed.

Skippers Point was named after a skipper who found gold there in 1862. Which skipper, that is the question? There seem as many answers as there are authors. Skipper Duncan could be ruled out as a year late for the accolade. Captain Malcolm is advanced by some. An anonymous "skipper" arrived with a party of Welshmen, say others. Then there is Captain Gay. The most detailed aspirant may also be a year out — one John Falconer, skipper of the yacht in which James Hector, Provincial Geologist of Otago in 1863, surveyed the Hollyford.

You can at least be sure of the names still visible in the large cemetery, which is the best-preserved part of the town, if anything, much improved, for the firs have matured into a graceful surround. The sixty plots are only represented by twenty headstones now.

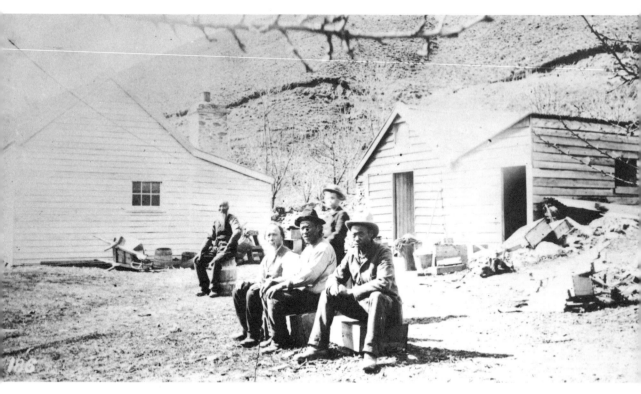

Skippers Point. *Ng Collection, Alexander Turnbull Library.*

There is William Williams of Cornwall, aged thirty-eight when he died in 1873; Colin and Mignonette Macnicol, Peter Tayler of Manuel Burn Bridge, Stirlingshire, Robert Duncan, accidentally killed, Native of Nairnshire, Scotland, and Samuel Johnston and his family, Eliza Jane, James Robert and Mary — the stone ruins of their hotel are across the gully. Skippers' most famous son is also buried there, the diminutive John Aspinall, an inventive miner who was praised in his time for not putting profit before progress.

The old wooden school house over the way is now an outhouse ruin of the Mt Aurum (Mt Gold) farmstead. Bert Tripp has informed the curious in the hallowed tradition of classroom carvers that he was a pupil there from 1898 to 1904, and that he returned to carve again in 1962.

The publican at Skippers Point wanted to pay a flat fee for the transportation of his first barmaid. The packer had been tipped off and insisted upon payment by weight, the lady being somewhat embonpoint.

The Roaring Meg stream and Gentle Annie track and bridge are named after two local barmaids. Meg was a personable redhead who was not averse to using the butt end of a bottle on any customer who got fresh. Gentle Annie was even tougher, she only looked slight.

There were twenty-two pubs at one time between Queenstown and Skippers, the first being Jack's Hotel, now part of a henhouse out of Queenstown. It was said you needed one drinking hole for every thirty miners. In 1872 there were 220 licensed hotels on the goldfields, one for every 200 citizens — today it is one for every 2,500. And you could probably treble the licensed numbers if you included the sly-grog shanties.

Many bush licenses disappeared when county clerk, Philip Burbage Bolt, raised the licence fee from £15 to £20. He pocketed the difference, was caught in 1887 and put away for five years.

Goldfield life was at its toughest on the Shotover. As well as floods and landslides there were sixty-degree frosts that cost toes and fingers, pneumonia, pleurisy (or just plain unavoidable rheumatism from working all day in freezing waters), knife and gun wounds, typhoid and scarlet fevers and diphtheria, for which the only antiseptic remedy was the medieval burning of sulphur and scattering of chloride of lime. The Maoris suffered terribly from measles, bathing themselves in the pathetic hope that this would cool them down. Miners risked and endured any suffering in the pursuit of gold.

Today Skippers Point is a summer picnic spot, usually for landroving families. The area may come back to life if the million-dollar gold dredge proposal goes ahead.

Eight kilometres above Skippers Point at the source of the river was **Bullendale,** most definitely a dead-end settlement. It was named after the Bullen Brothers, who introduced quartz mining there in 1869.

The decaying dotage of the Skippers Point School. *David McGill.*

Population of Moke Creek, 1949. *Alexander Turnbull Library.*

In winter Bullendale is shrouded in perpetual snow. The faithful old horses that trudged up this shingle gorge during winter often arrived with icicles hanging from their mouths and manes. Margaret Glennie wrote in the 1 June, 1960, issue of the *Weekly News,* of birch branches weighed to the ground by winter snow and washing hanging frozen stiff on the line for days. Despite the inch-wide metal spikes in each heel, the children preferred to slide everywhere. She knew old Bourdeau's old horses, Lubra and Kate.

Summer was rainbow meadows of buttercups, foxgloves, dog daisies, sweet william, golden broom, green ferns and the white-blossomed ribbonwood, whose bark could be pulled off like strips of lace. In the fruit season they picked pillowfuls of gooseberries, raspberries, strawberries and red and black currants that the miners had planted.

There had been two mines, the Achilles and the Phoenix, Bullens owning the latter. When the mines closed in 1900, 200 miners were out of work. A small Chinese community stayed on in their fenced-in area, prospecting in the creek, never learning English, never perhaps invited to learn.

There were thirty at the school and, incredibly, the annual bachelors' ball attracted visitors from Queenstown and Arrowtown.

In 1878 a flash flood carried off many of the houses. They rebuilt. Then the mines closed and that was the end of Bullendale. There are no houses there now, but the machinery lies rusting.

Matt Sceffer, or Seffer, was for many years the last resident of **Moke Creek,** which was also known as Zephirtown, a corruption of Sceffer. This tributary was as rich as the Shotover, especially at **Moonlight,** named for George Fairweather Moonlight, its discoverer in 1863. Now it is called Atarau, Maori for Moonlight.

Once there were 3,000 miners in the area, including about 500 Chinese. They took £4 million worth of gold from the area, which included feeder streams named Jones, Stewart, Butcher, Deadhorse and McGills (which the author's modesty puts in that order).

A school was erected at Moke Creek in 1880, consisting of stone forty-five centimetres thick. Moke Creek was the settlement, and four stores were established there, one also serving as post office and hotel. Vasilio Sceffer was one of the storekeepers. This native of the Crimea spoke seven languages, grew his own tobacco and made his own cheese, wine and butter.

Matt was born at Moke Creek in 1868, and it is hardly surprising that he never cared to leave such plenty, which included much food for the mind; the Moke Creek library contained 500 calfbound classics including Carlyle, Dickens, Macaulay and Trollope, who came close to dropping in.

The famous Moke Creek Library, 1950. These 500 leather-bound volumes of English literary classics included the novels of Trollope, who passed nearby in his travels through Central Otago. Arrowtown Museum now looks after the books. *Alexander Turnbull Library*.

The library was at one time housed in the Sceffer's residence, and Matt claimed to have housed all its contents in his head. Dr Anderson has written of his understandable misuse of long words he had never heard pronounced, like "simulstaneously" or "redicled" or "glacial eposh". Mind you, I know a professor of psychology who says "mys-uled" for "misled".

Matt had a strong belief in the value of cheese before bed, claiming that it lifted the weight off the stomach. He had a horse that opened the door when hungry and which, he told an astonished reporter in 1940, was all the company he needed. Matt successfully predicted, among many other things, the Napier earthquake, so there must be more than gold in that thar creek.

Maybe bachelor George Fairweather Moonlight would have fared better if he had stayed. Dressed to kill in a bright red shirt, white moleskins and crimson sash, he descended on Clyde and blew £2,000 in three months. He was found dying on the West Coast, clutching a bag of gold nuggets. He was too far gone to say where he had dug them, but he surely passed over in happy mind, for he died with his gold on.

Glenorchy, near the top of Lake Wakatipu, had a bit of a gold rush. In late '62 there were diggings at Fews Creek, Simpsons and Bucklerburn. The locals, one of them smartly informed me, will have none of this ghost town image hovering over their cosy little village, thank you very much. Well, the gold was a couple of kilometres away. Even so, it seems best to scarper over to Mt Ida, where they're as proud as punch of their ghostly remains.

66

8

Dry bread, seldom better
The Mt Ida fields

Days and days I've been prospecting,
Washing countless dishes;
But the prospect I'm expecting
Never meets my wishes.

Poem in the *Mt Ida Chronicle*, 9 February, 1872.

"How are things panning out? Making tucker?"

"Dry bread — seldom better."

That is the more authentic origin of **Drybread.** It was also known as Glassfords, after a local. The alternative origin of Drybread was that a Russian Finn, whatever that is, failed to strike gold there and was heard to declare mournfully, "Nothing but dry bread for me."

Tinkers, into which Drybread was absorbed, received its name from a similar question about how things were panning out, to which the response was, "Just tinkering about." Tinkers may also have been called Sugarpot.

Tinkers it was in 1863, **Matakanui** it is today. Peter Chandler of Ettrick and Skippers tells me it is one of those phoney Maori names that the Post Office was obsessive about redrawing the map with between 1895 and 1912. Chandler has unpublished tomes that, if stacked end to end, would very likely go twice round Central Otago, and will probably end up in some university in Texas, drat it. Chandler says the Post Office obsession was only nipped in the bud when the Survey Office refused to ratify these changes.

Drybread and Tinkers had 3,000 miners between them, and they were about five kilometres apart. Matakanui is now a one-store, one-hotel village remnant. The Newtown Hotel is said to have got its name when it was shifted from Drybread. The Duggan's store was a dance hall before it became a store in the 1890s, and also post office and office of the Mt Morgan Sluicing Company, whose name-plate was next to the front door until it was swiped a few years ago.

The Undaunted Claim, Matakanui, about 1880. Its remains can be seen a short distance from the Newtown Hotel. *Hocken Library*.

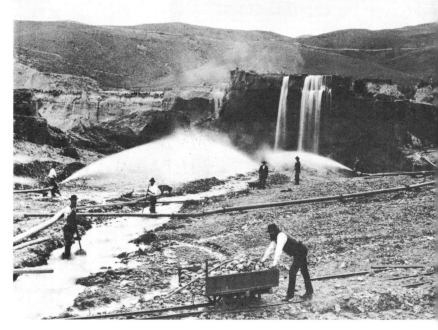

The marvellous old Matakanui store, now nearing the end of its professional life. May its kauri counters rest in peace. *David McGill*.

You couldn't buy, borrow or steal the atmosphere inside. It takes generations of sugar and flour and currants in old wooden bins and unending elbows on the massive three-sided kauri counter to achieve that rich mix once familiar to all patrons of country stores. The once ubiquitous "Time for a Capstan" plate is on the counter frontage, and so is that limpid lady puffing on "A Man's Cigarette". The International Harvester Calendar at the back is dated 1897. The huge scales on the counter were under sentence of metrification when I called.

"Do you sell much?" asked a sceptical girl in jeans.

"Wouldn't be much good if we didn't," was Mrs Duggan's sturdy reply.

Today, she explained later, was race day, so it was quiet. There were admittedly only five or six houses left, but it was a wonderful spot — if only there was more rain.

Ophir was named after the boat in which the Duke and Duchess of York sailed into New Zealand but its original name was Blacks, and is commemorated in the hotel. It was actually Blacks No. 1, to distinguish it from another Blacks. The name came from the folk who owned the run on which gold was discovered. Ghostly, broken remnants remain within the township, unwelcome, neglected guests of progress.

Garibaldi Diggings in Italian Gully behind Oturehua on Rough Ridge has gone with the wind and the rain and the snow after a brief, uncharted life in 1864, when Becks was known as White Horse, and Oturehua, very likely another phoney Maori name, was Rough Ridge or Ida Valley. The name changes get very confusing around here.

Ophir post office is a solid survivor from the period after the goldrush, when the town was known as Blacks No. 1. *David McGill.*

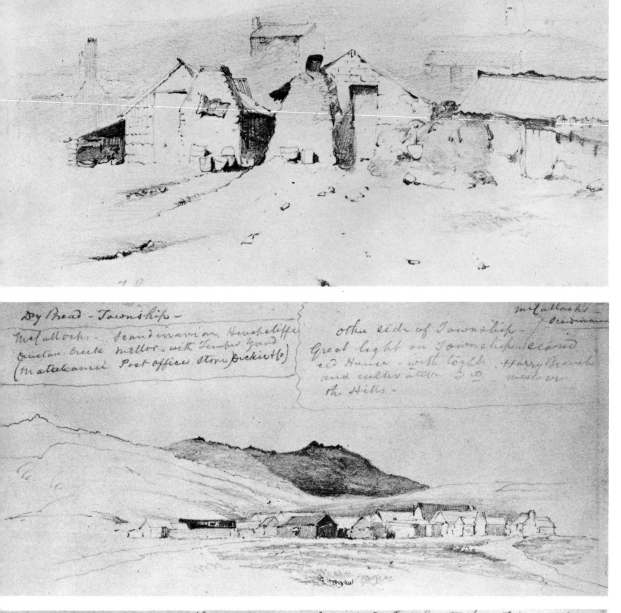

Dry Bread - Township -

McCulloch's - Scandinavian Hendcliffe
Duston Creek - Mellor - with Timber Yard
(Matukanui) Post office Store Dickie & Co)

other side of Township -
Great light on Township - Cloud
CD House - with light
and cultivator CD
the Hills -

McCulloch's
Scandinavia
Harry Travell's
meat on

Black's No 1. a Thunder Shower had recently inundated the Street. Feby 9. 1869

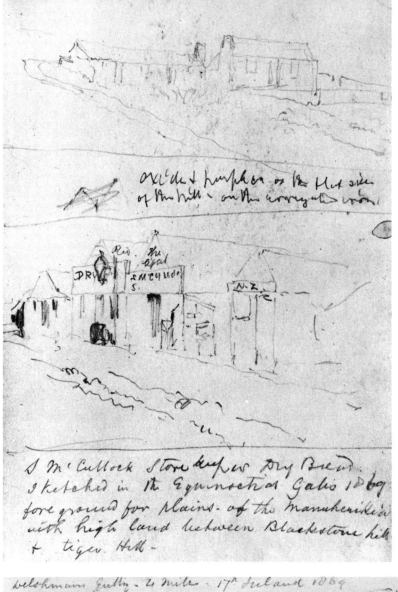

S McCulloch Store keeper Dry Bread.
Sketched in the Equinoctial Gales 1869
fore ground for plains of the Manuherikia
with high land between Blackstone hill
+ tiger Hill -

Andrew Hamilton's goldtown sketches. Blacks No. 1 exists within the Ophir of today — but only just. Welshmans had its name Latinised to Cambrians out of pure snobbery. Photographs of the originals. *Lakes District Centennial Museum.*

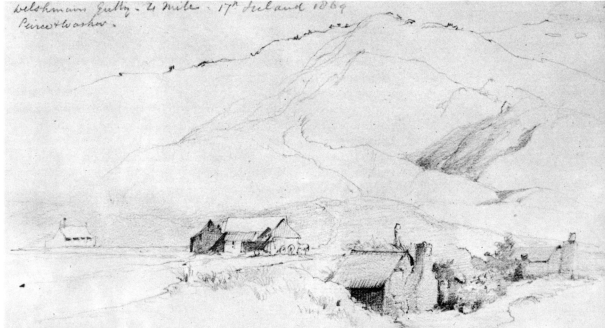

Welshmans Gully - 4 mile - 17th Ireland 1869
Peirce + Washer -

Blackstone Hill has given up the ghost — it was **Hills Creek** in its heyday. The settlement was situated at the extreme north end of the range after which it was renamed, and workings included Woolshed Creek, German Hill, Pipe Clay, Pegleg and Penny-weight. It was one of the highest settlements in New Zealand at over 700 metres above sea level. The Prince Alfred Hotel went up there in 1864, the first of thirteen and the last surviving, its remnants by the bridge; the weary traveller could once get a roast meal off the spit. The town had active public and Masonic halls and athletic and social clubs, especially in the Otago high-country sports of curling and skating.

Once the mining stopped, **St Bathans** acquired one of the country's best skating rinks. In summer it is the deepest blue lake, in stark contrast to the chalky clay around it. St Bathans itself is, for my money, the most charming bust-town anywhere.

Naturally that was not its original name. It was established in early 1864 as **Dunstan Creek,** which the pedantically minded might feel places it a few chapters back. Further offence for such folk is awaiting them in the next chapter, where the area around Naseby, once called Mt Ida, comes into the burn-yard below. This chapter could have been the Manuherikia Diggings, if it wasn't for their length. So be it. There was nothing orderly about the Otago goldfields.

Dunstan Creek had a population of 2,000 or more, with a mere fourteen licensed hotels for their pleasures. The 1976 census says there are eighteen people left in the location; Kevin Crosbie says there are six, and three of them are him, his wife and son, who run the last remaining pub, the Vulcan.

Naturally it was not originally called the Vulcan. It was the Ballarat, but after the Vulcan (or was it the Ballarat?) was burnt down twice, the one inherited the other's name, if you see what I mean? Anyway, it is said to be the first sun-dried brick building in New Zealand, and dates from 1869. You're sure of a warm welcome there.

The St Bathans Lodge No. 126 next door is now a storehouse for empties, and the registered office of the Scandinavian Water Race Company is no more than its nameplate.

This pretty little village snoozing in the shade of old trees at the bottom of a loopy lane had a longer and livelier life than most major goldtowns. In 1864 it was strictly canvas, the choice of whisky was Dunvilles or Stewarts, and Hobart Town Jack rose to promote a strike to lower the beer price from 1s to 6d. The Tennants Ale cask that he mounted his campaign upon fell through, and the strike never got off the ground.

As the region's centre, Dunstan Creek had trading departments, government buildings, a cottage hospital with three wards, the

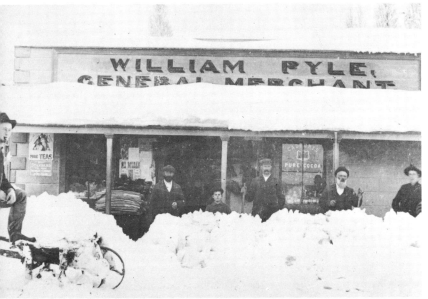

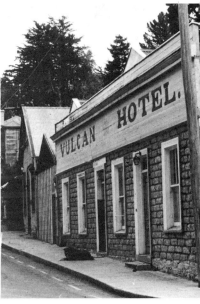

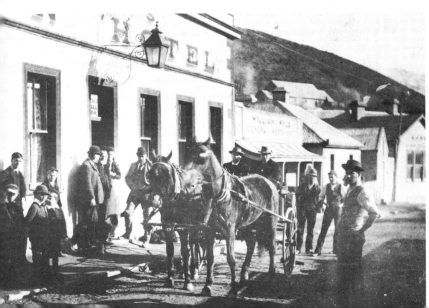

Top Left: St Bathans, about 1894. *Southland Museum.*

Centre Left: William Pyle's snowbound St Bathans store, now lost and gone forever. *Alexander Turnbull Library.*

Above: St Bathans is reduced to this one famous commercial proposition. *David McGill.*

Bottom Left: St Bathans, May, 1896. *Alexander Turnbull Library.*

usual businesses and a newspaper. A Town Improvement Committee was elected in 1865.

G. S. Sale, the new commissioner of the goldfields, came to speak, despite his having a reputation as the "arch tyrant of Westland", which smacks of nothing so much as the calumny of a sworn enemy, such as that which persisted between the *Eatonswill Gazette* and its rival the *Independent* in *Pickwick Papers*. Sale could expect enemies for he called goldmining an evil. It forced the growth of a country unnaturally, he opined, whereas development should be slow, secure and peaceful. One wonders how he got the job.

If that wasn't enough, he expressed sympathy for women for their lot as drudges working in draughty, overcrowded conditions, serving the little they could get their skills into, largely unpalatable mutton and dreary damper, and condemned to "black sick loneliness".

In a manner of writing, the 1869 *Mt Ida Chronicle* correspondent agreed, commenting on the paucity of Christmas dinner there: "A junk of roast mutton or beef", without sight of a roast crane or peacock served with its tail, never mind no "pickled oysters and buttered crabs", a "true Rhenish" or a "flowing flagon of Braggett". And "as to brandy, whiskey (sic), and gin — save the mark!" There was nothing compared to them when "Gog and Magog imbibed pots and flagons of hydromel".

Like Sale's comments, this was over the heads of the good miners; indeed, it was said you could walk on their heads on a Saturday night in St Bathans, with reference to the dense pack rather than to a prone position.

"The lady who took everybody's eye," said the *Mt Ida Chronicle* by way of recompense in September, 1869, "must have had a lot of them."

The men had little time for soft notions in the gold days, which were perhaps the high tide of male chauvinism. Vinegar Hill diggings nearby was called after the Battle of Vinegar Hill in Wrexford, Ireland, and with good reason. Dunstan Creek was largely Irish, and Welshman's a few kilometres away was not so named because it was Scots. St Patrick's and St David's Days were traditionally celebrated with an inter-town brawl. The two communities were occasionally persuaded to harmonise "Land of My Fathers" and "The Wearing of the Green", which came as naturally as fighting, but was no substitute for it.

Gladys Nicolson-Garrett in her recent book, *St Bathans*, gives a grand picture of John Ewing, manager of the Vinegar Hill mine and uncrowned Mining King of Central Otago. His innovations included the first use of carbon aid lamps for round-the-clock work. The 1896 *Handbook of New Zealand Mines* praised Ewing, the Bullen

74

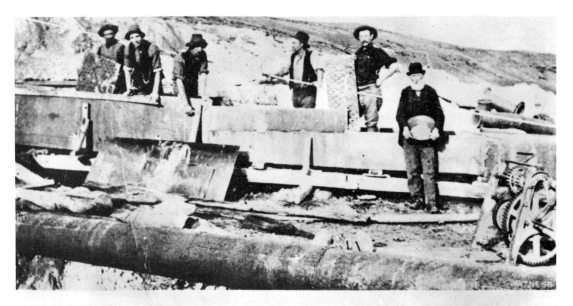

THE WASH-UP AT THE VINEGAR HILL HYDRAULIC SLUICING CLAIM, CAMBRIANS.
Mr. Hughes (director) standing in front with dish of gold; Mr. T. Morgan (manager) third from right.

Alexander Turnbull Library.

Brothers and John Aspinall of Skippers for steady, persevering work and lack of pocket lining, instead ploughing the profits back — model capitalists.

Ewing later went haywire, wasting time and money on patented atmospheric elevators.

Welshmans had its name Latinised to **Cambrians** for, as is apparent by now, no name was sacred. Vincent Pyke said Cambrians was more refined. Gladys Nicolson-Garrett says it should be "Cambrian", but she has no dogmatic position on St Bathans, having heard eight versions of its origin. She can vouch for when it happened, when a deputation of citizens approached Superintendent Warden Castle on 5 December, 1865, to change the name.

Like so many names in Central, it would appear to be the handiwork of J. T. Thomson, later surveyor-general and always surveyor extraordinaire. He often favoured his homelands. Ida, for instance, was from the Ida tower in Barnborough castle in his native Northumberland, Ida having been the flamebearer who established the kingdom of Northumbria. St Bathans was after the abbey at St Albans in Berwickshire, home of his maternal grandfather. Many claim a more direct connection with St Bathans on the Isle of Iona. Bathan or Baothen was the Scot who succeeded Columba at the Abbey of Iona in 597 AD.

Whatever the truth is on the conflicting mists of origin, St Bathans does seem to have chronicled more old timers than most. It was the era of name changes, and it was also the era of nicknames.

75

A splendid example of St Bathans carpentry. The building was threatened with fire the day after this photograph was taken. *David McGill.*

There were Charley Balloo, Jimmy the Grunter, German Charlie, Billie the Dog, Possum the little pianist, Jimmy the Plugger, Matchmaking Matthew from Limerick, who liked using polysyllabics such as heterogeneous and consanguinity, and Jack Rafferty, called Gory Onion because of all his oaths and whose boot tops were made of gold inset with pick and shovel motifs.

St Bathans welcomed the travelling folk with a pitch. Indian hawker, Ahadibox Mulloch, had thimbles, buttons and pins for the housewives. Barney White Rats put on a show for the kids, its highlight being ducks and geese marionettes. He was said to have acted with Charles Dickens. The Saturday afternoon sewing and dressmaking that Mrs McConnochie conducted in front of a coal fire with coffee and scones for afternoon tea sounds cosy enough to satisfy those fastidious Dickensian gentlemen of the Pickwick Club.

St Bathans has declined slowly and surely, but it did hit the headlines once again in 1967 with its vote for longer drinking hours, registering twenty-two for and none against. Today it is for tourists and farmers, faring better than Cambrians, which mostly consists of a few holiday cribs. So the Irish won, bedad!

Gold was taken down to Naseby, and the infamous Burgess Kelly, Levy and Sullivan gang did their best to take it on the way, but a tipoff saved the bankers' day. Sergeant Garvey caught Burgess in a similar fashion to the way Garrett was apprehended, with a banknote on Burgess being identified as the last issued by the Oriental Bank in Dunedin and belonging to a shepherd that Burgess had robbed.

Garvey was another of the pioneer law and order men on the goldfields. He was one of the 190 who survived the Charge of the Light Brigade, yet his end was miserably characteristic of the goldfields. He ignored advice against setting out in a blizzard over Mt Ida in late September, 1863. His companion, Mounted Trooper McDonald, was found two days later alive but badly frostbitten. After four days Sergeant Garvey was found dead, one glove alongside, with a peaceful expression on his face and his horse cropping snow tussock nearby. He had travelled twelve kilometres in the wrong direction.

"The hardships endured by these men," wrote the *Lake Wakatip Mail* in October, 1863, "have been something frightful, and enough to appal the stoutest heart. Yet, through sleet and snow, the miners have stuck to the place."

This was the story of the goldfields, although it did refer to Sixteen Mile Rush on the Hogburn, later known as the Mt Buster diggings.

Hogburn and all the other "burns" deserve the particular attention of their own chapter.

9

The way of all excess
Thomson's Farmyard

Wild winter on the frozen hills,
The rocky peaks, the ice-bound rills,
The lowering red of early morning,
The even with its misty chills . . .
The distant Clutha's shadowy valley,
The eastward Taieri winding nigh.

David McKee Wright, 1897.

Hogburn Gully, nearly two kilometres from Naseby, was discovered in the winter of 1863. At this time flooding was making diggings difficult on the Dunstan and Molyneux, Cook's name for the Clutha, which was J. T. Thomson's. Thomson, somewhat unfairly, has been blamed for the plethora of animal-prefixed "burns" in the area which is sometimes known as Thomson's Farmyard.

Thomson was simply the surveyor at the time, and his submissions for Maori and classical names were not acceptable to the bigoted worthies above him, who demanded good Scottish names instead. Facetiously, he offered Hogburn, Eweburn, Kyeburn (swine), Wetherburn or Wedderburn (castrated ram), Gimmerburn (young ewe), Swinburn, Fillyburn, Stotburn (bullock), Horseburn, Hareburn, Mareburn, Sowburn, Pigburn and Capburn (cat). To his disgust and dismay, the names were accepted.

At least, that is Johannes Carl Andersen's version, and this great Turnbull librarian is generally regarded as our best placer of nameplaces.

The less inhibited newspapers of those days naturally had sarcastic praise for these "good simple names connected with the experiences of ordinary daily life".

An estimated 5,000 rushed the area around Naseby, but the returns were moderate by comparison with where they had rushed

77

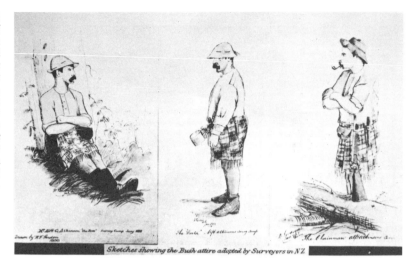

"The boss, the doctor and the Chinaman": sketches of surveyors by W. F. Gorden in 1888. The original is held in the Wanganui Public Museum. They were truly dedicated public servants, doing their duty rather than making a bundle. Somehow they always came out as figures of fun in the public mind of the day, despite their pioneering precision and propriety. *Wanganui Museum.*

Sketches showing the Bush attire adopted by Surveyors in N.Z.

from. Wedderburn, Fillyburn, Mareburn and Gimmerburn were minor settlements. Sowburn became Patearoa in the phoney Maori tradition.

The **Kyeburn Diggings** were probably the biggest and certainly the noisiest of the farmyard rushes to retain their first name. There were 2,000 miners there. Edwin George put up the first hotel in 1863, selling only spirits, for beer was bulky and expensive to cart over the roads of the time. George was a bright Cockney entrepreneur who added a butchery and bakery, gave church services, weddings and christenings and provided entertainments and sports like Cornish wrestling, collar-and-elbow wrestling, grinning-through-the-collar, pigcatching-by-the-greasy-tail and hornpipe contests, sometimes on the bar-top.

Kyeburn Diggings had dancing on the village green, races, performances by minstrels, phrenologists and mesmerists. There was quite a fuss in the press when, in 1872, a Kyeburn man who had moved north to the Maerewhenua Diggings was summarily buried in a common sack. Kyeburn Diggings was a goldtown in the merry mould of St Bathans, and with its own strong identity, but now it is no more.

Hamiltons Diggings were probably bigger than Kyeburn's. Near Patearoa, they were discovered in 1863 and named after James Hamilton the runholder, who was kinder than many farmers in selling the miners stores. There is, as is so often the case, a counter-claim that Hamiltons was named after Hamilton Brockleman, leader of its four discoverers.

By 1864 there were upwards of 3,000 rowdy diggers there, served by five bakeries, three doctors, a police camp, the Bank of New Zealand and Union banks, and a newspaper. Water was five cents a bucket. Today the water race is used by the Waipiata Youth Centre.

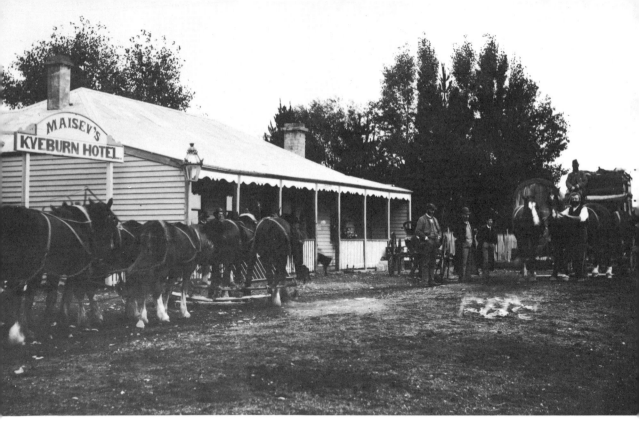

In 1863 there were 2,000 thirsty miners in this locality. *Hocken Library*.

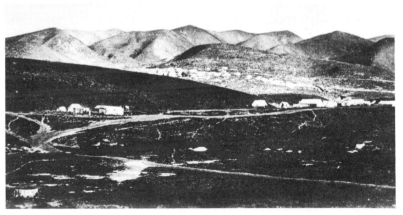

Hamiltons, about 1862. *Hocken Library*.

The courthouse at Hamiltons is now the Waipiata library (Waipiata also got the school bell), and Hamiltons' wooden houses were moved to Ranfurly. The 1865 Union Church was used for all denominations, and for school during the week. There are remnants of the iron cottages with their vegetable gardens and speargrass hedges, and the tiny stone-enclosed cemetery.

Further down the Maniototo, **Styx** had been operative since 1861 as a stopover for voluntary and involuntary travellers. The proof is still there in the old hotel and stables and the rugged stone jail with leg-irons on the walls.

79

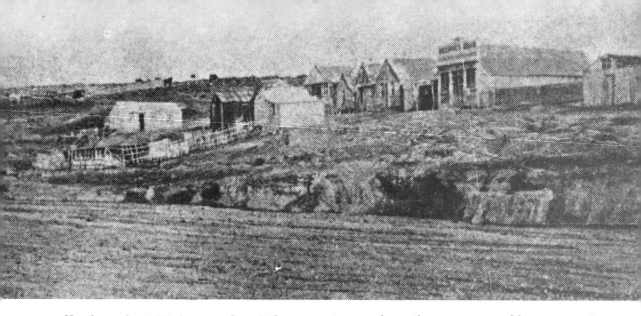

Hamiltons, about 1871, from
J. C. Cowan's *Down the
Years in the Maniototo.*
Alexander Turnbull Library.

Styx jail was a step-up from the common goldtown security
facilities. Often a policeman would have to chain his prisoner for
the night to a rock, tent or log, and there is a reported case of an
Irishman who took up his log and walked.

Styx is also reputed to have the smallest post office in New
Zealand, two metres square. Its hotel had a unique licence allowing
it to be closed for half the year because it was snowbound in winter.

Andersen says Styx is a rare example of a vulgar name being
elevated to a classical precedent. The area was known as "the
Sticks" because of the marker sticks in the river which showed the
miners where it was safe to cross the dark and dangerous current.

It was too nice to last. The Post Office stepped in with the phoney
name of **Paerau.**

To the west, **Serpentine Flat** was rushed at the same time as the
farmyard burns. There is nothing there now of the 500 miners in
Golden Gully, except the ex-church which was occupied by an old
miner in the 1930s. The name came from the rock, says Andersen,
not its sinister appearance. A. W. Reed says it is because the river
looks like a snake. Take your pick. By January, 1872, the *Mt Ida
Chronicle's* own correspondent reported that the only work being
done at Serpentine was by the "Celestials, and none know better
than 'John' how to keep his or there (sic) own counsel".

There were diggings as early as 1862 in the Mt Highlay area, at
Murphys Flat on Run 109, Timbrells Gully under Mt Highlay, the
Deepdell Creek branch of Shag River, and Coal Creek at the head of
the Shag River. The big township developed at **Macraes Flat,** then
spelt "McCraes" and better known as **Fullartons.** By the late '60s
there were five stores there (one serving as post office), a bakery, a
Bank of New Zealand, fourteen hotels, two dancing saloons and a
restaurant. It was standard practice for anyone who won heavily on
cards or billiards to shout the bar.

80

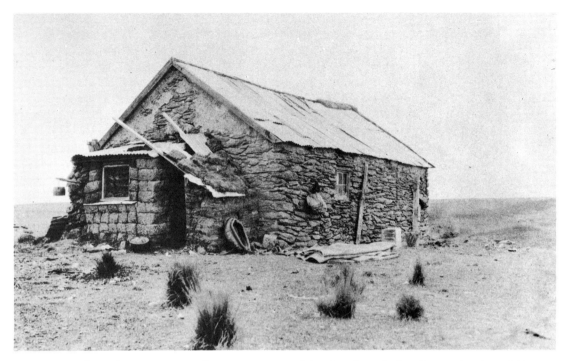

As was often the case, a smaller upper township developed. It had three stores, an hotel and a butcher but no baker, so baker Tom Powis carried ten loaves at a time on his head to the upper folk.

By 1871 Macraes was down to a population of 131, many of whom still indulged in horse racing and athletics. A local was the heavyweight catch-as-catch-can champion of New Zealand.

It was part of the schedule of that immortal tramp, the Shiner, to arrive at Macraes for Sunday mass and sing:

Don't blame the wealthy squatter, if your luck should be out.
Don't blame the struggling cockatoo if he knows what he's about.
Don't blame the Colonial Government if your children lack for bread.
But blame the wayside shanty for the reckless life you've led.

It was at Macraes that Shiner won free drinks in exchange for his foot-stamping trick. Publicans Stanley and Griffin did not object to Shiner's tricks so long as the other fell victim to them too. Stanley's hotel carried the sign, "While I'll Live I'll Crow" and Griffin's "Established 1864 — Still Going". He ain't, but Stanley is. The village has remnants, like the original 1870 school bell and a replica of the original stone school, the remains of a baker's oven, a bootmaker's and stone stables.

Macraes and **Nenthorn** were supplied with farm produce from the little village of Moonlight, where farmers' wives set out with their baskets along Butter and Egg Road. Only the road, the farmers

Once a church in Golden Gully, Serpentine, according to L. G. Penfold of Dunedin in 1931, as reported in J. C. Cowan's *Down the Years in the Maniototo*. At that time an old goldminer used it as a home, and remembered the days when 500 fellow miners huddled in these cold climes. *J. T. Paul Collection, Hocken Library.*

81

and their wives and supplies are left. Nenthorn is not easy to locate, even though its ruins only date back to 1888. If in doubt ask a local.

For Nenthorn the next two years laid the golden eggs, and that was it. In 1889 Nenthorn had a jockey club and a scheme for a water supply to the surveyed town, although only its main street was up — and ever so. Along main street the calico, sod and iron structures included over twenty hotels, two banks, a public dance hall and skating rink, boarding houses, bakers, fruiterers, butchers, blacksmiths, a watchmaker, stables, builder, chemist, barber and accountant, and the *Nenthorn Recorder*, published by Smithyman.

"Never in my life," reported John Boyd, who waited at tables in Laverty's pub, "have I seen such drunkenness, so many brawls and fights with knives, boots, lumps of wood, etc., brought into play. I have seen Laverty's manager standing on the bar, with a short stock whip, lashing the men like a bullock driver."

Boyd left after two weeks, pursued by the Swedish chef brandishing a carving knife while, no doubt, the orchestra struck up a suitably sprightly tune.

Now Nenthorn has gone the way of all excess. Nenthorn was not alone in its high living, not by a large nugget, but it did aspire higher than most. It talked of being the Upland City of Otago, a rival to Dunedin. Instead, its stones were ignominiously removed, for stone was scarce and in demand. The highminded might see parallels with the fate of Sodom and Gomorrah.

Dunedin itself did very nicely out of Otago gold, even though the nearest this was struck to Dunedin was **Mullocky Gully,** twenty-five kilometres away at Boulder Hill, on the east bank of the Taieri. There Simon Fraser applied for a prospecting claim in July, 1863, and 3,000 miners briefly chased him.

The miners spread out to the smaller claims of Tucker's Gully, Sailor's Ridge, Blackmans Gully, Parkers Reef and Slaughter Creek, putting up wattle and daub cottages. "Mullocky" was the name that the Victorian miners used contemptuously of the inefficient amateur surface sluicing they observed at their arrival on the Tuapeka Fields. The Game Hen Hotel was the last remnant of Mullocky Gully.

Mullocky Gully may well have been named after Donald Malloch, who pioneered the mail service from Waikouaiti to the Manuherikia in 1861. Some gold has been found in the Waikouaiti area, but it has largely been a place where you depart from for somewhere else. This was true even way back to the whaling days of 1837 and through much of the mining period, especially when it was the safest landing on the coast near the Pigroot Track leading over to the Dunstan.

June Wood has estimated seventy-eighty goldfields in Central Otago, from Boulder Hill to Glenorchy to Fatboy Diggings behind

Luggate. Otago had made £24 million out of these fields by 1872, but nothing was put back and most of the goldtowns disappeared as quickly as they had emerged. Much of the land reverted, in Vincent Pyke's marvellous description, to "absolute solitariness . . . the solemn loneliness of its mountains; the ineffable sadness of its valleys, the utter dreariness of its plains . . . everywhere clothed in a sober livery of pale brown vegetation, relieved only by grim, grey rocks . . . (the) only sound . . . the melancholy wailing of the wind among the tussocks".

Habitable land was taken over by farmers and orchardists. The Old Identities that Thatcher sang of were back in command — the people who were there when the miners arrived from Victoria and were so dubbed. They had never wanted the rampaging miners. Perhaps there is some kind of revenge operating among the descendants of the farmers who had their sheep stolen by the miners and their runs ripped up, for now the miners' huts serve as cribs or haysheds, or are simply destroyed.

"Cultural vandalism" is the phrase Mike Bennett, Director of the Arrowtown Museum, uses to describe wilful destruction of our heritage. Like the astonishing time he saw a yellow bulldozer come charging out of a stone hut in the middle of a field, taking its walls with it.

"The museums," writes Gay McInnes in *Castle on the Run*, "have the flat irons, cradles, door of jailhouse, a Sitz bath, Victorian knick-knacks, pink glass decanters, picks, shovels, billies and tiny bottles of gold nuggets, and somebody's grandmother's wedding-dress. Those bearded gentlemen gimlet-eyed, and their good Presbyterian ladies in their black silk dresses and high collars are the custodians of the past, and the door is safely locked."

David McKee Wright:

And life grew harder as they saw the growth of settlement and town;
And working here, and tramping there, they fought the battle to the
 end,
Until the hair was grey enough, and strong back began to bend;
And now they're in the Old Man's Home – dead beat.

If you're not dead beat, dear readers, let's look at the goldtowns once below and above Central.

Livingstone and **Maerewhenua Diggings** are fit to be tailings to this chapter because they had access to Naseby through the Dansey Pass and were where many Central miners went, including the Kyeburn man who was buried in a sack. Naseby was the administration point of these fields.

Gold was discovered in May, 1868, but it was not until the following year that a minor rush of 100 men occupied the two settlements either side of the Maerewhenua River. Stores were

established at Livingstone together with a Wesleyan chapel, which was blown down in 1872 and not replaced. By mid-'73 there were three hotels, the Commercial, Royal and Victoria. One of those stores was a post office too, and a butcher, saddler and hairdresser had set up businesses.

"Maerewhenua is a queer place," wrote a correspondent of Livingstone, "principally remarkable at present for pigs, dogs, poets and music."

A school was opened there in 1874, and another across at the Maerewhenua Diggings. The schoolteacher worked both half-time, walking the five or six kilometres in between.

That year the government laid off the township, calling it Livingstone in honour of the explorer, one presumes, though the locals were calling it Ramsaytown in honour of a prominent organiser and investor from Oamaru. For once the government prevailed, though in little else. Naseby warden H. A. Stratford reported that the field would provide steady employment for 300 miners as well as "the same number of the heterogeneous who invariably follow in the wake of the sons of toil". Not only was he wrong there, for never more than a third of a given number of miners were needed to service them, but also the population started to go down.

It was known as a "poor man's diggings" because the gold was fine and dispersed over a wide area. Frost and drought alternated to rob the races of water, and there were also disputes with land-owners over the polluted water that the fields produced downriver.

Maerewhenua Diggings ran behind Livingstone all the way, developing in 1872 and having its religious services in school or hall, more like the "Upper" township relationship of many Central fields.

Incredibly, an Athenaeum was built at Livingstone in 1894 to seat 200, who were undeterred by the hotel losing its licence. The town also ran a brass band in the early years of the century. Today the size ratio of the two ex-towns remains constant, Livingstone location having a population of twenty-six, and Maerewhenua location a population of twelve. They have diminished and grown old, like a long-wedded couple.

For the Canterbury record, **Bealey** below Arthur's Pass no longer has a population rating, but in the mid-1860s the Bealey was a shanty hotel where, for a florin, you could get a bed of straw and, for another florin, a breakfast of bacon and coffee. Canterbury surveyor Thomas Triphook laid out the township of **Klondyke** equidistant from both coasts, and 100 men congregated round the jail, telegraph office and hotel. It hardly deserved the name Klondyke, and lost it.

Klondyke was a stopover to the Coast, and there are a few more before this book gets there.

10

Poor man's diggings
Goldfields south of Central

Dash Preservation
Dash the track
Dash the sandflies there and back.
Dash the rivers and dash the weather
Dash New Zealand altogether.

Found on rimu stump gravemarker, Preservation Track, 1899.

The *Otago Daily Times* of 4 February, 1865, carried a report by
Arthur Harvey on the Mataura field as "a fair poor man's diggings".
The phrase would sum up the goldfields of Southland and Fiord-
land. They did not compare with the riches of Central, and could be
considered only superior in one engaging aspect — the false hopes,
foolish plans and obsessive name changes of the authorities of the
day.

Orepuki is the classic. There is a suggestion that it was once
called "Aropaki", but that is only the start of the complications
surrounding a name whose antecedents and postcedents are so
admirably summed up in its meaning — "crumbling cliffs".
Orepuki was, and to some extent still is, three towns in one, laid
over each other like coats of paint over the walls of a mid-city flat.

Monkey Island is about where it all began in 1865. Well, actually,
it began in the 1850s when Henry Hirst from Huddersfield was the
first man to conduct a cattle drive from the south to Gabriels Gully
— a most unfortunate "first" for Hirst! When gold was discovered
there, he took his compensation and retreated to a farm opposite
Monkey Island. He must have thought himself bejinxed when gold
was found on the beach there. This time, instead of compensation,
the minor rush of 100 or so miners clustered round his back door
requiring food. It may have been a desire to control such coinci-
dences or a feeling that he was fated to be at the centre of men's
affairs that drove him into parliament in the 1870s, where he

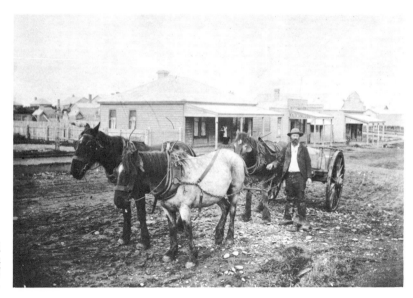

Orepuki in the good old days. Photographs of Jack and Eva Wilson. *David McGill.*

suffered the singular fate of failing to be re-elected by one vote! A persistent man, he was returned for Wallace again.

Hirst's gabled homestead is still there down by Monkey Island, and his faith in local farming has been sustained by his successors. He has a granddaughter living in **Hirstfield** up the road, although it only exists officially in his name, in reality it is Orepuki. This fact was not known in Invercargill a few years ago, and led to unfortunate complications, which I will come to.

Beachcombers can still get gold there from the sands, but not in the order of the 622 grams in four days that one party took in 1866.

That year Walter Pearson, Commissioner of Crown Lands, surveyed the township of Orepuki, his confidence in its potential founded on seventy miners living in the bush and thirty on the beach. A jetty with a derrick was established, and the steamer *Halcyon* was duly wrecked on Monkey Island.

Meanwhile, the miners were moving up-country following James Kirton's discovery of alluvial gold. It was an inexorable uphill process, and the township was moved over a kilometre to accommodate them, being renamed **Garfield.** Houses were shifted. Some were pit-sawn and some made from fern tree trunks, which were said to be warm and snug. There were two hotels, the Eagle and the Commercial, two stores (one running the post office as was usual), a butchery, a bakery, a police camp, school and library.

Garfield's downfall coincided with the rise of coalmining in 1879 and the problems of access. A new township of Hirstfield was laid out back down the hill, but the locals refused to abandon the name "Orepuki". The officials would not back down either, which is why the official postal address remained Hirstfield. This led to

86

the confusion in 1977 when people buying Orepuki sections in Invercargill found, after leaving for their new locations, that they were, in fact, sited down by Monkey Island. It was an honest mistake, but the cause of much indignation, for people thought they were retiring to the fabled peace of Orepuki (which may have under 250 in the district but, according to the outgoing postmaster, has the highest proportion of old folk anywhere in New Zealand).

There were about seventy Garfield houses returned to Orepuki, and a number of shops. They now stand empty in the still-declining business area, down from three pubs to one.

The site of the Garfield business area is now an empty field, except for the daffodils and hyacinths in season and gorse and broom all the year round. Ducks occupy the lagoon formed over Garfield's largest goldmine and sheep graze in the children's playground. Two goldminers took over 3,000 grams from the school gully, but were halted in their encroachment onto school ground until they agreed to pay for the shifting of the school — a rather surprising degree of co-operation from the Education Board by today's standards.

A Mr Lee, MA, schoolteacher there from 1891 to 1909, spoke of the mud everywhere, exemplified in a schoolboy essay that advised: "Grass is useful for wiping the mud off your boots." Lee thought the classrooms overcrowded and ill-ventilated; children were sitting with shoulders overlapping on warped forms. It took him seven hours of dutiful if not courageous travel to winter evening classes in Invercargill.

Another Mr Lee managed the shale works, which opened in 1899 and attracted a population of 3,000. This was Orepuki's heyday, with its businesses including a jeweller, saddler and bootmaker,

Adamson and Sons, Orepuki, from a splendid but, alas, anonymous collection of country stores photographs around Southland — a charming album awaiting a publisher. *Hocken Library.*

and its services two public halls, three churches and a newspaper, the *Orepuki Advocate,* which only lasted until the sudden closure of the shale works in 1902. The government said it was too expensive to mine, but the locals were not unaware that the duty had been lifted on imported kerosene and paraffin, and they placed the blame at the feet of the American oil companies. A subsequent geological survey indicated large shale deposits five kilometres out in Te Wae Wae Bay, which is perhaps why locals talk of an oil strike there one day.

Jack and Eva Wilson live on the school site, one of the few parts of Garfield that was not sluiced away. Jack was the original employee of the Orepuki Rabbit Board, and its foreman until his retirement a few years ago. Eva has been Orepuki librarian for four decades, and has chronicled local history, which is full of good yarns and anecdotes. A man lost a bet on his mare when it was well in front because it suddenly stopped dead to let its foal catch up. A lad died bizarrely when poked in the stomach by a classmate while he was demonstrating that he could write on the blackboard while leaning backwards. The township was close to starvation when supplies could not be landed for several weeks; volunteers trekked out over the mountains, including Granny Tielle, who returned with a twenty-three-kilo bag of flour. This perhaps lessens the impact of a man winning a £5 bet by carrying a ninety-kilo bag of flour from Pahia to Orepuki. My favourite was the woman who turned up at a masquerade day for bowling-club fundraising dressed in her husband's clothes, and was sent home by the constable as indecent.

Orepuki serves as an example of the deflationary times last century. Comparing food prices in 1866 and 1886, flour dropped from 35s a 100 pound bag to 9s 6d, tea at 3s 6d to 2s 6d a pound and sugar from 7d a pound to 4d. The other side of the coin was that gold only increased in value from £3 14s 6d to £3 16s 6d an ounce, and miners' wages dropped from an average ranging from £3 to £6 a week, to £2 8s.

In its day Orepuki had its champion woodchoppers, its All Blacks and Dr Mathews, who always raised his hands above his head to strike a light for his pipe. Now it just has memories, from its own past and those imported by people retiring to this haven of peace.

Eva Wilson grew up at **Round Hill,** almost halfway to Riverton, which was founded by her grandfather Captain John Howell. She went to school next to Ly Chong's billiard parlour in the days when Round Hill was known as **Canton** or **Chinatown.** There were forty or fifty Europeans and 500 Chinese there in the 1890s when Eva's father, Fred Hart, managed the Round Hill Gold Mining Company. It was one of the rare cases where the Chinese arrived first, largely because the Europeans had done their once-over-lightly mining effort and failed to go deep enough.

The great black hope — the Orepuki shale works. Locals still mutter darkly about government collusion with big overseas interests, causing its shutdown. Thar's oil in that there harbour they tell you. *Southland Museum.*

Round Hill in 1903, when it had every reason to be called Canton. This doubled as the Chinese Temple and public hall. Today the area is just a round hill scattered with brandy bottles and square black home-made bottles, if you know where to look. *Ng Collection, Alexander Turnbull Library.*

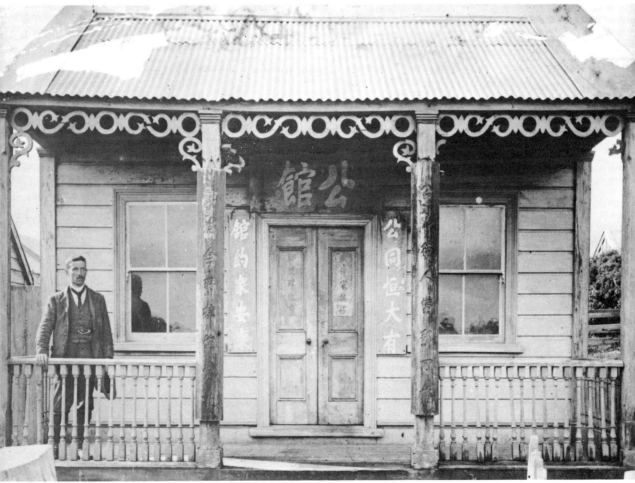

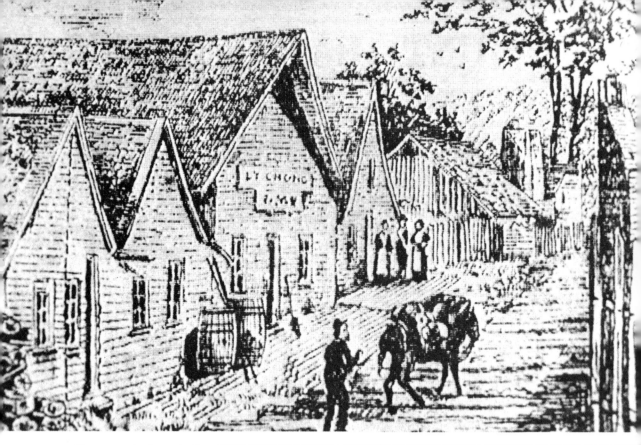

Canton received a typically
bigoted response from
European passers-by,
although local whites seem
to have got a different view
of the Chinese miners.
David McGill.

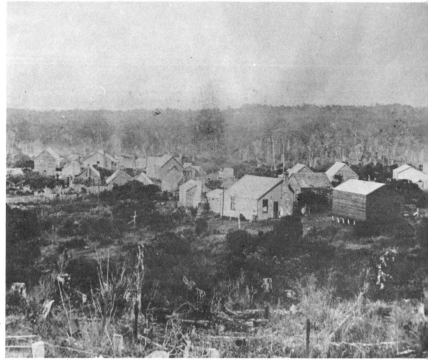

Round Hill with the fringe
on top. *Southland Museum.*

90

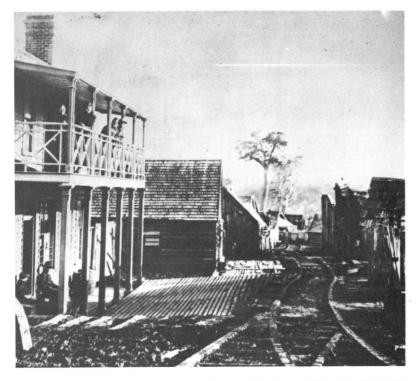

Round Hill before it reverted. *Southland Museum.*

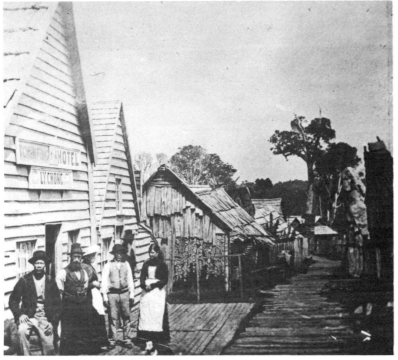

Round Hill's main street, about 1900. *Southland Museum.*

91

The first licensee was Ti-on. Later it was Tommy O'Brien, who renamed the pub the Criterion. O'Brien's nephew Fred Smith is still there. He managed the pub and the mine, after Fred Hart. Fred Smith lives with his daughter's family there, part of the farming population of thirty-one listed as resident in the location today. There is a growing occasional population of bottle seekers after the brandy bottles from China and the local square gin and water bottles that the Chinese manufactured themselves. These uneven black bottles are collectors' items and most attractive, but you have to know where to look for them; the Wilsons naturally have a good collection.

Fred Smith is in his middle-eighties now. He has a position on the sofa where he can look up at the very round hill that gives the place its name. He was in hospital when they closed the mine

abruptly in 1954. It was New Zealand's longest-running gold-sluicing claim.

"Should never have been closed," he snorts. "More gold there than was ever taken out."

Fred has the "pensions" used for fantan, round metal discs with a square hole in the middle, and a "dew nappy", the ivory half-ball that the game was played with. Pensions were put on the four corners of the card, or points between, and two people took the bank. Even money was paid on the corners and three to one in the middle. There would be several hundred pounds sometimes waiting on the half-roll of the dew nappy.

Police from Riverton did their best to trap the gamblers, but the guards did their duty without a slip-up. When a policeman crawled determinedly along the nineteen kilometres of water race to earn his just arrest, all he found were Chinese playing dominoes — as always. In fact, the guard had spotted him and taken a short cut.

Fred recalls good relations with the Chinese, apart from the tricks that the children played on them. His parents were the only Europeans that were invited to the Chinese New Year celebrations; a week of feasting on duck, pork and chicken, garnished with imported oils, herbs and sauces and washed down with Chinese brandy.

There were two old Irishmen, Vaizey and Paddy Brick, who were favourites with the children.

"Would you like some bread and blackman?" Paddy would ask the kids, meaning bread and treacle.

When they got home, Mum would say, "So you've been at Paddy Brick's, have you?"

One of Fred's brothers, Frank, was killed when he went to the assistance of his shiftmate Joseph Bates, who had fallen into a sluice hole and broken his leg. In going to his assistance Frank got stuck in the sand and couldn't get out of his thigh-high gumboots. The water level rose and they were drowned before the next shift came on.

They earned 8s a day for a six-day week, and were docked if late; there were no prizes for being early, except the saving of two men's lives.

The ironic punchline comes in the pencilled scribblings of their third brother Jim Smith. Their father and uncle were the Europeans who had sunk a shaft eight metres deep and failed to strike gold, and the Chinese had gone one-and-a-half metres deeper and found it. But their father did well out of selling them wood and their uncle made something out of them with booze. Their father had been a bullock driver associated with the sawmills in the region, which always became an important secondary industry where goldmining developed.

93

Jim Smith elaborates on the tricks his brother mentions, which included tripping up the Chinese and pelting them with snowballs. He remembers the schoolmistress blowing the whistle to stop the children watching the boozy fights of the eight women who lived with the Chinese, known variously as Larrikin Liz, Irish Kate, Bush Mary, Scotch Nell, and so on. When one of them got too rowdy, the policeman was called from Riverton. She would not go to the paddy wagon, so a Chinaman was hired to wheel her in a barrow to the wooden trolley.

The *Western Star* offered the conventional picture of the Chinese of Canton as "slow but most persistent toilers, who lived cheaply, saved consistently, gambled regularly, and found their chief enjoyment in the dingy den, lying half asleep, and lighted into oblivion by the dull red gleam of the opium lamp".

Jim Smith has particular memories. Twice a week a pig was killed, and each Chinaman received a piece of pork on a flax string, "never wrapped". Two Europeans robbed a gambling den with a toy pistol, and naturally the Chinese could not go to the police; one old Chinaman, however, saved his sovereign by swallowing it. Seven Chinese made their fortunes from one claim and sold out to seven others and went home; those seven did likewise, but the third seven did not quite make their fortunes, which sounds like some kind of a parable.

In the end the Chinese were eased out by European law. They only had miner's rights; the company took out the right to work the complete forty hectares and was supported by the warden's court. A fire destroyed many of the Chinese huts in 1899, and most left then.

Preservation Inlet, 1885.
Alexander Turnbull Library.

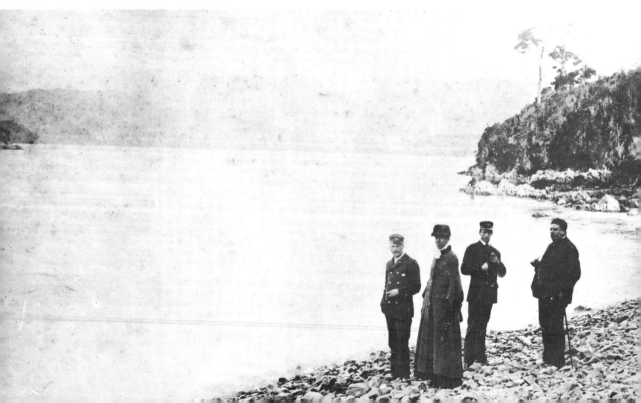

They buried their dead temporarily at Riverton, but they were later lost along with many other Chinese remains on the ill-fated *Ventnor*, which sank off New Zealand.

Gold mining in the last decade of the nineteenth century brought Preservation Inlet closer to development than the planned settlement of a quarter of a century earlier. **Cromarty** was surveyed in 1869, followed by several other patronising attempts by the authorities to settle Highlanders around the bottom of the South Island and on Stewart Island. The never-existent township of Jamestown on Lake McKerrow, named after James Macandrew, the Superintendent of Otago, was the most disastrous of all the planned settlements. In 1870 even the surveyors on the way in by paddle-steamer got stuck, with rescue parties heading for both Queenstown and Hokitika. Some sections were taken, including one for a store, but the settlers soon retreated to Martins Bay, which was also a dismal failure as a settlement.

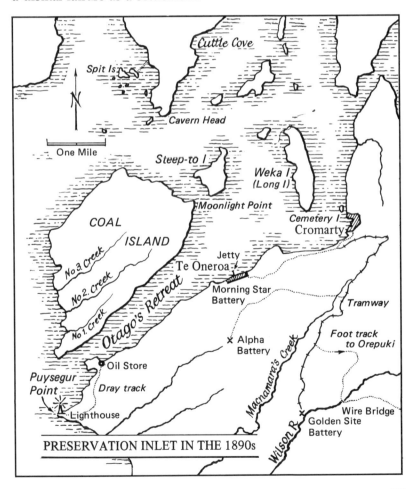

PRESERVATION INLET IN THE 1890s

95

Coal Island was where the gold miners first congregated. Those vigilant veterans, still around from the Otago and West Coast rushes, got word that the lighthouse keepers had struck. In August, 1890, the *Otago Daily Times* reporter located seventy miners there, "in the old-fashioned tent", with deep trenches cut round the tents to drain away Fiordland's downpour; nothing much could be done to combat the winds that blew at over sixty-five kilometres per hour for a third of the year.

Late the following year Cromarty was finally established when miner James Smith felled a tree, which struck another and the roots revealed a rich lode. Although Cromarty was apparently named after James Cromarty, a miner who had drowned near the lighthouse, ill omens never got in the way of gold fever. Cromarty's first section was sold in December, 1892, by which time 100 miners had arrived. The following year a further thirteen were sold, averaging around £7 to £8.

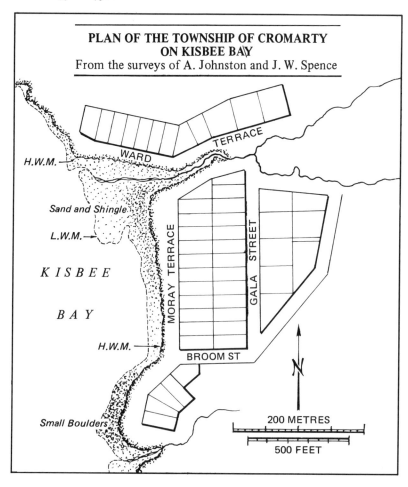

PLAN OF THE TOWNSHIP OF CROMARTY ON KISBEE BAY
From the surveys of A. Johnston and J. W. Spence

Cromarty came and went with the Golden Site mine. The dominant town building was the Kisbee Hotel and Social Hall, run by Joseph and Sarah Sherlock, who celebrated their 40th wedding anniversary by shouting "bumpers of genuine champagne", then packing up and moving to Christchurch. Charles Anderson and Mrs Fox ran boarding houses, the latter said to rival the hotel in liquor sales, not to mention the three sly-grog shanties also on the main street, a corduroy or manuka-lined track. Robinson and Bradshaw ran stores, the latter also handling the mail, whether by sea or by land from Orepuki. There were two shoemakers and a billiards room. T. J. Gilfedder taught school and Dr G. H. Fox practised medicine from 1896.

Ernest Bradshaw was one of the storekeeper's family of nine boys and a girl. He recalls the "native crows" enticing children with hops and short flights, only to "scoot off" into the bush to join the "millions and millions" of parakeets, kakas, pigeons, robins, tomtits, fantails, kiwis, kakapos and wekas. The wekas prowled the streets until they were hunted off by dogs and miners carrying nooses on the ends of sticks.

The dinner tables should have offered a great variety of bird dishes, but there is record of a small famine in July, 1898, when the 250 residents anxiously awaited the steamer. Apparently traditional foods were preferred. The following year a fish-curing plant was set up, but it, too, failed.

It was good growing soil, boasting a twelve-and-a-half kilo cabbage. Perhaps the lack of food related to the lack of women in those days when men worked outside and the women within. Some support for this stand comes from a letter to the newspaper in 1898 which plainly pronounced that "Preservation Inlet is an excellent place for young ladies to come to who wish to be married."

A letter in the *Weekly Times* dated 1 August, 1902, perhaps explains why they didn't — it referred to "an atmosphere loaded with suspense, curses and sandflies".

There was a string band in Cromarty and, in Christmas, 1892, Fiordland's first regatta and sports meeting. In 1893 the first polling booth was set up, but no candidates came. Bradshaw estimates there were 1,000 residents, but polling only recorded forty-nine for the Liberal Macintosh to twenty-five for Hirst. In 1896 Hirst came and spoke on an upturned boat for two hours, and probably wished he had not, for this unlucky man's following was reduced to a mere two votes. Michael Gilfedder was the successful Liberal this time, and he spoke there too; later he pushed for road access from Orepuki 144 kilometres away but, as with everything else about the town, he was unsuccessful. Another candidate, the Reverend T. Neave, combined politics and preaching, also holding a Sunday night service. He was more successful with his first avocation.

The remoteness of Cromarty was surely summed up in Ernest Bradshaw's story of the lads there finding an albino kakapo, which was stuffed and sent off to the Canterbury Museum. It arrived about 1923, by which time Cromarty had been closed for an unlucky thirteen years.

All that is left today are rotting wharf piles and a few old bottles and bits of Dresden china from the Kisbee Hotel.

Te Oneroa or Longbeach, nearly two kilometres away, did have a single occupant, Jules Berg or Bjorg, up until 1950. This Swede built a hut from leftovers, and gardened and goldmined and served beetroot and parsnip wine to any visitors during his twenty-eight years there.

New Zealand's most westerly township was established around the Morning Star mine, which was operating in 1895. It was a surveyed township, had several hundred people, three stores, two blacksmiths, two butchers, several boarding houses, a chemist, a temperance bar and a church hall-cum-social centre erected by the miners, who also did their own policing of "objectionables". John Stirling was the kingpin, running a general store and acting as postmaster, baker and Justice of the Peace.

At Christmas, 1897, Te Oneroa had a sports day and regatta which included races for married women, single women and for old men, and a "running high jump". In the sailing race the two boats tipped in the strong wind and the competitors had to be rescued.

The Morning Star mine went into liquidation in 1903, and so did Te Oneroa. By 1907 a visitor observed thirty houses without a single occupant.

Both townships are now part of the Fiordland National Park, where the reverted bush is shared by native birds and the blackbirds, chaffinches and redpolls introduced by the Europeans.

Stewart Island's planned settlement at Port William did not last the year because the Shetlanders had not been told that set-lining didn't work here. Gold did a little better at **Port Pegasus** because the intended tin mining activity showed up gold in the wash and 200 men materialised. In 1899 Louis Rodger was encouraged to try and make the traditional retail killing, and set up as storekeeper, postmaster and publican. But the miners melted away, and the next year Rodger was bitterly blaming the failure of the mines on bad mining laws, government apathy, lack of money, speculation and inexperience, a list familar to any Leader of the Opposition.

"If properly worked," he declared, "it would extinguish the public debt of the Colony!"

But then, mining down in the deep south never was "properly" worked — for which those "millions and millions" of birds have cause to be grateful.

11

Short and sweet
Golden Bay, Waimea, Marlborough

I'm waiting for fresh information,
If the gold is all there you will see
I'm off to the golden location,
The Wakamarina for me.

Charles Thatcher.

Gabriels Gully was the first great goldtown, but the first goldtown on the Mainland was **Gibbs Town,** Golden Bay. In fact, the bay was not named solely for its golden sands. The New Zealand Company survey parties reported gold there in 1842; in those days of serious social experiment, gold fever was not an affliction.

Gibbs Town was named after William Gibbs, who bought a twenty-hectare block in 1855. He could not sell it for his price of £40 the following year, which was as well, for in 1857 the asking price for the best foot of frontage at Gibbs Town was £8. His property had become the centre for 2,500 miners — a fiftieth of all the folk in the colony.

It was the shantiest town. The Commercial Hotel, one of seven, was a long tent with a bar, store, post office and dining room. A chimney of sods was surmounted by four bottomless beer casks, lashed to a piece of scantling that had been driven into the ground. A half-metre-square gash either side of the chimney served to condition the air.

Bedstead Gully was the most famous of the diggings, becoming rich enough to reach its township status of pub, dance hall and bakery — the bare essentials of a goldfield town. It was so called because the miners found a bedstead there, probably left by a surveyor.

Washbourns, later Slateford, was the only other settlement, perched below a pack trail at the mouth of the Slate River. It had several stores and hotels, and a post office.

Gold could be found in the Aorere River (the name meaning a stormy wind or flying scud, foul warning of the pelting rains and bitter winds that were experienced). Still the miners managed to make merry with balls, concerts, canoe races and horse races on the beach, while the women collected the firewood.

Laying out the township of Collingwood on the terrace above did not go any way towards realising the hope that it would rival Nelson, and nor did the quartz mining and sluicing of the 1870s and '80s, which did lift **Ferntown** across the river to the level of three pubs. The area is bleak and bust, which makes the pub there that much more attractive.

In the 1850s there were minor rushes to the Baton and Wangapeka Rivers too, up at the head of the Motueka River. **Baton** and **Upper Wangapeka** today muster seventeen people, **Lower Wangapeka** does better with twenty-seven, but only because lower settlements mostly do. None of them ever really did much good. Baton had a pub run by London policeman Tom Taylor, and a school and a post office that received mail by horse once a week. By 1900 everybody had gone and the timbers were rotting. The gold, said a local farmer, was back where it belonged, underground — at Fort Knox!

In the 1870s there were digging efforts on the Mt Arthur Tablelands, the small settlements of **Balloon** and Butcher Town. There was also a Chinatown, Starvation Spur, Commiskey Creek and the familiar Golden Gully. Water was as precious as the gold they sought, and lack of water did them in. Billy Lyons stayed on to be known as "the grand old man of Balloon", still intent on digging a ditch through to Peel Lake — as futile but no doubt as engrossing as the efforts of the lad to empty the sea with a sand bucket.

The Wakamarina goldfields did rather better in a shorter time, booming and busting in that fabulous year, 1864. The fields had a fabled beginning that folk tales are built upon. In 1860 Elizabeth Pope, wife of the local sawmiller, was rinsing the washing in the river and spotted some yellow muck which, on closer examination, proved a threat not just to her washing, but to her way of life. She didn't make a deal of fuss about finding gold, and nobody took much notice until the Superintendent of the Province attempted to halt the drove south to the Otago fields by offering £1,375 for the discoverer of a workable field. In no time four men had proved Mrs Pope prescient, and the rush was on.

The *Nelson Examiner* reported in April, 1864, a fifty-kilometre line of people stretching from there to the Wakamarina, like that freak spring tide that surges up the Northland creek.

"Old hands were well-equipped," said the *Examiner*. "Others, green as the foliage under them, toiled on under loads which in their ordinary transactions they would not have attempted to carry along a level road . . . farmers and tradesmen, professional men and

100

Wangapeka. *Thelma Kent Collection, Alexander Turnbull Library.*

mere boys, fat men and lean, old men and young, all in quest of gold and yet who knew as much about it as does — say the Lord Mayor of London."

One Thursday in May 1,000 miners arrived, and a further 750 the next day. Even a one-legged man limped there.

Otago alone lost 4,000 men, for there was gold here for the scooping, one group taking nearly 12,000 grams in twelve days. Four Greeks were said to have left with £10,000 each, which today would be equivalent to around the half-million dollar mark.

Canvastown was the bottom and base town, with 2,500 of the 5,000 miners on the field. Gold and what it could buy had gone to their heads.

"At Canvastown," reported the Nelson *Colonist* of 10 May, 1864, "quarrels, noise, fighting, and uproar on Saturday and Sunday evenings, are said to have been excessive . . . one man had a portion of his fingers bitten off."

Gold waits for no policeman, and turns men normally good enough into ghouls. Wakamarina, more properly Whaka-marino or Whangamarino, meant "peaceful bay", but it must have been named before Te Rauparaha's time, and certainly before this gold plague.

The *Colonist* pursued the theme on 31 May: "In the total absence of any authorised person to take the management of the goldfield, might is supressing right, and the jumping of claims an almost daily occurrence . . . 100 men taking forcible possession of a claim held by thirteen."

101

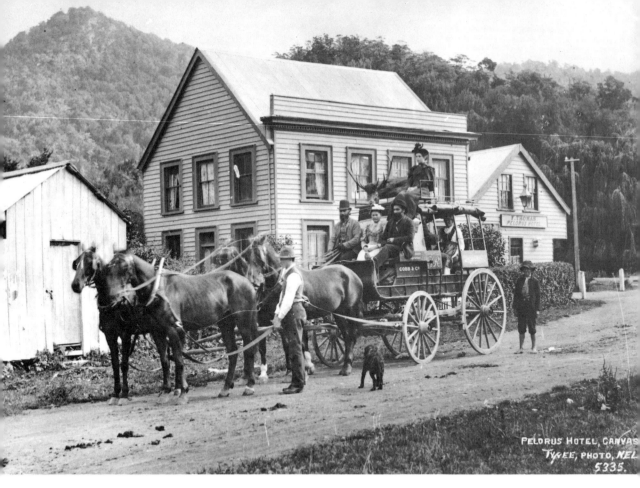

PELORUS HOTEL, CANVAS
TYREE, PHOTO, NEL
5335.

Canvastown. *Tyree Collection, Alexander Turnbull Library.*

Not that this got in the way of toasting the departure of the Bank of New Zealand buyer, Mr Boddington. First were the loyal toasts, to the Queen, the Prince and Princess of Wales, the Royal Family and the Duke of Cornwall.

The lawlessness reached an all-time New Zealand peak in the infamous Maungatapu murders of 13 June, 1866, when the Burgess-Kelly gang killed five prospectors on their way from Deep Creek to Nelson.

Deep Creek was the richest diggings up the valley and had its own township, with two stores, two hotels and a little white courthouse that is now a holiday bach. The area remained active up to 1923 with quartz reef mining.

Roy Rush grew up down in Canvastown, where the neat little post office and community hall still function, if not as actively as the wayside pub. His wife grew up at the top end, among the miners, her mother running the boarding house and her father the Fisk Hotel. The Rush family have settled for halfway.

Mrs Rush was born in 1909, when her mother was teaching at Deep Creek; her father had built the swing bridge over to it, obviously a gallant fellow.

102

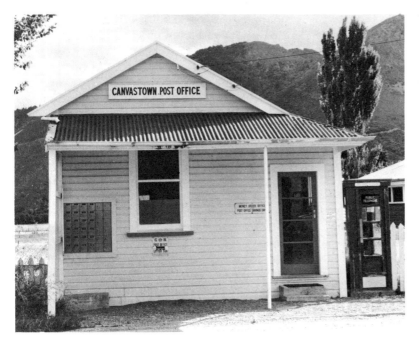

The post office, hotel and a few other buildings are all that is left of one of the biggest goldtowns at the top of the South Island. *David McGill.*

When she was two they moved up to Top Camp, where the battery was.

"It was so noisy going day and night," she said, "you only woke if it stopped."

Her mother ran the post office and looked after forty boarders, many in whares round the two-storey boarding house.

Creek names demonstrate the gallows humour of the miners — Dead Man's, Maggoty, Dead Horse and Doom. But Mrs Rush remembers the "high old jinks" at euchre parties, dances and singsongs. Her dad had the first Ford, around the First World War. On pay day the miners would want to get down to Canvastown or Havelock; on the return journey there would always be fights in the back seat, and her father never knew whether to risk stopping. It was back to work stoned broke for another two weeks.

She took the miners hot tea and four plates of food at a time, tied in a tea towel. There were floods and fires enough, but the fact that she was sent off to boarding school at thirteen years of age may have had more to do with the miners.

The *Otago Daily Times* for 6 January, 1865, observed, with a sigh of relief written between the lines, that Canvastown was returning to its original obscurity, as "once more a few shanties will be all that remains to mark the scene of the great rush". Otago looked forward to welcoming back its miners and the Old Identities up that way to getting back their pastures. Unfortunately for Otago, the miners headed towards the West Coast.

103

In the late 1880s the top of the Mainland had another go at gold fever, this time fanning out from Blenheim.

John Hart discovered gold in the **Waikakaho Creek** just up the road from Blenheim. It was largely a businessmen's venture that was abandoned six years later for lack of water. A man called Jellyman had opened a restaurant there and Alfred Dillon built a twenty-six-room hotel. There was a store, slaughterhouse and school, and fifty-seven signatures on a petition won the occupants a post office. Young bloods rode over to Okaramio hall for Saturday night fun. Lads too young for that were employed to crawl into pipes to hold the heavy hammer against rivets, and were deafened. Waikakaho's failure cannot be greatly lamented.

The real rush the same year was to the Mahakipawa or Cullen Creek in the next range over. It was named after farmer William Cullen, who did his damndest to stop the miners coming in. They discovered that if a vehicle could be driven through, the route could be declared a public road — a rule that would cause chaos today, as it did then. Tim Clancy was engaged with a coach to drive through, and Corry was supplied with a whip to stop him. The miners put a bottle in Corry's free hand, and he was able to observe Clancy's progress past him from a prone position.

About 1,000 miners followed Clancy into **Cullensville.** And out again. Now the farm gate is locked, but you can peer over it at a paddock where Cullensville once was.

Many did well. Stuttering Dave arrived with nothing, begged a shovel and made £600 in six weeks. But many were ill-prepared and

Mahakipawa post office, reputed to be the smallest in the country. *Chaytor Collection, Alexander Turnbull Library.*

104

slept rough, often without even a blanket. William Fortesque was the first to minister to their needs with a bakery charging 8d a loaf, 9d if delivered. He added a butchery and store. Mrs Elizabeth Dickinson's accommodation house was licensed as the Miners Arms in October, 1888; at the time she had 200 guests for breakfast and dinner, queuing up in a soup-kitchen line outside her marquee tent. Another hotel had the sobriquet, The Piggery.

The rush began in the May. By Christmas there were five stores, three bakeries, two butchers, three bootmakers, two drapers, two skittle alleys, two billiard rooms, a post and telegraph office, an oyster saloon, a shooting gallery, two restaurants, a National Bank, a courthouse with a resident constable and a cordial factory whose proprietor recommended his herbal beer to diggers as "a fine remedy for tapering off".

Entertainment flourished. A literary institute, a racing club, cricket, football and athletic clubs, the Linkwater Defence Rifle Club, picnics, sports and the Mahakipawa Blackbirds troupe of entertainers, were some of the attractions. Once a wrestling bear came to town to take challenges and first up, blacksmith Gordon Hughan, has left behind this account of the engagement: "Off went my boots, the bear stood up and danced around. In I went and claimed the first fall, then another and another. The owner of the bear said it was a 'dog' fall, and wanted me to continue to entertain the audience, but as I had done my turn I headed off with the bear after me, and when he grabbed me by the leg the crowd scattered. There were plenty of volunteers after that, but they did not fare as well as I did and some had to call the owner to take him off."

Remittance man Jimmy from Heaven (James Watts) recited his goldfield ballads to the assembled multitudes, dressed in tie and tails and always with his front to the audience, for he had no seat to his trousers. Two of his verses on the Duncan Valley duffer were:

At midnight rushed the diggers bold,
All eager for the phantom gold,
In visioned hope of future spree,
And long adieu to poverty,
Changed to this their melody,
Duncan's Valley, RIP.

Keen night winds chilling flesh and bone,
Long sleepless nights in blankets blown,
Duffered first the Maoris flee,
With their eternal 'tinaqui',
Sunless vale of misery,
Duncan Valley, RIP.

Which is not bad, if you ignore the punctuation and spelling and a dash of what we would now call racism.

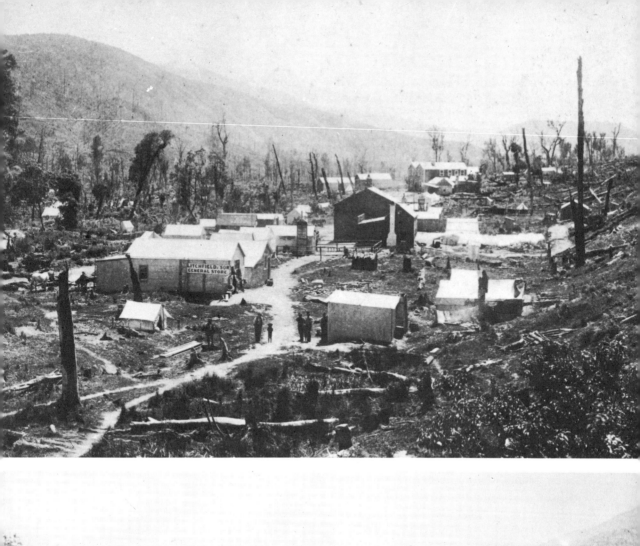

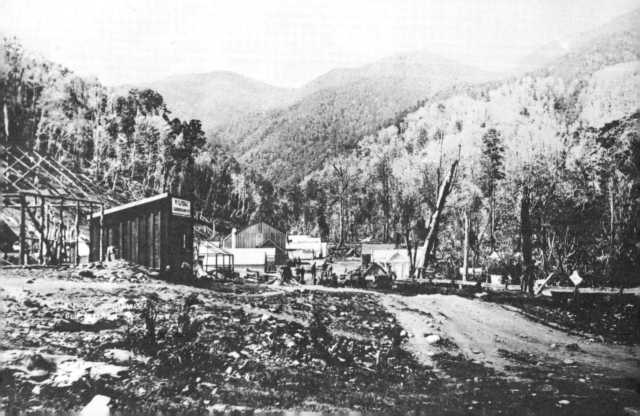

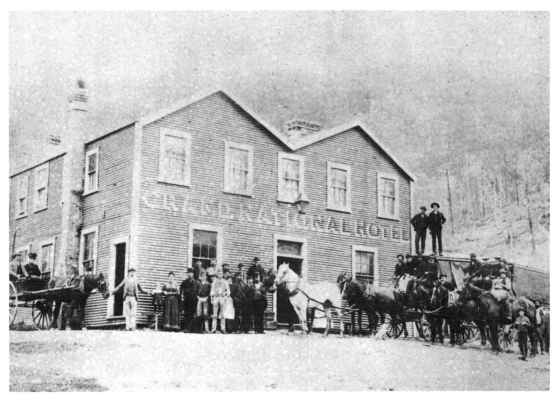

Cullensville's Grand National Hotel. *Alexander Turnbull Library.*

Charlie Coleman lives nearly two kilometres from Cullensville, where his father was the butcher. His grandfather Tommy was a brother of Bonar Law, a Prime Minister of Great Britain. Cousin Jim from Canada has been over to see Lord and Lady Whatnot relations, but Charlie says he is not a pushy sort so he stays put. At the time of writing he is in his eighties and still works on his son's farm. He remembers his grandfather's reputation as a rough diamond, "rough outside, good within".

In 1928 Charlie met Cullensville's last miner, eighty-year-old Geoff Morton, who was 198 centimetres tall and thin as a match. He told Charlie where there was still gold to be had, and Charlie has passed on the information to those who have asked. If times are tough, he reckons you'll see miners back there.

In the 1880s **Paturau** was the centre for several hundred miners on The Golden Blocks or Taitapu field. **Dogtown** and **Pennyweight Town** were miners camps above Lake Otuhie.

Owen River contained a minor gold rush in the 1880s, with its name switching briefly to Owen Junction in deference to the designation awarded it by some anoymous post office official. There were eight claims filed there in 1886, and a fifteen-room hotel and other buildings housed the miners. It, too, had its upper and

Facing Page:
Cullensville in the 1880s. *Alexander Turnbull Library.*

Cullensville. *Tyree Collection, Picton Museum.*

Gold chip shares of last century. *Picton Museum.*

lesser settlement of **Wakatu** and a brewery at Brewery Creek — where else? It was easier than lugging booze over from Nelson. Eight folk remain.

The Maud Valley, 112 kilometres south of Nelson, was missed in the earlier rushes. There was a minor rush to **Howard** in 1916, and a government-assisted one in 1932 which did better, especially further up the river. Maud Creek did best, although a settlement was formed at **Maggie Creek,** with store, post office and smithy, and later a library; local farmer John Kerr named the creeks after his daughters. Traces remain of the adze-hewn beech-slab houses with cedar tiles and walls lined, because of the cold, with newspaper, flour-pasted up and mice-nibbled down. Stories linger of the drastic solutions formulated to combat the theft of firewood — huts were blown apart by dynamite secreted in stolen logs. This could explain the bad blood said to have existed between the "Canterbury boys" and the Dalmatians; its culmination was an epic fight that only stopped when a Dalmatian was tossed into a fire and had to be carried out for treatment on a stretcher, no doctors being handy.

The rush to the north of the South Island went against the prevailing movement to the West Coast, which the *Otago Daily Times* was sure would amount to very little. The *Times'* error is developed in succeeding chapters. I leave the Mainland's Golden North with this ditty from the Wangapeka Boar's Head Hotel:

> *Boars young and boars old,*
> *Boars tender and boars bold,*
> *Come to Wangapeka*
> *And you'll get boars enough.*

108

12

To the West!
The beginnings of the Coast goldfields

To the West, to the West, where the ships run ashore,
Of wrecks we have witnessed two dozen or more;
Where bushrangers congregate, as you've been told,
And simple bank clerks are deprived of their gold.
Where beef's eighteenpence, and where diggers devour
Rusty bacon, and bread made of vile flour.

Experience of Hokitika, Charles Thatcher.

Samuel Butler wrote in 1860: "The West Coast, that yet unexplored region of forest which may contain sleeping princesses and gold in ton blocks, and all sorts of good things." The Maoris had already long known its secrets, but at that time Reuben Waite was the only white man to listen. The people of Nelson sneered at this "madman from Victoria" when he set out in 1861 for the Coast, but when he returned with the golden goods they heaped praise upon him that he could do without.

At least, that is Waite's version in his brief but forceful account of himself as the original gold-trailblazer on the Coast. He was storekeeper and goldbuyer to the first miners, some say their exploiter, by his own account more sinned against than sinning.

He blames the Otago rush for holding things up, although he does concede that sailors were mortally frightened of the Wild West Coastline. The first rush to the Waimangaroa in January, 1862, was cut off from supplies, and the Maoris kept the Europeans alive on nikau root and seafood. **Lyell Creek** was developed from the end of '62.

The place was named by Julius von Haast after Sir Charles Lyell, whose *Principles of Geology* was an inspiration to Charles Darwin. Lyell itself inspired a particularly vigorous attack of gold fever. Waite writes of one man coming overland from Canterbury and surviving on raw woodhen caught by his dog. Another consoled his

Reuben Waite, West Coast gold pioneer and father of Greymouth. *Alexander Turnbull Library*.

109

hunger by studying a cookbook he had with him in this wilderness, to Waite "a martyr! a true philosopher!"

To the Victorian miners Lyell was "purgatory", a three-kilometre struggle along the sides of unstable and perpendicular gorges; when they got there they could expect no fresh food and no law but that of their own enforcement. They could rely on rain, snow, floods, sandflies, mosquitoes, firewood that was never dry, permanently damp clothes and mouldy flour. Nuggets the size of footballs were their only consolation, although three diggers did advertise in the *Nelson Examiner* for a lady wife "not utterly repulsive in appearance, and over five foot five inches in her stockings".

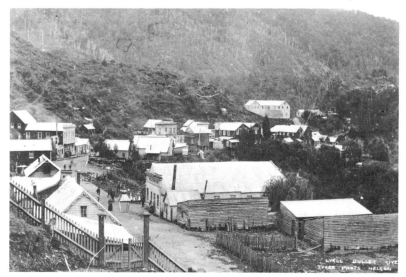

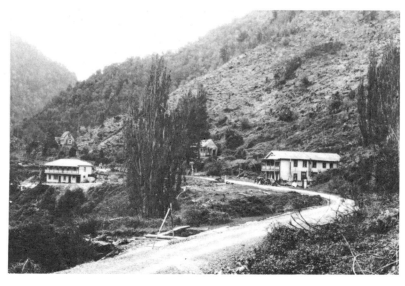

Lyell Creek became The Lyell, then Lyell and now it is no more — the story of the Coast. *Top:* 1894. *Bottom:* 1930. *Alexander Turnbull Library.*

110

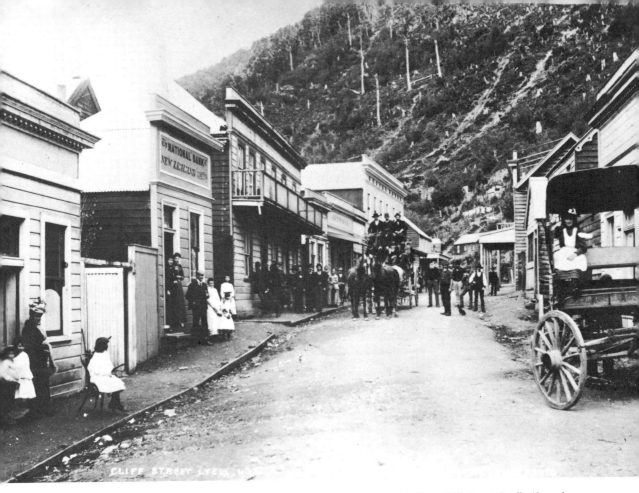

Cliff Street, Lyell. *Alexander Turnbull Library.*

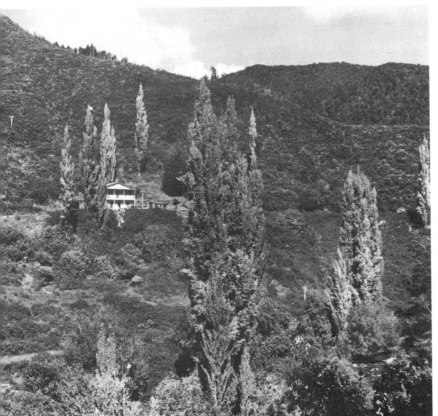

Lyell in 1951. *Alexander Turnbull Library.*

There is no record of whether a woman came forth into the wilderness, but Lyell did support 2,200 miners, the stores and pubs being supplemented by two churches, a courthouse, a newspaper office, a school, bank, post office, police station, mining office and brewery. Holloway's pills were there from the first newspaper, promising complete health for a shilling, and warning against "vile American counterfeits!" The newspapers of those days were dominated by testimonials from ex-sufferers from chronic constipation, dyspepsia and liver trouble, a testimonial perhaps to how many still did. Many suffered malnutrition from a diet of flour, water and booze; one victim declined further when he took literally a doctor's suggestion to eat animal food.

At the turn of the century the *Cyclopedia of New Zealand* thought Lyell of "unromantically weird appearance" and Thomas Cook "a most remarkably situated township, consisting of one curved street cut out of the hillside". In 1963 its last building, the Lyell Hotel, was burnt down. Memories linger in the misty gorge, of Paddy the Ram, so-called for his butting abilities, of Peter the Greek, the only man game to ferry supplies there by barge, of Blower the woodchopping champion from Sydney who never took a fag out of his mouth, and of Biddy of the Buller, who kept a clay pipe clamped in her mouth until she died, aged eighty-six.

The diggings below Murchison, which was Hampden then, rivalled Lyell following the redoubtable George Fairweather Moonlight's **Mangles Valley** find, then Maruia, Matakitaki and Glenroy. For the hundreds of miners who burrowed like moles all over these valleys, a few survivors hang on around Burnbrae, Rappahannock, Glenroy Valley, **Mangles, Matakitaki** and **Upper Matakitaki,** where the famous Lost Tribe of hillbilly miners were said to have hair on their teeth. **Fern Flat** did rather better, with 400 miners through the mid-'60s, and a post and telegraph office and school still surviving in 1900. It has eleven citizens left.

The rush moved quickly over to the Coast proper, to Hokitika, known as Okatiki at first. Thatcher knew as much when he wrote:

The French girl is soon leaving here,
And she'll say to the diggers so cheeky,
"Ah, parlez-vous Francais, m'sieur?"
When she arrives at Okatiki.

Greenstone Creek was where the West Coast rushes proper began, from mid '64, although only after Waite had survived an ugly mob convinced that they had been lured to a duffer. He had nothing to defend himself with when they gathered around his store with a mind to lynch him. They were incited by a Dutchman whom Waite had already accused of stealing a case of his gin.

"Vell, poys," said the Dutchman in Waite's rendering, "ve vill

112

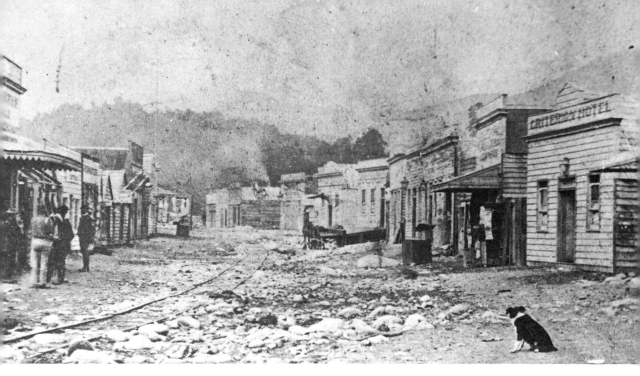

Greenstone in the 1860s.
Alexander Turnbull Library.

take vot ve vants from Vaite's store and ve vill hang him aftervards."

It makes you realise how many "w" letters there must be in English. Waite then has a Cockney chime in, straight out of the pages of Pickwick.

Waite contends they have been misled by others, and he is proved right, but not before an Irishman attacks him. A friend's hand saves his head from fatal contact with a half-full bottle of old tom. A grand and all too brief narrative.

Once the gold was rolling in, Waite made sure to charge the "grumblers" more for provisions; he noted that the Dutchman had not shown his face again.

Greenstone Creek had twenty pubs to absorb the diggers' time and talents. Ah Sun Mo had one of several stores. There was a smithy, a surgeon, two Banks of New Zealand and a school. Mona Tracy was poking around there in the 1950s. She found a derelict store and, in it, a ledger with an entry for one bottle of Macassar oil at 1s 6d, and for carriage of a perambulator and one hymn book at 4s, so clearly this forgotten town once reached the tenderer stages of civilised life. Today the census lists one civil life left in the Greenstone location.

"Plenty pork, plenty duck, plenty brandy" was the Chinese description of Greenstone, to which could be added Ah Sun Mo's sales of patna rice, ginger, shark fin, dried whitebait and grayling. The West Coast Occidentals preferred booze, bacon and flour, and referred to Oriental plans to be buried back home as "tinned Chinamen".

113

Of the succeeding rushes in this area, Totara Flat has survived, but not **Nobles, Duffers, Granville, Half Ounce,** and lesser creek diggings such as Sullivan's and Brandy Jack. In 1875 Half Ounce and Granville each ran five pubs, two butchers and two bootmakers; Half Ounce also had an hotel/butcher, two stores, three drapers, a surgeon, carpenter, cordwainer, baker and cattle dealer. Granville claimed a senior constable and a cordial maker. Nobles Gully had a gardener, hotel/storekeeper, second store and a carpenter. Duffers lived up to its name, with only a butcher. Schools and post offices came and went.

Three Mile or Ho Ho has held on, but not **Six Mile,** later **Forkstown,** then **Waimea** and, finally and fabulously, **Goldsborough.**

Goldsborough was the supply centre for the Waimea diggings, peaking at 6,350 folk in 1867. This was the Coast's peak population year of 29,000 people, thirteen per cent of the entire population of the country. A contemporary summed up this big, brash town as "filthy", its stores, hotels and buildings having "a mouldy, rotten appearance . . . at night the rats run over you in thousands". Dick Seddon kept store there before he moved on to keep the country's accounts.

Goldsborough. *Alexander Turnbull Library.*

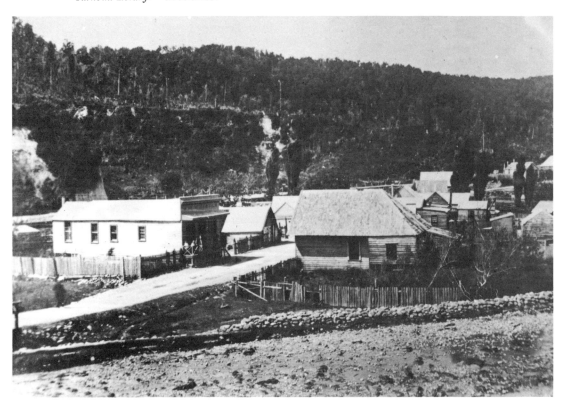

114

New Year, 1865, was when the West Coast rush finally fired, with Waimea's population leaping from 100 to 3,500 in three months. Charles Money saw the town emerge literally overnight: "In the heart of a dense and almost untrodden bush a street had arisen as if created by the magic wand of an enchanter. Swift as the walls of Aladdin's palace, stores, shanties, public-houses, butchers, bakers, and doctors' shops were to be found on every side."

Although diggers did well, they paid through the pocket for provisions. A four-pound loaf was 6s, twelve times its price after the rushes.

Fighting was the traditional pastime. A digger described a typical Sunday night in February, 1865: "Almost every half hour a cry of 'fight' would be heard, a space would be cleared in the street, and two half-naked and wholly drunken men proceed to hammer away at one another until they were separated, which their respective mates generally managed to effect. Of course a drink must be had to make things right, and so the combatants and their friends would proceed to the nearest grog-shop, and wish each other 'luck' over their 'nips' until they were called out again by another cry of 'fight'."

In this tough town that same month a pickpocket was reprieved from hanging but had to run a gauntlet of kicking, punching and very irate citizens.

Today Goldsborough is rubble. There is a sign to say it did exist, and a claim for tourists to sluice around in.

Its twin boomtown of **Stafford** is doing a little better, with an old lady and a man; he has converted the butcher's shop into a garage, but the hooks are still there.

In its heyday Stafford had four churches, a literary institute, a public library, and six policemen. It was named after its first storekeeper, Pegleg Stafford. It developed through 1866, and in August Warden Keogh described trade as brisk. "The number of drunken men lying about," he reported, "speaks favourably of the rush."

That month you needed more than £100 to get frontage on the main street, where sixty businesses flourished, a third of them pubs. The town and its seven hills carried a population of 2,500, and shared the *Waimea Chronicle* with Goldsborough.

The Scandinavian lead centred on Stafford suggested the large numbers of Norsemen there, and diggings named Callaghans, Italians and Greeks indicated the concentrations of other nationalities. The Kaniere diggings further down had an **Arthurs Town** and a **Blue Spur** township like Central Otago, and lesser settlements at Woodstock and Kaniere Forks. In 1875 Blue Spur had a teacher, baker, hotel/storekeeper, butcher/storekeeper, and Augustus Boys as postmaster-cum-pub/storekeeper.

The remnants of
Goldsborough. *David McGill.*

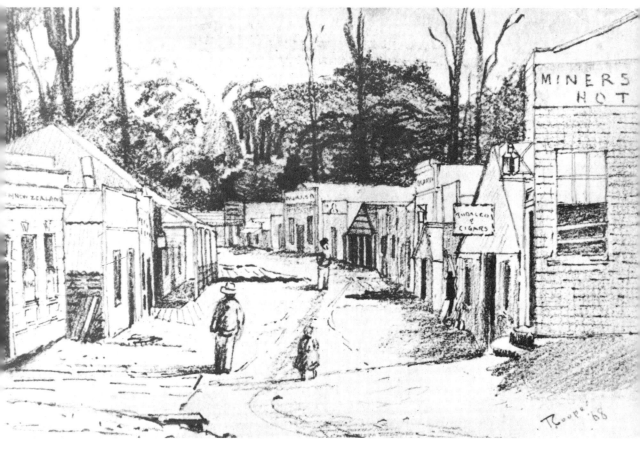

However, the great forgotten township was in the northern Waimea field — **Chesterfield** or **Lamplough.** It has even been forgotten where it was, for both Lamplough and Chesterfield now appear on maps in a coastal position, whereas, according to 1868 maps, the original Chesterfield and Lamplough lead are positioned almost as far inland as Stafford. It is for certain that there were thousands in the area, and Chesterfield was laid out for their benefit. Just to complicate things, Lamplough of today is called Awatuna.

The rush began where Lamplough is listed now, in the winter of 1867. About 2,500 diggers headed up the muddy track, looking "something like huge frogs with the greater half of their bodies submerged, hopping forward by degrees, and croaking all the way". Owens, the discoverer, named it after a Victorian field that he had worked successfully. Warden Keogh marked out the township of Chesterfield on a nearby terrace and within a month it had sixty stores, two dance halls and a Catholic chapel. Three months later the muddy bubble had burst.

Stafford in 1868, sketched by Thornhill Cooper — photograph of the original, one of several Thornhill Cooper sketches held at the Hokitika Library. Thornhill Cooper was a clerk for the Bank of New Zealand at Hokitika between 1867 and 1869. This scene was sketched on 23 January 1868. *Hokitika Library Collection, Alexander Turnbull Library.*

117

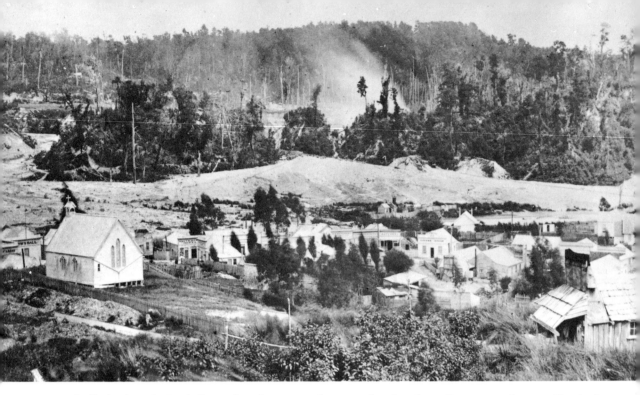

Another township nearby that has disappeared was effectively an Upper Kumara. It was called **Larrikins** after the young "Joes" or New Chums who had been sent up river as a means of getting rid of them and had later struck luck. Their town had a hotel, watchmaker, store and snobshop, or shoemaker. The name probably stemmed from their behaviour when they came into the big town.

"Get your best dresses on," the proprietor of the Theatre Royal dance house told his ladies. "Make arrangements for a pleasant evening. The larrikins will soon be in town."

Cousin Jack was close by, an Upper Lower Kumara if you like, where the Cornishmen clustered, their beards square-cut beneath the chin and judged unlucky by their own proverb:

Where it be,
There it be.
But where it be,
There aren't we.

They were surely an exception to the Coast's golden rule of the mid-'60s. The rule advanced across the Grey and up the coast to include the most action-packed goldtowns this country has seen. Heigh-Ho for Charleston and Addisons Flat and the Battle of the Orange and the Green!

Before trekking further west, **Zala Town** must be mentioned, for it was just above Lyell and was part of the later quartz-crushing activity. Antonio Zala discovered the Lyell Reefs and, by 1875, there were several hundred people there, about forty houses, a post office

118

and several stores. Clergy visited occasionally and the magistrate monthly. William Burns was mine host at the Miners' Arms and Louis Boutell offered accommodation to those who did not have their own. In 1878 its name was summarily changed to Alpine Hills, but that did nothing to slow its demise.

HOTEL

BAR

Autographs
M. A. Lodge

NOTICE.
By Order of the Licensing Commission this Bar will close permanently as from 31st May, 1951.
M. A. LODGE,
Proprietress.

2885

Sincerely we thank you for past patronage and sincerely we say—"Charge your glasses, for the toast is to your own health and happiness."

MAMMOTH

PUBLIC

TIME GENTLEMEN PLEASE

IN MEMORIAM
In cherished memory of the MAMMOTH HOTEL. Born in the wild tranquillity of the untamed eighteen-sixties, and left to rest as peacefully as it can, amidst the civilised chaos of the turbulent nineteen-fifties.

THE "MAMMOTH"

SAYS "GOOD-BYE"

To all those thirsty souls who have passed through the portals of The Mammoth over the years, this souvenir leaflet is dedicated.

Fare thee well! and if for ever,
Still for ever, fare thee well.
—BYRON.

"On this memorable day, 26th May, 1951, I most cordially welcome all old friends and acquaintances, and take pleasure in extending to them, one and all, the hospitality of the house."

M. A. LODGE, Proprietress.

The decision of the Licensing Commission to withdraw our license will be regretted by many, most of all perhaps by our good friends of the Matakitaki Valley. We have our regrets, too, and as the curtain falls on the long and eventful life of "The Mammoth" we think of those countless happy memories of the days gone by—memories that will ever linger.

And as the Cock crew, those who stood before the Tavern shouted — "Open then the door! You know how little while we have to stay, and, once departed, may return no more."
—OMAR KHYYAM.

One can imagine what a send-off the Coasters gave this marvellous old Matakitaki pub in 1951.
Alexander Turnbull Library.

119

The West Coast's wild beginnings come to a fitting conclusion in the court of the Lost Tribe, the Matakitaki Mammoth Hotel. There the King of the Lost Tribe, Tom May, officiated over the diversions of hundreds of diggers, conferring merriment and cod knighthoods to such as Brandy Mac, Flour O'Wheat and the Emperor of the Celestials, the last no more nor less than a Chinese digger. The Mammoth was burned down and born to booze again several times, as you might expect. When it finally closed its doors on 26 May, 1951, proprietress Mrs Lodge sent out black-bordered invitations to its wake, and offered this epitaph:

"Born in the wild tranquillity of the untamed 1860s, and left to rest as peacefully as it can amid the civilised chaos of the turbulent 1950s."

Berlins coaching stop. There was mining activity here briefly. *Alexander Turnbull Library.*

The Mammoth rested and rotted for a few more decades, but finally it met the same fiery end as its predecessors.

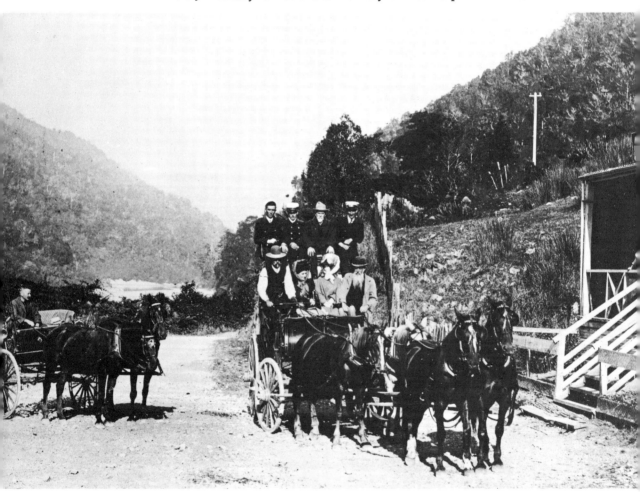

120

13

War! War!! War!!!
Addisons versus Charleston

The gals are preparing to go
At the West Coast they'll shove up some Clubs there,
They'll open grog shanties you know
And no doubt make plenty of dibs there.

Charles Thatcher.

By 1865 Reuben Waite's pioneering days were over. He was ill for nine months in Nelson with the swamp fever; it was during that year when his own 3,642 hectares were over-run and the riproaring towns established that were to define the Coast forever. By the time Waite got to Westport, there were thirty ferry boats hove to, and hundreds of miners streaming across his property; at night it was the turn of the rats to stream across the miners, making it necessary to cover heads with blankets. The rats ate the flour and the miners ate his cattle, for which he sought and failed to get recompense.

Addisons Flat was called after the Negro who struck gold there, or **Waites Pakihis**, "as it is indifferently called", sniffed the *West Coast Times* for 1 October, 1867. The *Times* was unimpressed with claims of 3,000 miners there, but then it was published in Hokitika; local evidence suggests there were 6,000.

The strike was made near Dirty Mary's Creek, which acquired its name from Mary's comments on the muddy mess passing through her door. Some time later the banshee wail of a murdered woman was supposed to emanate from the place towards midnight, a tentative but irresistible attraction for the lads from town. Dirty Mary herself died in Nelson, convinced she was Queen Victoria; Waite also died there, convinced he had been cheated out of his just reward for finding gold by the "greedily grasping" Nelson authorities.

The size of Addisons Flat can be more accurately gauged from the twenty snobshops rather than the number of stores, pubs and churches. The shoemaker was much more than a shoemaker, he

121

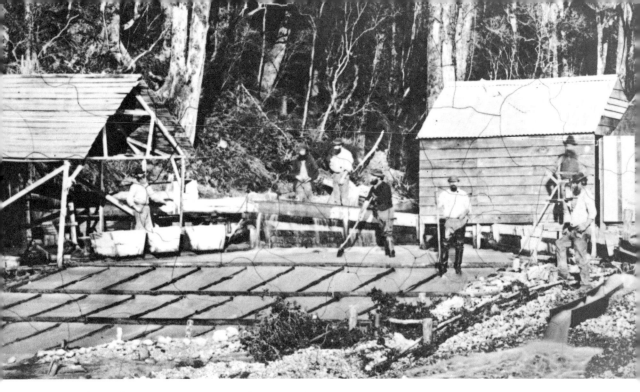

was the man who kept saddles, harnesses and reins in good repair, and any other leatherwork, which included sluicing hose in the days before rubber or plastic was available. The barber was the other jack of several trades, somewhat like today's chemist, the man who would also bathe you and restore your hair by magic potions or wigs.

The men enjoyed a merry round of eating, drinking and repenting, with a brewery there to maintain the pattern from store to pub to church. There was a jail, but it was never locked, and ended its days as a fowlhouse. There is a record of two dancehall girls being fined for throwing gin over each other, for that was a criminal waste. The men were not averse to a bit of waste themselves as they were making upwards of £100 a day; the lighting of cigars with bank notes became a status symbol of their excess.

This town made up one half of the biggest punch-up in New Zealand's history, the other allegedly **Charleston,** across Dirty Mary's Creek. Some of the lads who had crept down to Dirty Mary's Creek were still around in the early 1920s to give Dan Moloney their version of this epic encounter in his *History of the Addisons Flat Gold Fields*. At times Charleston had double the population of Addisons Flat, as indicated by the number of grog shanties — over twice the forty that could be found at the Flat. But when it came to the great fight on St Patrick's Day, 1867, both sides mustered 3,000 men.

The trouble, like the beer, had been brewing for some time. Father Larkin had got into trouble with the police for a "celebration

of protest'' at the hanging of the Manchester Martyrs. To pay for the good Father's trial, Charleston held the grandest ball ever at Sheehan's casino, the grandest on the Coast. Tickets were £1 a head, and £500 was raised. Paddy Galvin was MC, Stanton was on cornet, Patsy Mulqueen on clarionet (sic) and, for sure, Dandy Pat put his heel through the dance floor in the finishing step of the Connaught Jig.

Come St Pat's Day and feelings are running high. The Paddy's have their parade right enough, but then the Proddy's stage a counter demo. It is too much for Mick Ward, who bundles Bella Newton off her grey. The Orangemen see red, but the Men of Green are too much for them. There are reports of stones, pitchforks, pick handles and blackthorn sticks welting, bashing, crashing and laying about in all directions. Jack O'Keefe has a stray Orangeman cornered and is about to lay in with the axe handle when Jack Hussey pulls him up short of the act. "For God's sake, O'Keefe," pleads Hussey, bending the broken blade of his crosscut saw, "don't kill him until I have the pleasure of havin a whack at the Orange divil."

In the original Battle of the Boyne King James's men retreated from King William's. In the reverse down under, King William's men retreat over Dirty Mary's, gather their forces from the terraces and pakihis (dry beds of former lagoons or rivers), and storm back, sworn to kill every Irishman who gets in their way. They have the weapons for it: double-barrelled shotguns, pistols, pitchforks, spears, clubs, pick handles and heavy stones tied in their wives' stockings.

The Irish form up under an ex-English officer, who orders them to "Take no prisoners!" They set off with cheers and singing "God Save Ireland".

God hears their prayers, or only He would know what would have happened. Magistrate Kynnersley exercises a quick wit, telling the Orangemen that their opponents are 12,000 strong, then moves across to inform the Irish that a force of 10,000 is marching on them with mounted cannon in support. Both sides retreat.

When the Orangemen discover they have been had, they petition the Defence Department for troops to put down the Irish troubles. There are 500 troops on the way when the captain hears them singing "God Save Ireland" and puts back with his contingent of ex-Irish soldiers. The Orange crowd gather at Westport to welcome a steamer, but all they get is a cripple playing "The Wearing of the Green" on a flute. Brokenhearted, they declare peace. (The documented version is in my book *"The Lion and the Wolfhound"*, 1990.)

The towns do come together on the news front, as Goldsborough and Stafford did, with the merging of the *Westport Times* and *Charleston Argus*.

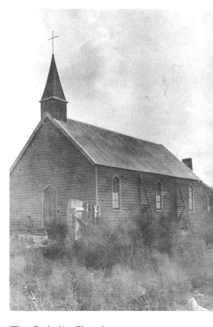

The Catholic Church, Addisons, where children went to school from 1867-1880 (when they finally got a school there). The church was burnt down later. *D. Mahoney Collection, Alexander Turnbull Library.*

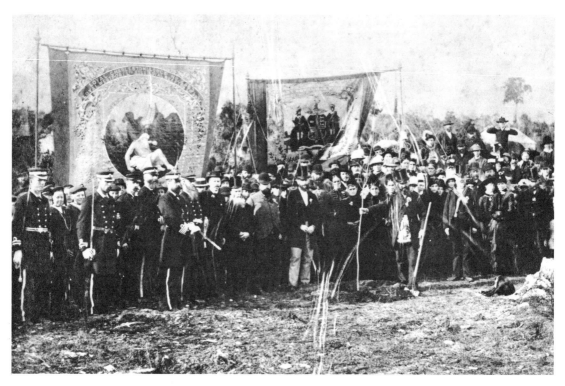

"War! War!! War!!!" is declared on the readers of the issue of Tuesday, 2 March, 1869, but it is only Charleston's Professor Dupois conducting a price offensive: haircutting 1s, shaving 6d, shampooing 1s, all three for 2s, "Baths at the ready at all hours, Ornamental Hair Manufactured to Order."

Another advertisement invites Addisonites to join "Bullerites, Caledonianites, Lyellites, Marriedites, Singleites, New Chumites, Old Chumites and all the other ites" in buying domestic bargains, "on account of the skeedaddling of his late tenant".

On a much more elaborate and regular basis, Fleming, Parry and Murray address themselves to the reader with bold acrostic wit, promoting their own names and their stock of rich velvet jackets and ladies' boots, concluding:

Assemble Bullerites! there is no funning.
You're sure to get an article that's stunning.

A Charleston correspondent promoted togetherness with the rhyme:

Hurrah! hurrah! for a County
 So jolly and so free,
From Westport to old Cobden,
 United we shall be.

124

The *Charleston Herald and Brighton Times* of 8 October, 1870, went and spoiled all that by chortling at the *Westport Times and Charleston Argus* for changing its name to the *Westport Times*, and then for changing it back to the *Westport Times and Charleston Argus*. The *Herald* was put in mind of a chameleon. A wag at its elbow prompted it to call itself *"The Charleston Herald, Westport Smasher, Mokihinui Deserter, Addisons Reporter and Lyell Ripper."*

In 1891 the Herald changed its name to the *Charleston Herald, Brighton Times and Croninville Reporter.*

Charleston quietened down considerably in the last three decades of the last century. The worst its paper could find to fulminate about was the "cold blooded ruffian" who poisoned the postmaster's poodle. There were local amateur dramatic productions to promote, and men were saying a woman would "look Spanish" if she smoked, "but you may be sure that it is a fool of a man who urges his sisters or his wife to take to cigarettes".

Humour was creeping into the miscellaneous columns. It would be an odd wife who felt the pangs of jealousy because her husband hugged the fire.

Then there was the cold down south so bad that a shepherd found some hares frozen stiff. When he returned to collect them, the sun had come out and thawed them and the hares had run away.

Maybe that's not so funny nowadays, with millionaires freezing themselves. So what about the jockey who called his horses Kerosene and Petroleum because they were a paraffine steeds! Boom, boom!

But this is tame really, compared to Charleston's early days. In 1866 they were starving, and when the boat finally got through that incredible strait-jacket into Constant Bay, the cattle were ready for cooking within half an hour of swimming ashore.

By the next year Charleston was booming. Pubs were as thick as shamrocks in a bog, the average age was twenty-four, women were outnumbered twelve to one, and it was considered a promotion to be transferred from the Bank of New Zealand in Wellington to the Charleston office.

Charleston had two newspapers and three lodges. A Negro seeking admittance to one of them was japed into a bogus initiation with buckets of bullock blood, sheep heads, bones, groans, chants, stripping, blindfolding and general gobbledegook.

The lodges attempted a moderating influence. One member was rebuked for being inconsistent in holding "a licence for a house of ill-fame and associated with prostitutes".

Unabashed, the pubs competed with each other for customers. When the European offered free dancing and singing every night, the Shamrock hit back with a Grand Ball and Supper, no tickets needed. The pubs were open till dawn, and offered reading rooms

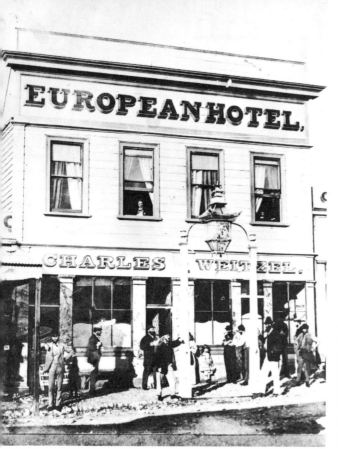

The European Hotel, Charleston, in 1868, its first year or so — the beginning of a century in the service of West Coast thirst. *Alexander Turnbull Library*.

The European Hotel, 1940, and sinking fast. *Alexander Turnbull Library*.

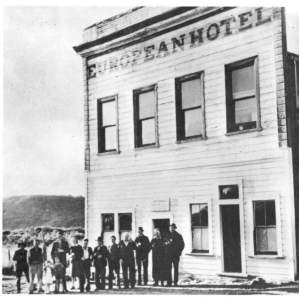

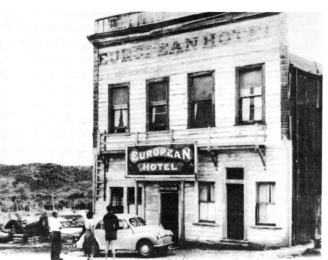

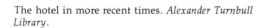

The hotel in more recent times. *Alexander Turnbull Library*.

The hotel in its death-throes in 1963, aged ninety-seven. It just saw out its century. *Pope Collection, Alexander Turnbull Library*.

for the less addled; for the more credulous, primitive movies of painted scenes from battles were directed across a stage in sections. Performers included Shakespeare Joe Schmidt and fiddler Scotch Jock and The Duck, involving ducks dancing on hot plates — the duck dancing eventually invited prosecution. Old Calamity was an early one-man band of fiddle, horn, cymbals and kettledrums. Gambling was poker or 45s, a diggers' card game from California involving legs, queer suits and Maggie, cries of "Get Jinx!" and "Go for the Doctor!" And every night of the week there was a dance, hotels employing up to ten girls, who would dance for a two-bob shout.

Charleston had Hannah's first shoe store, New Zealand's first races and a man who took out his own weight in gold.

Today holiday homes are sprouting among the ruins, with only the European Hotel still functioning. The first shall be the last, for Charles Weitzel set it up in 1867. He had it available for weddings too and, naturally, the wedding breakfasts with 150 fowls on the table and Dick Seddon among the guests. The new pub has photos around the walls that tell you how the old pub was. The proprietor tells you that the old one went over a decade ago. It was tinder dry, a Leaning Tower of . . . well, Booze.

The old hall nearby is bare of everything but a clapped-out piano. The gold city is played out too, no more now than a quiet weekend retreat.

Brighton was a smaller version of Charleston. It was reputed to be the fastest-growing goldtown of all; 160 buildings were put up in five weeks including fifty-three hotels, a wooden lock-up and courthouse. It had its own paper on 18 December, 1866, but this was soon absorbed into the *Charleston Argus and Brighton Times*.

The town had nine streets, including a Shamrock, Rose, Lily and Leek, a tactful attempt to keep the peace. Naming the town after a peaceful English seaside resort was neutral, although there is a

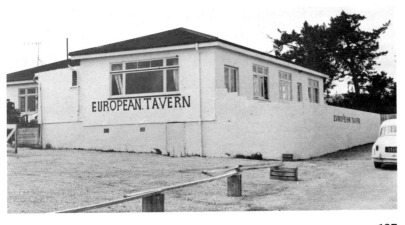

The new Charleston tavern, with the author's trusty old Rover on the right. *David McGill.*

127

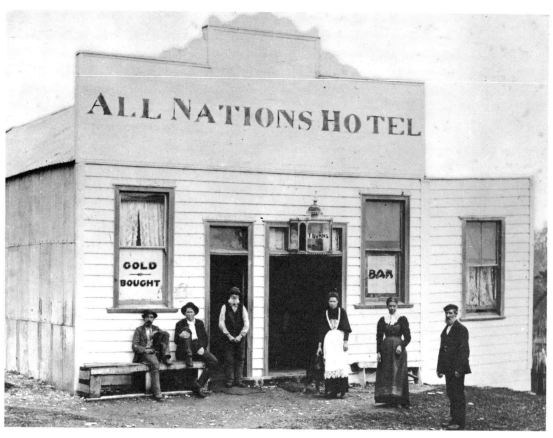

suggestion that it was at first called Bright Town. Kynnersley assessed its floating population at 5,000, but then he estimated only 3,400 in the entire Charleston area, which suggests that head counts were no more reliable than those the media make today of demonstrators.

The Foxes was Brighton's original name, after discoverer Bill Fox. It had a horse tramway and twenty snob shops, two churches, a brewery and a hospital.

Further down the coast, **Canoe Creek,** officially Pakington, supported 1,500 miners for several months during 1867. By the end of the year storekeepers were doing a round robin and shouting each other in turn, which at least kept their money in circulation.

Barrytown had 2,000 miners and eleven pubs, and name changes from Fosberry and Barryville. The All Nations Hotel is its sole surviving pub, although the school and countryside are in good nick.

This coastal strip was relatively straightforward in its goldtowns. The richest and most confusing vein of ex-goldtowns lies inland, up the Grey River.

128

14

Slap-up, shifting shantytowns
The Grey River goldfields

The Cry is now 'Rush Ho!' and away the diggers go,
To the norrad now they make their way.
And if good news comes down
We must hook it from this town
To build another city at the Grey.

Charles Thatcher.

In 1867 the *Grey River Argus* described Rutherglen as "a collection of stores, hotels, and dwellings of wood, calico and iron, put together without much if any regard for architecture". There were thirteen hotels and all those shops beginning with "b" — the butcher, baker, barber, blacksmith, bootmaker and, of course, the billiard saloon.

"Just fancy," continued the bemused *Argus* correspondent, "the click of billiard balls, a sound which is generally associated with heated rooms, flaring gaslights and dark courts, in the midst of a primeval forest. I defy the most romantic imagination to indulge in sentimental reflections when turning from contemplating the soaring pines around him he catches the words — 'Yellow on red and green's your player'."

Today this raggletaggle remnant of a town sleeps cosily near Shantytown, a neat re-creation of the way it was. This is the middle of what was the New River diggings, centred on **Marsden** just up the road. The diggings and settlements here were numbered in mere hundreds, from those colourfully-named creeks Cockabulla, Cockeye and Mosquito, down Duffers Gully and Eight Mile to Liverpool Bill's on the Waimea. **Maori Creek** or **Dunganville,** after a member of the Westland Provincial Council, had two churches, two stores and a school, but no water, which makes it a West Coast

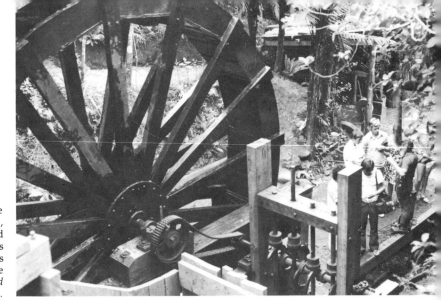

West Coast goldtowns are born again for the tourist, who can pan for gold and ask all the questions he likes for a dollar or so. It looks like the Coast's best chance to boom once more. *David McGill.*

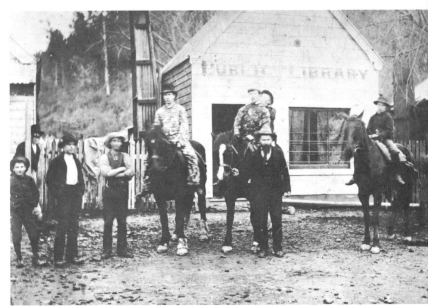

Dunganville, or Maori Creek, 1868. *W. F. Heinz Collection, Alexander Turnbull Library.*

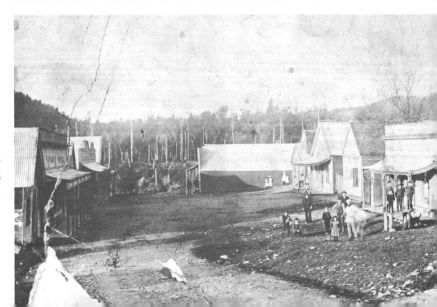

Dunganville, or Maori Creek. *W. F. Heinz Collection, Alexander Turnbull Library.*

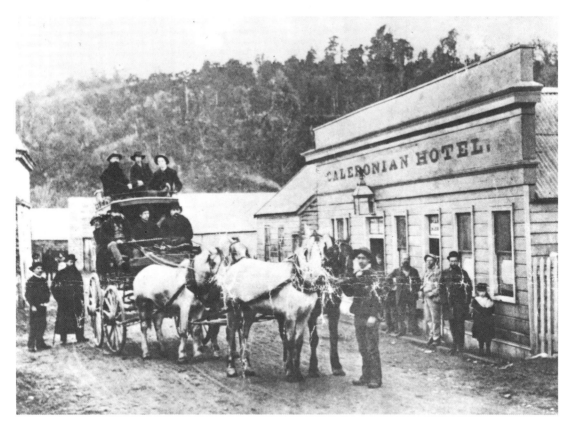

curiosity. **No Name** or **Nemona** had several hundred diggers in August, '67 and **Upper** and **Lower Welshmans** about 400.

The road, via the charmingly named Boddytown, was the '65 goldtrail from Greymouth. The coast road passes Paroa, which was Saltwater when several thousand miners worked a beach that "literally blazes with gold". There was a **Lagoon Town** just over two kilometres south of Saltwater, not to be confused with the Lagoon Town on the southern spit of Hokitika River or the Lagoon Town by Totara.

One building that is now situated in Shantytown is the **Notown** Catholic church, built in 1866 with timber shipped from Auckland. It was barged up the Grey and sleighed in eight kilometres. If anything, it is harder to get there today. Even in the middle of summer a landrover would have trouble fording some of the "streams". It's a morning's walk in, and a rather eerie one at that, as the thick bush closes into a canopy over the road in places. The township still has a few old buildings, half hidden in the bush.

The name suits it now. The surveyor was supposed to have said that it looked all right on paper, but that it was no town — naturally there was a Boswell nearby to pass on this gem.

Notown was very much a town in its day, being the centre of innumerable quick strikes. *W. F. Heinz Collection, Alexander Turnbull Library.*

Notown is indeed next to nothing now. *David McGill.*

131

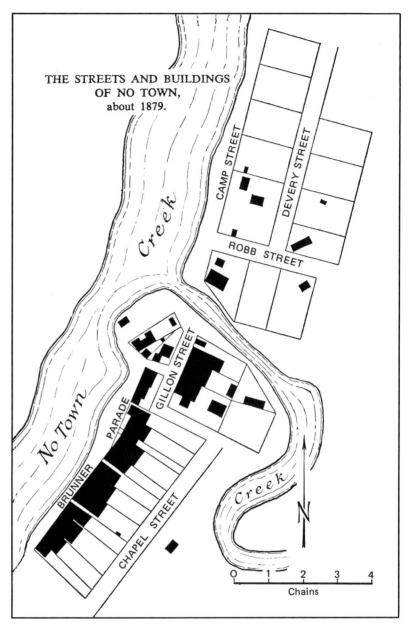

THE STREETS AND BUILDINGS
OF NO TOWN,
about 1879.

CAMP STREET

DEVERY STREET

ROBB STREET

GILLON STREET

BRUNNER PARADE

CHAPEL STREET

No Town Creek

Creek

Creek

N

0 1 2 3 4
Chains

In fact, Notown had six streets and upwards of 5,000 diggers, with twenty-five hotels to keep them happy. It was one of four townships that materialised following George Fairweather Moonlight's restless prospecting after leaving Central in early 1865. The other three were **Moonlight Gully,** which had a brewery, **Red Jacks,** named after a prospector or, alternatively, a red-haired dancing girl, and **Twelve Mile,** or **Kamaha.**

132

Settlements extended forty-eight kilometres up the Grey River, finally connecting up with the Buller River at Inangahua, of earthquake infamy. Much of these old towns has been destroyed in earthquakes; few were ever more than 500 people strong. Like the rusty, secret flow of beech stained creeks, they have dribbled away under the green embrace of the bush.

The miners brought their favoured names with them — Hatters Terrace, Half Ounce, Red Jacks, Callaghans, Golden Gully, German Gully, Fenians, Sunday Creek and Duffers. Nelson Creek held on better than most, and is still called a town in the 1976 census, although locals disagree about whether it was named after a sailor who jumped ship, or a saddler. In fact, it was initially Hatters Terrace, a hatter being a miner who worked alone, in this case said to be one John Thomas. Across the creek was the bigger settlement of **Try Again Terrace,** which had forty business premises and Roman Catholic and Anglican churches. It expected to get the road on its side, but didn't, and disappeared.

Red Jacks had 200 diggers in 1865; now it has cherry trees. There was the inevitable **Chinaman Flat** nearby, and a **Welshmans,** where they dynamited the top of the hill to get at the seam.

Twelve Mile was the river depot for goods heading up to Notown, and at one time had fifty or so businesses along its narrow, crooked street. One of the hotels was run by the Gillans, who seemed to attract distinguished guests, including King Dick himself and Mother Aubert.

Orwell Creek had a rush of about 1,000 in August, '68, according to the *Grey River Argus.* **Callaghans** had fifty miners in 1869, but it also laid a claim to introducing the foxglove to this country, this time the culprit being a homesick Irishman writing over for the seeds. The same year **German Gully** had thirty houses made of wood, with little gardens attached.

The houses were split slabs and saplings, with shingle roofs. The miners lined them with sugar, chaff and flour bags, and the flour bags were stitched together as blankets, called Adelaide rugs after the place of origination. Bunks were sacks fastened to poles and stuffed with ferns and creepers; they were said to be quite comfortable. Food was bread and stew, and roast kaka if you were lucky.

Miners kept to themselves. One old chap was leaning against his door at Nelson Creek for four days before somebody checked him out and found he was dead. Concern was expressed in the press that eight had died in the area from neglect or carelessness, a reference in the latter to men falling drunk over precipices or into rivers. The policeman there was liked but judged useless; he even allowed a prisoner to escape and continue his villainy.

Despite this, the boom continued. **Lower Nelson Creek** had six

stores, two accommodation houses, two hotels and a brewery. There was another hotel at the junction of Nelson Creek and the Grey River known as the Hammer of God; logs were pushed into its grate from outside the chimney.

Fenians was an example of the transitory nature of these settlements. This tributary of the Kangaroo had a drapery, two stores and two grog shops for the few months that the gold lasted, then the businessmen moved on. **Sunday Creek** was another.

Bald Hill and **Dogtown** nearby extended to a school, a cemetery and the well-known figure of Sugar Nan, who wore sugar sacks to the outskirts(!) of Hatters Terrace, before changing into a dress for town shopping — much the way the old Chinaman carried his boots into Lawrence, and put them on before entering town. We seemed to lose our eccentrics along with our goldtowns.

Deadman Creek had up to 100 in 1871, and an hotel and illicit still. **Camptown,** a river landing south of Red Jacks creek mouth, was known for the raffling of its two-storeyed hotel — 500 tickets were sold at £1 each. The owner needed the money to impress the Devereux family of Hokitika with the reliability of his intentions towards their daughter.

Kangaroo had 200 miners' licenses issued for it at Notown. A lot of Frenchmen worked claims at Kangaroo, and sent all their gold back to France. Peaches Eaton, who has written about the area and lives at Nelson Creek, has found salad oil bottles marked *La Paix* on the site, as well as many a bottle of Davis Painkiller, which was ninety-one per cent alcohol and a favourite hangover cure. Tommy Doolan was jailed for shooting a possum there, but not before he prophetically announced that one day people would be paid to shoot them.

Napoleons also reflected the French presence, and had its own Casino de Venise to rival Charleston's. A popular West Coast ditty, no doubt often sung at both casinos, was *The Digger's Farewell:*

> *Jem, short for Jemima, one of the girls*
> > *Up at the dance hall on the Creek,*
> *Not one of your usual sort, all curls,*
> > *Grecian bend, paint and cheek.*
> *But a quiet girl, who says one night*
> > *As I was leaning over the bar,*
> *Spending my money and getting tight,*
> > *"Jim," she says, "What a fool you are!"*

Adams Town on the Little Grey or Mawheraiti River, only achieved recognition at its end, when it was down to five diggers and two storekeepers. The storekeepers spun a coin for the odd customer, and fights often ensued.

Arnold and **Squaretown** rate recognition as busy supply depots

134

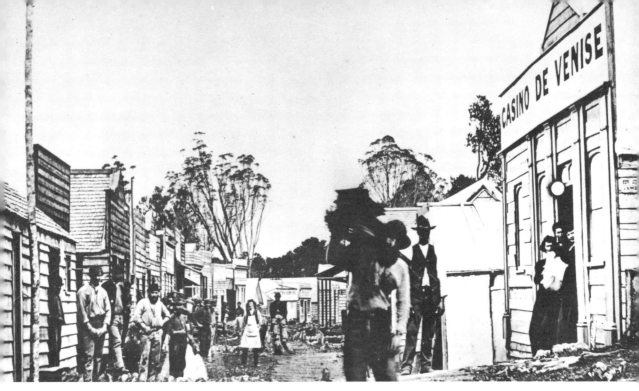

for thousands of hungry miners in 1865 and 1866 respectively. Arnold is the almost defunct Kokiri and that is fractionally better than the quite-dead Arnold Siding a couple of kilometres north, but fractionally worse than Maimai, Squaretown's later name.

Waiuta did not emerge until 1905, but it made up for lost time by becoming second in productivity only to the Martha Mine at Waihi. Its shaft penetrated 800 metres into the earth, while above, 500 or so folk lived contentedly until 1951. Now it is as complete a ghost town as you will find, with all the buildings and streets there, but the people gone. A friend of mine once heard a phone ringing in an abandoned shack, which made him just a little nervous.

Two men still live there. Aussie McTaggart on the outskirts, and Dick Willun, its unofficial self-declared mayor and postmaster, who lives in the former police station. Dick has a face like a mining disaster and a great enfolding tent of a hand that draws you in for a sherry.

"Have we had a Christmas," he declares, pouring generously from a flagon. "Sure I thought I was goin' to die. But, we came right. I've been here forty-two Christmasses, you know, but this one was almost the last. Too much gargle."

Dick shakes his head in wonder and relief.

"What was it like in the good old days, Dick?"

"They were rugged, they were tattered, they were torn. They'd give you a black eye without askin'. Yes. Then they'd give you a quid the next month, just like that."

"Who were they?"

Napoleon Hill's famous casino in Princes Street, 1866, in the much-reproduced and rather bizarre study by an early, innocent surrealist, perhaps? *Alexander Turnbull Library.*

Napoleon Hill, 1952. *Alexander Turnbull Library.*

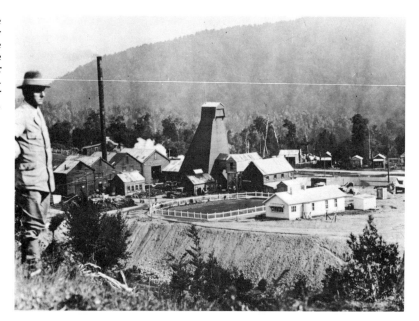

Waiuta. The four large buildings below the chimney are (from the left) the blacksmith's shop, the compressor shop, the boiler room and the winding room. Jos Divis looks on. *Alexander Turnbull Library.*

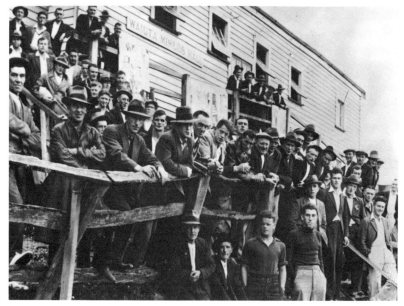

Waiuta miners at a union meeting. *Alexander Turnbull Library.*

"Everybody. Yugoslavs. Greeks. Italians. Cousin Jacks from Cornwall. There was a German, Harry Reich, a Prussian guard with a big moustache. He wanted to teach me the metric system — still got the book somewhere."

"Is there much gold left?"

"Sure there is, but what would you do with it if you got it all at once? As Mickey Savage used to say, 'Now then!'."

136

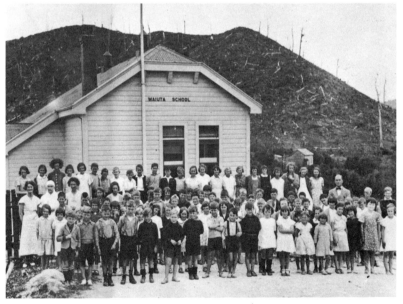

"Now then?"

"Now then!"

"Just you and Aussie left?"

"Just me and Aussie and me little dog and a fellow over there with
a family. He paints on glass. Not a bad poor bugger, but he wants a
wee bit of wakin' up."

Waiuta itself is well and truly asleep.

Dick Willun, Waiuta's unofficial mayor. Population: two. *David McGill.*

Blackwater back down the road was Waiuta's service town, and still is. Nellie Fellows is postmistress there, and has sacked Dick as postmaster of Waiuta seven times, he says. She also takes him groceries.

Nellie takes the kettle off the coal range and says that Blackwater went with Waiuta, like the cart with the horse. Now there is only a handful here. Once there were 400, maybe half Waiuta's population. They included forty Chinese, and there was a Chinese store where that paddock is across the road. Her mother was postmistress before her, and her dad worked in the Waiuta mine.

She still has her own claim, which she worked with three others during the Depression. They made £6 18s a week each from an ounce, which was rather better than the average wage of £2 10s a week. Spuds and onions were a penny a pound then, blue peas, sago and rice tuppence, so in some ways you were better off then. Apples from Nelson were a penny a pound:

"Now they import them for 50 cents a pound while ours rot! It's ridiculous. Oranges are 20 cents each and families can't afford to give them to their children. And butter has gone up!"

A strong vein of West Coast indignation there.

But when the television people came, she asked the interviewer if he'd heard of the child born in Nelson with cloven hooves.

He asked her if she was kidding.

"Noo," she said. "I wouldn't kid you, Hanafi. But the child's mother was a goat."

She roars with laughter at that. She's not complaining. There are only two on her telephone line, and the neighbour is on another exchange, so it takes a toll call to ring next door. But she still has her claim. Now the arthritis is better, she reckons she will have another dig.

Nellie Fellows, postmistress, Blackwater. *David McGill.*

138

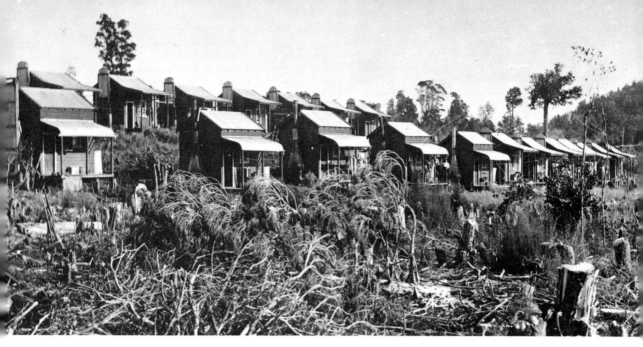

Ed Chandler has written of the good old fighting days there in *Waiuta Ghosts*. Sixteen once battled in the Blackwater pub after a sports meeting, nobody was sure why, but for sure it was a no-man-standing brawl. It only stopped when Tom Broderick got his leg broken. Then they all shook hands and had a drink, and two went outside to continue their personal battle.

There was bad blood with the Ikamatua "scabs", who had come in after a six-month strike. Waiuta had fared better, a fourteen-week strike ending in their ten per cent cut being restored.

Chandler presents fighting as a West Coast way of life. He recalls the instructions he received when a scrum was near the opposition line — to get the ball by "hooking, punching, butting, biting or even resorting to scratching". Possibly that was why Waiuta only ever had the one New Zealand boxing title holder.

Capleston on the other side of Reefton yielded the first payable Inangahua gold, in 1866. It had been called Georgetown after a local worthy, then Boatman's after a crew who jumped ship and prospected there. Finally it was called after prospector Patrick Quirk Caples, who also happened to be first council chairman in 1877, when there were seven hotels and 1,000 people. Now there are seven.

The Landing or **Emmanuels Flat** was the supply point for the Inangahua miners. A digger complained that there is "nothing here, only the bare flour, and tea without sugar . . . not a pipeful of tobacco, which commodity is as good as gold now, and unless the boats come today, the grog will be all gone, as the quality is so reduced that it would take some chemical man to know whether it is brandy or water . . . if we had something to eat we would leave the grog alone."

Blackwater miners' huts, an early example of state housing uniformity — the kind we would give our trendy teeth for now. *Alexander Turnbull Library.*

139

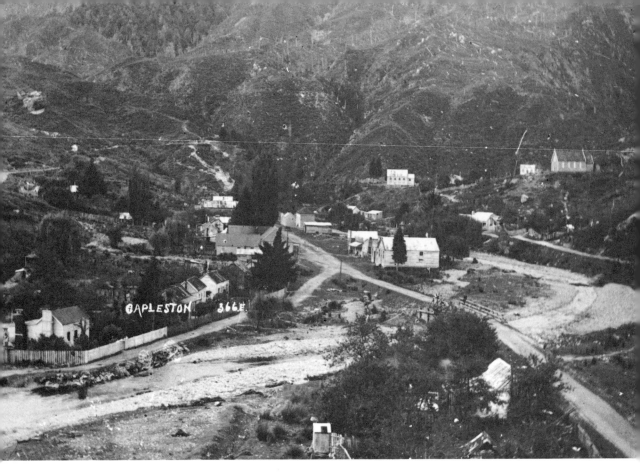

Capleston. *Price Collection, Alexander Turnbull Library.*

Kynnersley at the junction of the Buller and the Inangahua was named after the Commissioner of the Nelson South-west Goldfields, who found 1,000 men at work there in June, 1866. There were eleven stores and one woman, who had crossed the Grey saddle by horse, holding a babe in arms and with her two other children packed in gin cases slung across the animal's back.

Another **Kynnersley** was sited at Mokihinui beach in 1867. Much later Seddonville developed inland, with the Mokihinui Mine and St Helens still totalling over 300 people at the turn of the century. That had all the West Coast town trappings, the Knights of Labour and the Order of Good Templars. The *Cyclopedia of New Zealand* described it as "a distinctly sylvan little place".

Kynnersley was quite a different pan of gold, a relaxed settlement of 1,500 miners enjoying open-air bars selling "gin, whisky, brandy, rum, or anything you like". By 1883 R. C. Reid observed the typical goldtown fate: "A half-score or so of weather-worn wooden buildings, as many adult inhabitants, some children . . . the people unkempt and patchy in attire . . . in patient expectation the handful of dwellers at Mokihinui wait and watch, like the sun worshippers of old, for the first gleam of returning prosperity." An epitaph surely for all bust goldtowns.

15

The return to the wild
Around about Okarito

Ten long years since I landed here
In a trackless land of wet and cold;
Some of our times were pretty severe,
But who counts hardship, looking for gold?

The Digger's Farewell, 1874.

Okarito is close enough today to its aboriginal isolation to be a white-heron sanctuary. The wild and windswept marshes are not so different from when Abel Tasman was the first white man to sight New Zealand on 13 December, 1642. That is, except for the ubiquitous holiday baches, which are everywhere and anywhere today, and a few groggy remnants of the 1866 rush, like the old wharf shed rotting romantically into the shifting sands.

The gold miners crowded in at the end of 1865. By Christmas, thirty-three stores were serving 800 men glutted with easy gold pickings. "Everybody who does not dig sells grog," said a correspondent, "and everybody who digs drinks copiously."

And there was fighting, which the Irishmen and Orangemen were at from the word go. Newcomers were questioned about their nationality and religion, and if it was North of Ireland and Church of England, then knives, sluicing forks and stones were added to the welcome. The authorities put an Irishman, Inspector Broham, at the head of the investigating team, and he reported back on the need for extra police.

Gerhard Mueller arrived to survey a town growing so rapidly that by March, '66, merchants were paying £160 for ten metre frontages of scrub and flax at the south end of the lagoon. By April, '76, vessels had navigated this moveable port, some unsuccessfully, for sand was as easy to strike as gold in these parts and eventually spelled doom for Okarito's development as the Coast's third port.

141

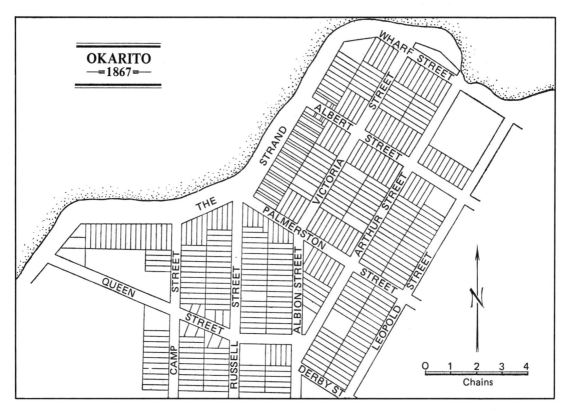

OKARITO
—1867—

The *Okarito Times* census showed 1,250 people there in March, '66, and 2,500 around it. The newspaper prospered with the region, by June being expansive enough to call itself the *Westland Observer and Okarito Times*. Its reporter observed that "selling twopenceworth of brandy for a shilling is a very paying game". Newsworthy events included one group making £1,700 each for three months work and the Bank of New Zealand having £10,000 of its notes exchanged for Bank of New South Wales' ones after a rumour likening its standing to that of the harbour entrance; and then there was the man who buried his horse in the main street. Not that that mattered, for the whole shebang collapsed in the latter half of 1866. Flax and silver pine kept Okarito ticking over for some years.

Five Mile was the biggest of the surrounding subsidiary towns, with forty stores and 1,500 miners. It stretched for three kilometres along the sands and was so rich that plumb lines were used to mark the boundaries of claims. **Gillespies Beach** had 650 miners, eleven stores, two butchers and a bakery. Settlements of about 100 men each could be found at Three Mile Beach, Hunts Beach, Wanganui Bluffs, Saltwater Lagoon, Waiho River, Canoe Point or Okarito Forks and McDonalds Creek. Warden Price counted 3,090 in the vicinity in June '66.

142

Okarito's rotting wharf. *David McGill.*

Zala Mill at the Forks (formerly Okarito Forks) about 1903. Note the mill is driven by a water wheel, a form of energy we may yet return to. *Michael Collett Collection, Alexander Turnbull Library.*

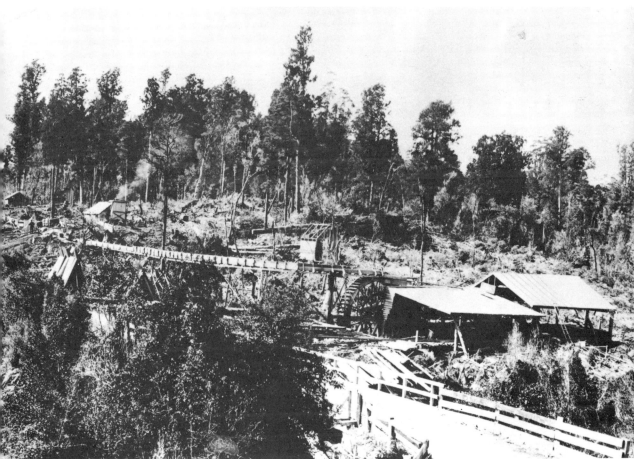

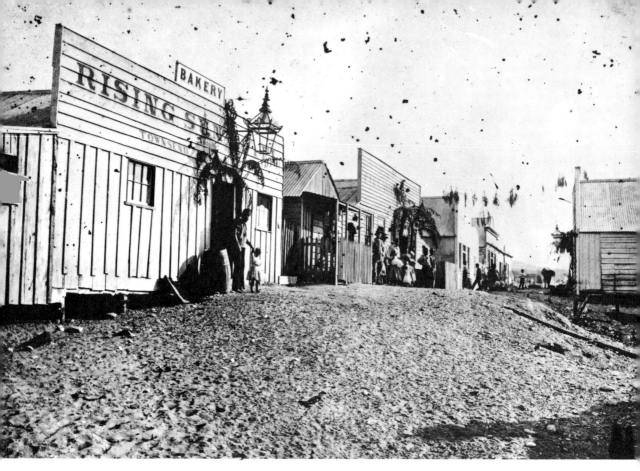

Five Mile Beach township.
W. H. Shannon Collection,
Alexander Turnbull Library.

Okarito counted three theatres and twenty-five hotels among the attractions on its dozen or so streets. The *Greymouth Evening Star* of 24 July, 1957, reported that a fire the previous week had destroyed the Royal Hotel on the Strand, the last pub in town. "It did more than destroy a hotel," said the *Star*, "it wrote the finish to Okarito itself."

Few places were plundered so quickly and so easily, although the greatest strike of all took place in 1860, when James Mackay bought three million hectares of Westland there from the Maoris for £300 — except for that bit of land around the mouth of the Grey, for which the Maoris are now negotiating a much better deal.

Okarito may not yet be down and out if some of that new brand of risktakers who are putting up a motel there know what they are doing. If? As the *Greymouth Evening Star* said on another 24 July, back in 1879, "there is very little between a man who has seen a ghost and one who has swallowed a bad oyster, so far as looks are concerned".

Hunts Duffer at Bruce Bay must go down as the briefest boom town on record, for it barely lasted a week. There had been goldhopers there in 1865, and they very nearly starved without striking. But prospector Alfred Hunt had the unenviable and rather

144

dangerous reputation with the diggers of being a great gold striker. His path was dogged, finally in March, '66, to the extent of 3,000 diggers with revolvers at his back. He led them, or they pushed him, to Bruce Bay where sapling and calico tents and store and grog shanties went up overnight. Hunt scarpered, and those who chased him perished or were found in a sorry state. The angry miners went on the rampage. Okarito Storekeeper Matthew Byrne was thought to be in league with Hunt, so his store was pulled down, his quartercasks of brandy ladled out to the mob and his hams and bags of flour scattered. Thirsty for more, they looted where they could and women were obliged to escape their attentions by disguising themselves as men.

Haast and Okuru were goldtowns briefly in 1867, but it is necessary to jump forward to 1874, the year of *The Digger's Farewell*, for the Coast's last great gold rush, at **Dillmanston.** This late entry in the gold stakes came to light up the road from Kumara when a search for an illegal whisky still brought the bright, fine stuff to the surface. The riproaring times were revived, as 3,000 miners poured in and the moonshine whisky was poured down along with the legal variety; the girls got back their taste for cold tea as the price they paid for their percentage of the drinks they could con out of the darlin' diggers.

In 1883 "Vagabond" thought it looked like parts of Nevada and

Dillmanston in about 1880, its name and status yet to diminish. *Alexander Collection, Alexander Turnbull Library.*

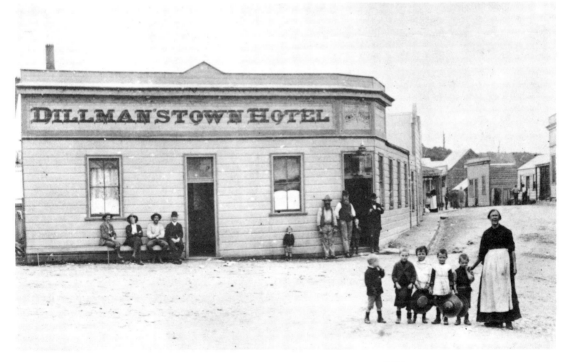

145

California: "Great flumes run across the road. Races, tailraces, sluice boxes, sludge channels — everything as one sees it on the Pacific Coast . . . Dillmans Town is not very extensive and the architecture is of the primal digger order, every house having an iron chimney built outside."

In 1890 Mrs Robert Wilson was even less impressed: "A total lack of refinement and taste . . . in the way this town is built, with sluices running through the streets, forcibly suggesting the idea that the one passion common to the whole population is a desire to find gold quickly, plentifully, and then go."

Never a truer word was spoken in earnest, judging by the few sorry old wooden houses left.

As Dillmanston was developing, hundreds more Chinese were coming onto the Coast, following, as usual, over the fields that the Europeans had abandoned in their haste and greed. While the Chinese worked over old claims, Seddon, in 1879, launched his political career on the Coast by working over the Chinese. They were a race "you cannot reason with". What was worse, apparently, they were in competition with women as well as men, for they were cooks and washerwomen! He wanted them sent back where they came from, all 1,260 of them — then, as now, in times of downturn scapegoats are sought.

Charlie Douglas spent thirty years exploring the Coast and he directed his contempt at the gold settlements. There were three stages. They began as calico towns, the sardine tin and broken bottle era. The weatherboard and sheet-iron period followed, with the bottles neatly stacked around the hotels. Finally came the borough, where "the inhabitants go to church, or chapel, and drink their stimulants at home out of a keg". Few made the final stage.

Reuben Waite had a more wishful view, that the power of gold would transform "the bleak and sterile wilderness to a region of luxury and wealth".

Douglas was more accurate, though Waite may have helped in the short term with his sowthistle and "coarimika" cures for scurvy and diarrhoea.

The Coast folded in on itself, burying the goldtowns in a dense green shroud. The surviving towns went on to timber, like Okarito, or coal, like Blackball, while the Coast itself retained the rough, brawling image of the gold days. Philip Ross May has come to the defence of the Irish here, pointing out that they received no more convictions than any other race.

But in many ways the Irish defined the flavour of the Coast, and no way more pleasantly than in the narrative flights of humour its newspapers favoured. Like the young lady who ate half a wedding cake and then tried to dream of her future husband. Now she says she would rather die than marry the man she saw in that dream.

146

16

The Coromandel crush
The true beginnings of the gold rushes

They say at Thames they find gold in quartz.
Pints will do me.

The first officially-discovered goldfield in New Zealand may have been a jack-up. Charles Ring got the £500 reward in October, 1852, and he still gets the credit in the plaque outside Coromandel. What the plaque does not say is that in Auckland in September, 1852, this sawmiller, who had turned prospector and had just returned from California, was actively promoting a reward committee and a larger reward for finding gold. He then went back to the Coromandel and returned from there to claim the reward for himself.

Alistair Murray Isdale offers the evidence, and he has spent a lifetime panning out the information on the Hauraki goldfields. He has made the museum at Thames a mine of information, and his own efforts include 10,000 pages of singlespaced notes culled from the newspapers of the day.

There is no question that Ring inspired New Zealand's first goldtown in 1852, known variously as **Driving Creek,** Upper Township, Upper Coromandel, Top Town, Kaponga Stream and Coolahan's Diggings.

Alexander Richard McNeil was born there on 4 February, 1881, in a little two-room shanty, smack on the line of the first ore body in which gold was discovered in New Zealand. The country's first two goldmines were here, and the first of many Tramway Hotels. It is overgrown or farmed now, but you can find it on the road fork left on the way to Colville and up the valley from the Whangaraho Stream bridge where Charles Ring struck. McNeil recalls the noise of the stampers beating out almost unceasingly day and night for the first fifty years of his life, for goldmining in the North Island was a quartz-crushing business, not a simple digger effort. Ring had known this and he knew that capital was needed to buy machinery to develop the Coromandel gold, and £500 would do for a start.

As the *Coromandel News* put it in October, 1887, there are three degrees of mining speculation: "Postitive, mine; comparative, miner; speculative, minus".

Driving Creek had, for a brief period, its own pen and ink paper, the *Coromandel Observer*. There were about 300 there initially. Isdale says the figure of 3,000 was absurd at a time when Auckland's entire population was only 7,000. The first rush of miners moved on after six months, disappointed at the results of their traditional surface-sluicing methods.

When machinery revived it, the township had several stores, a bootmaker, a barber, Mrs Kneebone's drapery, a butcher and the Tramway.

Sam Chapman has written of the township that developed up on the saddle at a height of about 250 metres, known as **Tiki Hill,** with an hotel, butcher and shanties. He also refers to the town of **Tiki** three kilometres on the Thames side of Coromandel.

North-east out of Coromandel takes you to the dizzying heights and howling winds of **Tokatea,** a goldmining settlement of 1869-71, when there were several hundred miners and a pub there. Locals tell you that even the hens were bent over several degrees as they crossed the windy saddle. The place today offers picturebook views in all directions, but the holes in the hills seem more suited to rabbits.

Opitonui is fourteen kilometres east of Coromandel. There is hardly a trace left of the township of 1,000 or what was once the biggest battery in the Southern Hemisphere. This was part of the Kauri Gold Fields Company's lavish development in 1900, which included its own sawmill and a steam tramway to Whangapoua. The concrete bullion strongbox lies in a field; a mere 933,000 grams passed through its protection, considered poor by comparison with the 2,800,000 grams found over the hill.

Tokatea Hotel, about 1880.
Was this also Tiki Hill?
Alexander Turnbull Library.

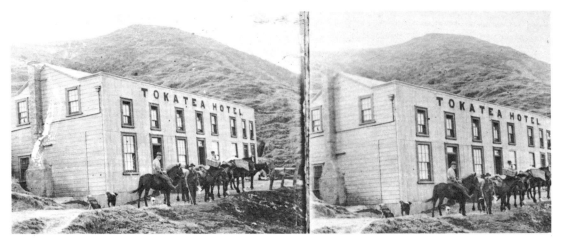

Opitonui was a bigger settlement than Coromandel is today, but all traces have disappeared under the Forestry Department planting and Keith Catran's farm.

A peacock flaps on to a farm gate. "Just there," says Keith Catran, "was where a shopping centre was planned. There were tennis courts next to it. In fact, the English gold company still own the road."

Forestry land rovers are the only regular traffic along it now. One kilometre up young pines have hidden L. D. Nathan's cellar, on the corner of West Esplanade Terrace and Taylor Street. Keith knows the area like the back of his big, chipped hands. The Maiden Mine is still up in the hills behind. It went down 120 metres, and most of it is in water now. There are also twenty or so wells in the area, overgrown and full of water, probably full of bottles from when the place was abandoned and, perhaps, some of his cattle.

"Wasn't there a story," he asks darkly, "of one of those taxmen snooping around and disappearing down one of them?"

Pat Hawkeswood was born at Opitonui one year after the town itself, but now he lives over on the main gravel road. He reckons the miners, notably Bates and Guthrie, ripped off the company; they cashed all the company cheques and lit out for America. Catran has supporting evidence from the managers' quarters, where he has found the little crucibles in which the managers burned the midnight gold, secondary employment at the expense of the firm and the government. The company eventually closed because it was losing so much money, and Pat's father, the butcher, was one of the businessmen left behind holding the miners' promissory notes.

Pat was five when the mine closed "on good gold". He remembers two hotels and any number of pig and whistles. Martin Heenan got six months jail for running one of these sly-grog shanties. The town also had a store, shoemaker, school and hall.

Kuaotunu is further along this road on the coast, and it had as substantial a gold settlement as Opitonui. It has become a popular beach resort, but its two subsidiary settlements have gone, the **Junction** town, or perhaps suburb, where the road branches into Pumpkin Flat, and the **Upper Township** three kilometres from the beach.

The Junction had a school, library and two churches, a band room, a boarding house, a store and houses. Irishman Joe Dyer lived there on Just in Time Road and is remembered for his Irish jig and his hospitality calls on neighbours. The children would take advantage of his homeward wending state; he invariably assumed a Quixotic posture with his legs stiff and pointing out towards the horse's nose, as if they were shafts. One time the lads reversed his saddle, which caused him to exclaim upon mounting: "They've cut the head off my horse."

Opitonui's main street!
David McGill.

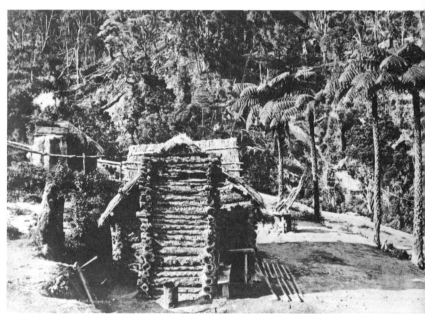

Digger's hut, Punga Flat,
behind Thames. *Zak
Collection, Alexander Turnbull
Library.*

He was the butt of the miners' jokes too. They boobytrapped a log
with dynamite and blew out his chimney. They substituted a piece
of quartz for the beef he was boiling, and he poked it and wailed:
"It's all bone."

Robert Stone Marshall Dorrin of the Upper Township also had to
endure child baiting on his reeling way home. "Bob, Bob, with the

150

rusty nob" they would chant. One day he pretended to be drunk, was baited, gave chase, and caught one of them. The thrashing put an end to their cheek; not as drastic a solution as the boys in the Bible who laughed at an old man and were eaten by a bear.

An altogether tougher identity was Dick the Hard-Head. He would wager that he could split open the panel of a door with his head; the wagers were said to be the main source of his income.

The Upper Township had a butcher, two bakers, two boarding houses, two batteries for crushing quartz, two stores, one with a post office attached, a draper and a dozen or so dwellings. The foundations of the hotel are still there.

Punga Flat takes a lot more finding. This 1867 goldtown a few kilometres behind Thames is so overgrown that you need secateurs to get in. Seriously. Alistair Isdale uses secateurs on all fours in pursuit of its past. A slasher, he explains, is useless against supplejack.

There were 200 there in the late '60s. The children went to school, but the headmaster went home and got drunk. One day the lads abandoned work in favour of setting light to the schoolmaster's shack; he survived, and then it was his turn to set them alight.

Father Nivard went up to visit his Irish flock there, and asked them what their mine was like.

"Well, Father," they said, "she's little but there's plenty of gold."

The good Father thereupon christened the mine "Multum in Parvo" — "Much in Little". Indeed. Two men won £8,000 from this area of 1,300 square metres.

These were petty bourgeois fields of little plenty. Some of the many claims were Eldorado, Harvest Home, Jamaica, Marquis of Waterford, Mocking Bird, Ruby, Vale of Avoca, Star of Fermanagh, Southern Pacific, Deeside and Great Republic. They all went well to 1874, and then staggered on to 1908.

Charlie Boxall stayed on until his death in the early '70s. One of his last deeds was a defiant objection to putting a bulldozer through Punga Flat. He said it would prolong his journey home on pension day, because there would be more width of track for him to weave across.

"Why," asked the *Thames Advertiser and Miners' News* of 7 July, 1870, "was Eve not afraid of the measles?"

"Because she'd Adam."

Measletown came five years later. It must be as inaccessible a place as there is, 800 metres up in the ranges behind Puriri; but miners, like magpies, dart off after any bright object. Their gold-fevered eyes turned south in 1875. Their horses stuck in bogs and fell over cliffs, and the compounding problem of a measles epidemic gave the new rush its name. It took a month to get goods there from Thames, around the coast and up the Tairua River.

151

Wind and rain caused most of the miners to pack up that first winter. Those left on 11 June, 1875, were hit by a storm that was reported in a graphic manner: "The residents of Measletown were quaking with fear on account of the proximity of big trees . . . the crashing of falling timber and the terrible soughing of the high branches of stately kauris." All except a few hardened gumdiggers pulled out, and slid and tumbled through mud and waist-deep water to the pub at Puriri.

The town site was shifted to a slightly better position and named after its discoverer as **Neavesville,** or Nevesville. It had taken this gumdigger six years to strike gold, and it took the man who had employed him, Jackson of Tairua, a gargantuan effort with pack-horses and corduroy tracks to open it up, but to little avail. Today the battery that was never used rusts away, for the big suction gas engine could not suck at 800 metres. Most of the miners moved further south to the Ohinemuri goldfields between Paeroa and Waihi.

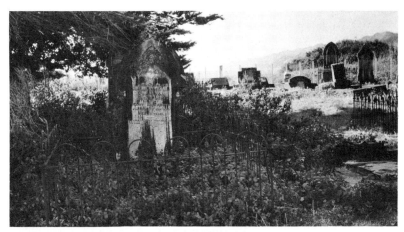

Thames graveyards — relics of man and machine. *David McGill.*

152

17

Waitekauri every time
Ohinemuri goldfields

Inspired by leadership of Mackay,
A camp of tents became a town,
And lights lit up Karangahake,
While batteries thundered its renown.

Karangahake, by Nellie Scott-Climie.

10 am, 3 March, 1875: "We can see clouds of dust — horsemen riding here — Edward Howard has just pegged out — horsemen are flying over the ranges — men are running to meet them — Payne and Cashel have pegged out — there is a cloud of dust all the way to the camp — behind the first horses are men on foot in relays — a Maori has won the race and is first on the ground with his rights — John Riordan and Pat Donnelly are here. . . ."

It could be a film script; it would make rather a good one. It is the *Southern Cross* reporter on the scene of the rumbustious beginnings of **Karangahake,** as crazy an occasion as anything that ever happened on the Yukon or in Hollywood.

It turned out to be a fools' race, for they all ran to the wrong place. It was a repeat of the Coromandel goldfield, a duffer for traditional diggers. It took another seven years before the machinery began to crush the gold out of the Ohinemuri. In fact, the area had been mined illegally since 1865, but the Maoris held out against the growing tide of rapacious Pakehas. James Mackay had the task of getting the land from the Maoris before the Pakehas took it. In some ways he could be seen to dupe both sides.

By initiating loans to the Maoris he got them into such debt that they had to sell land to pay it. When the *Government Gazette* announced that 3 March, 1875, would be opening day, upwards of 3,000 Maoris and Pakehas pitched tents on what was called **Mackaytown,** naturally. There were twenty stores to cater for their impatient eating, drinking and merrymaking. In the final result, it

153

The remains of Karangahake.
David McGill.

was a rather frantic example of racial harmony. Gold brought the races together again.

Mackaytown had first to fight for its name against Te Kahakaha, Williamstown, Fraserville and Lipseyville, which was often reduced to Tipseyville. The warden was Fraser, not a popular man. (He once sentenced a seven-year-old boy to jail.) His family proceeded to church preceded by a lad in uniform carrying the family bible. Mrs Fraser swept up the aisle as if conferring a favour on the Almighty. The locals finally got rid of him by voting him into Parliament.

Mackaytown's recreation ground also served Karangahake, which was short of flat land; miners from both towns locked in rugged football clashes. The town's first pub was made hurriedly from packing cases. The new hotel in 1898 boasted eighteen rooms, a dining room for sixty guests and a stable for fifteen horses. Within two decades Mackaytown was no more, its pub gone to Waikino, the post office to Hikutaia, the band rotunda to Paeroa, and the miners' hall to Waihi. The rest of it went up in smoke, so regularly that insurance companies refused to pay out on claims.

The school roll had reached 480, rather higher than Karangahake's, although its school is still there. Little else is. While Mackaytown has a new suburban growth out of Paeroa merging around the old buildings, Karangahake is little more than a picnic stop, with goldmining for fun across the river where the mines were.

By 1900 Karangahake rather fancied itself, with its line of elegant cottages and villas stretching out of town. There were several hotels, a coachbuilder, a blacksmith, five butchers, four drapers, a baker, a plumber, a hairdresser/tobacconist, an ironmonger, two chemists, two fish shops, a mercer, a tinsmith, four stationers, five

154

general stores, two tailors, two boot repairers, John the Chinaman's market garden, a newspaper taken over by the proprietor of the Dustpan and an ironmonger/stationer. The town had a volunteer fire brigade, its own sawmill and a horsedrawn ambulance. Hotel keepers had encouraged the establishment of a town water supply because they feared that patrons were slaking their thirst en route to the pubs. There were churches for Roman Catholics, Wesleyans, Anglicans and Presbyterians. The local brand of "Monkey" soap was advertised as *not* for washing clothes.

Karangahake's heyday was in 1910, by which time it had 1905 All Black George Gillett, a gun club, hockey, tennis, bowls, croquet, boxing and wrestling. The hill was still a killer for the poor horses and the river ran white with the cyanide used in crushing the quartz. Then there were no conservationists around to object.

Mackaytown. *Price Collection, Alexander Turnbull Library.*

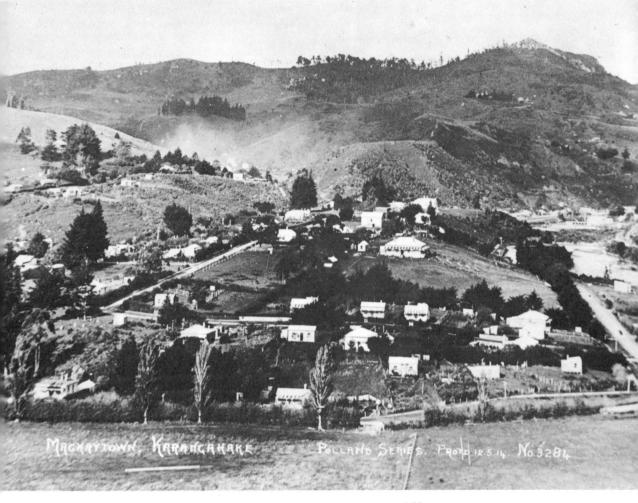

Entertainments included the harmonium, tin whistle, fiddle, concertina, music box, piano and the new and very popular phonograph. There were conjurors, waxworks, lantern shows, weightlifters, performing animals, trick cyclists, female impersonators, stockwhip experts, acrobats and bellringers. While watching, you could suck on boiled sweets, acid drops, aniseed balls, changing balls and conversation lollies, or hoe into chocolate fish, honeycombe, raspberry and caramel bars and liquorice.

The rather nasty sense of humour that was part of the Chaplin era came out in the clipping of a dog to make it look like a lion, while its owner was in the pub. When he comes reeling out he takes one look at the dog/lion and runs for his life, with his faithful hound bounding happily after him. Next day he is out with a gun — looking for the dog-clippers.

Karangahake had a brass band, visiting lecturers on Christ's Second Coming (a popular topic at the turn of the century) and visiting plays like *A Woman's Sin,* described as a comedy with humour and pathos, although the vengefulness of the husband sounds today more like tragic bathos. *The Shirt My Mother Gave Me* was a comic song and *There Is A Flower That Bloometh* was not — the weaker sex was always good for a laugh, but you didn't flirt with flowers.

In 1907 Karangahake petitioned to become a borough, and failed. This was as well, for a decade later it had ceased to be. There might have been a warning in its 1908 vote to go dry, which was intended to teach publicans a lesson for charging more than those in Thames. Karangahake had a population of 2,000 making it almost the size of Thames. Now its kauri homes serve out their time as haybarns.

George Chappell, who died in 1977 at the age of ninety-seven, handled £50,000,000 worth of gold at Karangahake. He was chief assayer and then Superintendent of the Battery. He slept above the Talisman mine strongroom with a Smith and Wesson under the pillow, and a policeman nearby with a Colt. He had every reason to think that care was required, for he had arrived in Karangahake in 1897 and passed eight fights on his way to work. The two pubs were open twenty-four hours a day with two-up schools going outside most of the time. Disputes were fought out on the recreation ground, the policeman keeping well clear; he was hardly needed, for wrong uns were run out of town. Gambling was pandemic; George recalls betting on two matchsticks floating down a stream. He only had one occasion to fire in anger, when he woke suddenly one night, saw a movement and blasted the mirror opposite his head to smithereens.

A popular song of the time was *Waitekauri Every Time,* a reference to the other substantial Ohinemuri goldtown that is no more. **Waitekauri** means "a pleasant place nestling among the hills". The

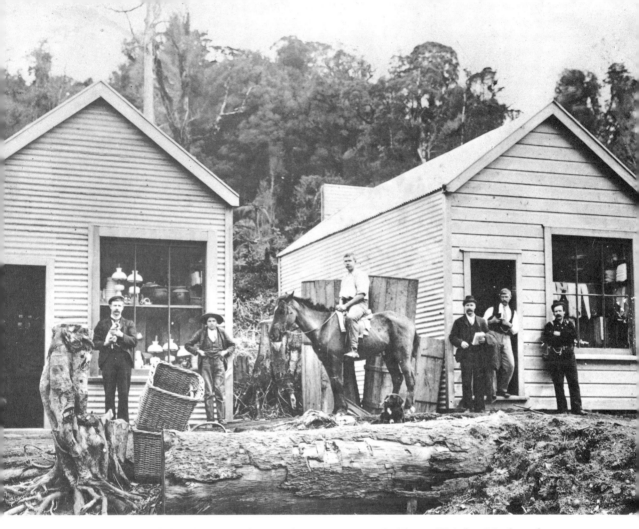

only indication left of the pleasant place is the signpost to Golden Cross Road and a concrete strongroom making an effort at surviving in a field, like the one at Opitonui. The local farmer had to bulldoze the mine kilns a while back because they were becoming a danger to his stock.

The town was supposed to have had the biggest water wheel in the Southern Hemisphere, which is probably an over-used and certainly a rather vague phrase, for that effectively means that we had a bigger wheel than the Aussies and the South Africans, and that's all. Although the battery got going in 1876, the town took another twenty years to stamp its mark. A feature of its early days was the residence of Charlie Bunting in a hollowed-out kauri log, four metres wide by two metres high, with walls two-thirds of a metre thick and declared by its occupant to be cool in summer and warm in winter.

The town had two hotels, the usual basic business premises, including a chemist and druggist, a builder, plumber and iron-monger, a pork butcher and two beef and mutton butchers,

Waitekauri in the early 1900s. The shops belonged to G. Marshall. *Alexander Turnbull Library.*

157

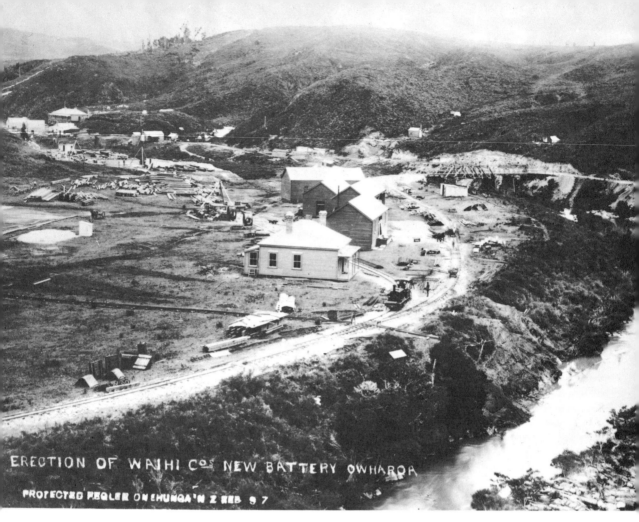

ERECTION OF WAIHI Cos NEW BATTERY OWHAROA

PROTECTED PEGLER ONEHUNGA N Z FEB 9 7

Owharoa battery, on the outskirts of Waikino, no more than a bridge now on the way to see the celebrated local lily ponds. *Waihi Art Centre Museum Collection, Alexander Turnbull Library.*

a saddler and harnessmaker, a baker/confectioner, a news agent/stationer and a boot and fancy goods importer. There was a hall, school, post office, jockey club, fire brigade, Roman Catholic church and newspaper.

In July, 1896, the Goldfield Co-operative store was established, with departments for groceries, boots, ironmongery, explosives, mining requirements, crockery and drapery. In such an egalitarian atmosphere and mindful of the recent depression, a ditty of the time ended:

> *As I think of the divvies in London*
> *And the bust up farmers here.*

The Goldfields Co-op established a branch at **Golden Cross,** the Upper Waitekauri near the mine-site. It had a draper, two butchers, a baker, a billiard saloon and a school with fifty-six on the roll, a recreation ground carved out of the bush and a population of 400.

Waitekauri, but only for a time.

158

Waikino survives as a delightful tourist mine town, but it is only half of its former self, for it once spanned both sides of the river. Nearby Owharoa and Rotokohu south of Paeroa had small rushes in 1875 and, in 1887, there was one at Maratoto above Waitekauri. Te Aroha came into gold in 1880, and a year later the goldtown of **Waiorongomai** was established five kilometres south. By 1900 it still had a post and telegraph office, a school, stores and a hotel that would seat 100, some indication of its brief boom.

The half of Waikino that did not survive. *David McGill.*

Komata Reefs developed in 1891; its quartz was at first sent to Waitekauri, then processed locally and carried by open buggy twice a month to Paeroa a few kilometres south. The school roll reached 100; the town had a butcher, grocer, post office/store, Chinese garden, racecourse, miners' hall, and occasional visits by Catholic and Methodist ministers on horseback. Sly-grogging kept their thirst in check, but by 1904 they had done their dash.

These northern goldtowns were peopled by wage earners. The times were more civilised and less lighthearted. "The near future is always a long way off," mournfully advised the *Waihi Miner and Hauraki Goldfields Gazette* of 1 October, 1895. "It never gets here." Modern times, civil times, depression times. The rollicking, carefree diggers who roamed the Mainland were never imported across the Strait except, perhaps, in those jabbers after the liquid gold, the gumdiggers of Northland and Coromandel.

Komata Reefs reverting.
David McGill.

160

18

Gum, gum, gum
Coromandel's kauri capital

When the tui sings, we'll be rich.

Coromandel gumdigger saying.

Neavesville also had its time as a gumtown, or rather, gum-camp. Kauri gum is unique to Northland and the Coromandel. The gumdiggers themselves were rather unique for being largely disaffected political refugees from the Austro-Hungarian empire, initially called Austrians, later and universally Dalmatians — Dallies to us kids in the Henderson area of Auckland, where so many of them settled to wine production. Gumdiggers were also rather unique for being content to live, as my mother put it, on the smell of an oilrag. They were voluntary tramps, preferring camp to town life. Bill Havill, who died in 1974, has described his carefree stint as a gumdigger at Neavesville in the 1920s, and this serves well enough to represent life on hundreds of these northern camptowns.

He set off with a friend, a five-kilo sack of flour, 500 grams of dripping, an axe, a frypan, tobacco, matches, tea, sugar, billy and a blanket apiece — the minimal and typical makings of a digger's life in the temperate north. Breakfast was flapjacks and sweet black tea; so was lunch, and dinner. The bush shanties there were grouped around the pub and post office, these two early signs of civilised life in fact vestiges of the gold days and not typical of a gum camp. Naturally the shacks were made of kauri palings. Beds were sacks nailed over four by twos. The pub was the centre of communal life, offering bread, stews, pastry even, and rollicking songs around the fire to the tunes that somebody tugged out of a button accordion, helped along by beer chasers. The beer came in twenty-litre kegs along with the meat and other supplies brought up by packhorses once a week from Puriri.

Bill observed three ways of harvesting gum. The daring helped the process along by climbing the kauris with hand hooks and toe

161

This man is not peeling potatoes, he is doing the next worst chore — scraping gum. *Alexander Turnbull Library.*

spikes, cutting the bark and leaving the green gum to bleed and harden for six months. The experienced used one or two-metre long gum spears. The least skilled paddocked with a spade, dragging dirt through their feet like a dog. The nut-bag was a sugar bag around the waist to hold the gum; they received 2s a pound if it was good, 1s 6d if ordinary. The Northland fields developed the washing-machine approach to harvesting gum chips. The Coromandel settled for extracting the best quality gum.

Gumtown was the gum and timber centre for the entire Coromandel, and was the only town north of Thames to number its population in the thousands. Its development came in the 1870s, after Whangapoua had had its boom as timber supplier to the Thames goldfields, long after Mercury Bay had first supplied spars for Nelson's fighting ships in the 1830s. A mill was established there in 1862, near the ferry landing across from Whitianga.

In 1864 a mill was established thirteen kilometres up river from Mercury Bay at a place drearily named **Upper Mill.** A settlement developed around the mill kitchen-cum-hall, including a bake-house, carpenter's shop, blacksmith and a store that was never locked. The men, millworker David Hamilton told the *Thames Star*, were "old soldiers, sailors, etc., rough men perhaps, but with hearts of gold and strictly honest".

162

Kauri gum sorting, about 1900, at Michelson and Company, Auckland, where the big profits were made by the middle men. First there was the problem of sorting over 200 classifications of gum. *Alexander Turnbull Library.*

Gumtown was five kilometres up river, the river being the only access for many years. In the '70s thousands of bushmen, gumdiggers and businessmen literally poured into Gumtown up this tidal reach. The coalfired boat *Little George* did a weekly run of mail and men, and a barge was specially built to carry the gum. The bushmen were earning $4 a week then. For that princely sum they took leave of civilisation at Gumtown, for as much as a year at a time. Packhorses went out daily to the camps with supplies, and came back laden with gum. Timber was floated out, although that is a polite word for the commotion of a log-drive once the plug was pulled on a jam-packed log dam. All the kauri came through Gumtown, estimated at over 2,000,000 cubic metres sawn; put end-to-end this would make a log plank from Auckland to Invercargill.

The diggers would appear to be a livelier lot than the axemen if their camp names were anything to go by — names like Rat Camp, Starvation Camp, Welcome Jack, Potomac, Bulls Run and No Gum. These camps had upwards of 100 men each, but were without any of the most minimal services. Even Gumtown, despite its key position, was a slow developer. It finally got a pub in 1881, a post office in 1887, no bakehouse until 1904, and then they brought up the bricks from the Upper Mill five kilometres downstream. By then

163

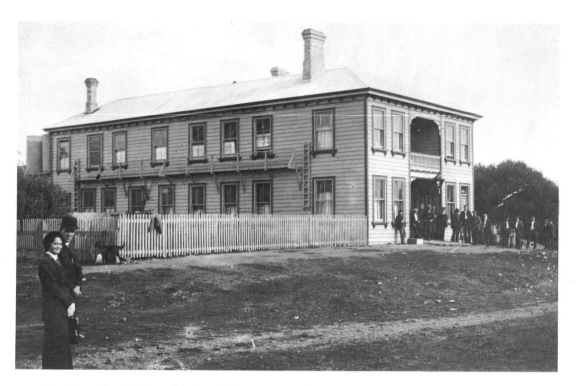

Gumtown Hotel, 1913.
Alexander Turnbull Library.

this frugal boom town also had three stores, two boarding houses, a hall, stables, carpenter, blacksmith, saddler, shoemaker and a billiard room. True to form, Gumtown even got its own races, with bookmakers to boot. Touring concert parties came, and the place even featured a minor gold rush in 1898; it had little effect in the peak years of the gum trade, with a high the following year of 11,000 tonnes.

There followed a boom decade with £2 million worth of production made annually, then the decline from the First World War, when synthetics killed the market. Britain and America were the primary importers, and their needs peaked at 10,000 tonnes; New Zealand had created a world glut. This made Gumtown the capital of the gum world, but did not inject much pizazz into the proceedings. The Dalmatians were a sober, hardworking lot whose needs were slight; when they needed a tooth attended to they went to see Gumtown storekeeper John Peebles, who laid them out on the floor, put one knee on the chest, got a grip on the tooth and pulled.

Facing page:
Passengers disembarking at Gumtown in 1913 when the river was the only reliable means of transport in and out. *Alexander Turnbull Library.*

The *Little George* mail launch and lifeline for Gumtown in 1913. Standing is Frederick Meikle, proprietor of the *Little George.* Arthur Meikle is sitting hatless. *Alexander Turnbull Library.*

In 1922 Gumtown was adjudged "unsuitable for a progressive farming community" and **Coroglen** became its new name. With the name went almost every vestige of Gumtown. Today there is a pub and a kind of a store at the crossroads. The store advises you outside "to leave your cigarettes and concepts at the door". It would appear

164

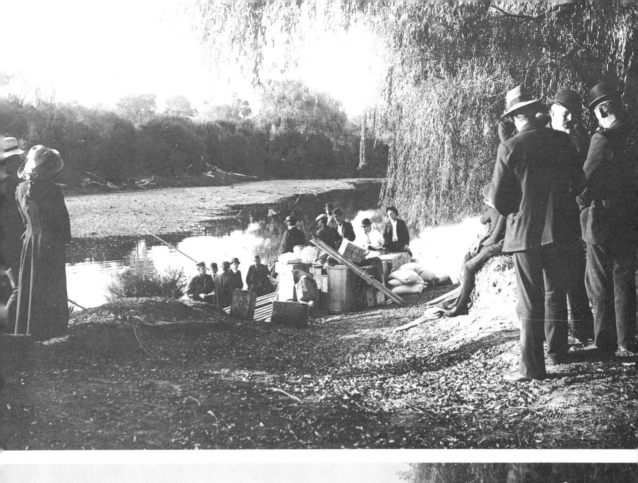
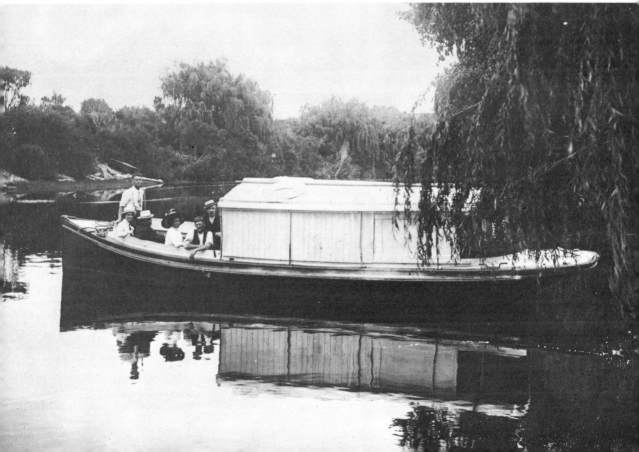

Coroglen does not seem to be doing too well despite ditching its original name of Gumtown, because this was thought to be holding back progress. *David McGill.*

people also leave their cash outside, for the herb buns aren't selling and the place was up for sale when I called. Even the "Alternatives" are not making a commercial go of the place. But I can report that the sunflowers are doing well and that the tui is back.

Further down the road at Hikuai's solitary store the old chap in specs and braces is leaning on the kauri counter doing the farmers' accounts with a moistened pencil.

"Got any iceblocks?"

"That's about all we have got," he says. He gets the iceblocks and adds that nothing much has happened here since the early part of the century.

It was 1923 by the time they had taken out the last great Coromandel kauri stand, those stands that one of the first exploiters back in the 1850s described as "places of unsurpassed grandeur". We will never know what one old-timer has called "the indescribable fragrance of a kauri forest". The Coromandel needed so little time, so few tenants and such meagre town trappings to clean it out completely.

166

19

A fine collection
The diggers of the north

Upon a Maori gumfield,
 Leased to a pakeha's store,
Was camped a band of diggers,
 With no supplies for more.

The Florentine, by Andrew Turner.

Ahipara the gumtown is thirteen kilometres above the present beach resort west of Kaitaia. You climb steeply and drive across a chalky blasted heath to a few tin sheds. A century ago there were 1,000 here, today it is the residence of the country's last professional gumdigger, Tony Yelash from Yugoslavia.

Tony is crouched over a water barrel.

"Hey!" he says, "you catch me by surprise." He holds up a dripping pair of patched trousers: "These my winter ones. Sometimes, you see, I must wash. Come, we leave them, I show you round."

His accent is as thick as his grizzled chin. He looks as solid as a kauri and his eyes dance like the polished chips of gum he keeps in bags in the tin sheds, waiting for the price to double from $30 to $60 a bag. He reckons there are 10,000 such coalsacksful out there in those 250 arid hectares.

Two little terriers trot behind Tony as he ambles past his vineyard down to the orchard, which was once the gumtown of Ahipara. A big black bull and a small black cow are its inhabitants, and they only have eyes for each other. Tony has made a Findhorn out of his patch of wilderness which boasts lengths of luxuriant grapevines, fields of watermelon and rockmelon and a flourishing vegetable garden.

"See those trees," he says, pointing, "There was a shop. By the bull, that was a billiard room. We had a fire brigade, and dance halls."

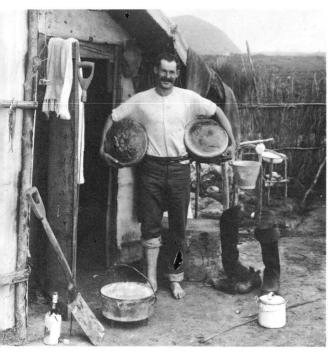

Above: Urlich's Bakery, Ahipara. *Alexander Turnbull Library.*

Tony Yelash, our last gumdigger, points to where Ahipara gumtown once was. He is pictured with his parents, in his vineyard and with his dogs in his gumfields. *David McGill.*

There were stores, an hotel, a postmaster, gumbuyers, and a school. Now there is just his residence, the dingy old-style bedsit, with wooden boxes and a wooden settee and the smell of old sacks. On the walls photographs brown and curl up. The flat wide fireplace dominates. There he makes his bread, big four-pounders rich and yeasty, not like this plastic muck, eh? He puts the billy on to boil and gets out the old postcards, letters, clippings and photographs, carefully sifting through his memories.

"That my wife Lucie. She die ten year ago. I miss her every day. These my daughters. Those my parents. These people from Australia, they write, see."

He pauses, thinking.

"Hey!" he says, "I know plenty jokes. You hear about the Maori and the Yank, eh? The Yank say in Texas they got the biggest steers, much bigger than these little cows here."

"Oh, yeh," says the Maori. "Hey, man, you better stay night, long way to go, eh?"

"Thanks, bud," says the Yank. "That real friendly."

When it dark the Maori put the Yank on the floor with the sacks of watermelons. The Yank wake up in the night and call to the Maori, "Hey, fella, what in the bed?"

"Don't worry, boy," says the Maori, "that just Kiwi fleas."

Tony falls about laughing, and says he knows plenty more. The gumdiggers tell him, now he tells the tourists. The Maori and the Yank in Queen Street. The Yank is boasting about the buildings being taller in Texas.

"Say," says the Yank. "What's that big building there?"

"I dunno," says the Maori scratching his head. "She wasn't there last night."

Tony doesn't get to Queen Street anymore. Or Dargaville. Or even Ahipara. He has a section in the new Ahipara, but he doesn't know what he would do down there. Up here he makes his own bread and wine and brandy. It gets a bit lonely, but then he does have plans to get his daughter in Auckland to join him and start up a museum.

We walk around the diggings, a dry, gorse-spiked desert. Blond young lads roar past in a beaten-up Morris Oxford, surfboards strapped to the roof. Tony waves, but their eyes stare straight ahead, intent on the big waves, beyond those 1,000 Arabian acres of piercing white sand-dunes. Here inland the air is squeezed of oxygen and the sun bakes and cracks the ground and all who walk on it. Gumdigging is backbreaking work, unlikely to come back into favour, except for a tourist tumble of the washing drum. Tony had a keen young chap working it on a fifty-fifty basis, but he soon lost his edge.

Today the tourists still don't get much past the glories of the Kaipara's Matakohe Museum, where the gum room is a glowing

Disney fantasy of translucent rocks clear as petrified honey. The locals display their treasures with the defensive pride of people who know they have inherited a Maharajah's fortune beaten out of the backs of scores of labourers. They tell you it is the finest collection in the world, and you would not disagree; you would not dream of anything better. Yet today it is only fit to put on display. It is more beautiful than gold, but you would be better off with a sackful of coal.

In 1908 the Tourist Department referred to Northland as the richest corner of the Dominion and gum as its brightest jewel, worth $1,000,000 a year, with the more mundane cement on **Limestone Island** in Whangarei Harbour coming up fast. The cement settlement did not last long, nor did gum, its bubble burst by synthetics during the First World War; by then it had earned $36,000,000. Middle men made most of the profits, the gumdiggers averaging 26s per Anglo Saxon and 31s 6d per Dalmatian weekly, the latter prepared to dig for it, although the former complained that they did not play fair and keep off another man's find.

Once there were 10,000 diggers scattered over the north, from **Riverhead** at the source of the Waitemata up to **Parengarenga;** the former now absorbed into the Kumeu area and the latter absorbed into the shifting white sands where the godwits fly. In between were 100 small camps like those on the Coromandel, if anything more dispersed, with a store never more than one kilometre away, but precious little else in the way of service. The more substantial walls and chimneys were of sod, and roofs were made of nikau palms, raupo leaves or grain sacks. As often as not in the balmy north they were stargazers.

For many it was a pleasant alternative to peering at the heavens from the confines of a prison cell. In fact, magistrates were known to suggest a stint on the gumfields instead of burdening the taxpayers or Her Majesty.

Gumdiggers were much closer to tramps than townies. Whether by choice or by circumstance, they avoided forming civilised congregations, seeming to fulfil the position society accorded them. "Only a gumdigger" was a disparaging phrase of the 1880s. "The deadbeats of the world," wrote a scornful contemporary, "come at last to an anchorage."

Yet it was very likely that a majority were forced there by the Depression of the '80s. They were a poor but by no means meek bunch, a polyglot collection of outcastes who produced the nearest New Zealand has ever got to an authentic collection of indigenous folk music; bluesy ballads that follow the best traditions of cheerily-presented tales of woe. Their instruments were the wheatstone mouth-organ, the penny or German whistle, the violin and Minstrel banjo, and home-made percussion:

Limestone Island in settled times. *Price Collection, Alexander Turnbull Library.*

Sunday relaxation on the Northern gumfields. *Northwood Collection, Alexander Turnbull Library.*

170

CEMENT WORKS
LIMESTONE ISLAND. 2441.D

DAYS PASTIME ON SUNFIELDS NORTHWOOD PHOTO

This is the song of the digger,
The song of the seeker of gum,
Sung in a kerosene twilight
To the sound of a kerosene drum.
A song of the sad and the sorry,
The men who have drawn God's wrath.
It's warbled in tent and in whare
Ev'rywhere over the North.

Neil Colquhoun and his Songspinners have put these rueful songs on record. That one was *The Way of the Trade*. Of more sociological interest perhaps is *The End of the Earth*:

The end of the earth isn't far from here
And it's getting much darker year by year.
For what are them bright shop samples for
When a man is hungry and a man is poor?
And's got no work worth working for,
And's running up north away from the law?
Aye! a-walking up north like everyone
To end up sitting out in the sun
At the door of a shack with a hole for a lum,
Scraping up clean a hundredweight of gum.

("Lum" was a North of England word for "chimney".)

The gumdiggers' state of mind was perhaps summed up best in the chorus line "Yo-ho-ho-wup! Yo-ho-ho-wup! Yo-ho-ho!", for the word "wup" was used to urge ploughteams on; in this case, it was a sardonic urging of the gumdiggers back to their scraping, an occupation of mindboggling boredom akin to modern assembly-line work.

The *North Auckland Age* newspaper went out to witness a gum camp: "For a mile or more we continued to follow the road which, taking a sudden turn . . . cut off from the world, on the edge of a reedy swamp, a dozen or two of small shanties. A mixed group of men were sitting in a cleared space of ground, chipping away with knives at pieces of kauri gum."

In 1840 gum had been used by settlers to light their torches. The first shipment of gum to the British and American varnish and linoleum binder markets was made in 1830, but the trade did not take off for another forty years. By 1890 it was developed and successful enough to incite protectionism, and the several thousands of Dalmatians coming in began to attract similar objections to those that the Chinese had endured.

The Northland fields stretched as far south as **Riverhead,** at the source of the Waitemata. There 120 diggers were served by a school and an hotel that was praised for offering comforts and luxuries

172

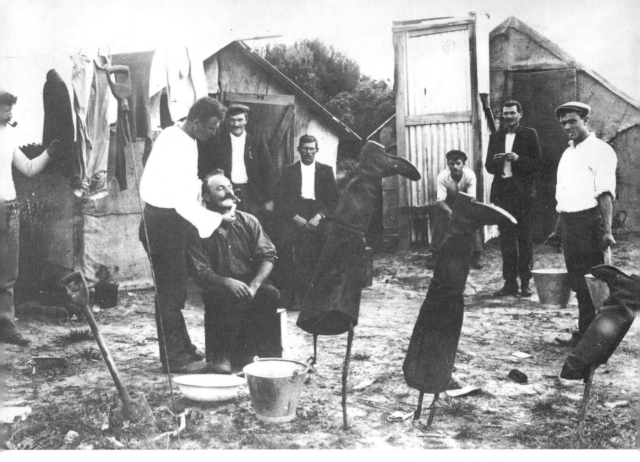

Dalmatian diggers on restday. *Northwood Collection, Alexander Turnbull Library.*

which would have done credit to a much bigger place. A township was laid out, but little building took place. A flour mill was established, and converted to mill paper.

The most intensive digging was around the Wairoa River. Often millowners were already operating, and the sudden influx of several hundred diggers presented a profitable expansion of their store turnover. There were settlements of diggers at Tucker's Flat near Matakohe and at the Ru Point area close to Raupo, while the short distance from Dargaville to Bayly's Beach included Scotty's, Jerusalem, Kennedy's and Welcome. Bayly's ticks over with tourism, while Tikinui took to toheroa canning. Tangaihi changed its spelling to Taingaehe, and Maunganui became Aranga, but their prospects did not brighten. Matakohe produced Prime Minister Gordon Coates and a fine tenor lived there in the person of Dr Carolan, medical officer of health for the Otamatea County and surgeon-captain to the Otamatea Mounted Rifles. He was most frequently requisitioned for concerts and entertainments. The prettiness of its gum collection has saved the town, while poor **Babylon** above Dargaville is down to eight people officially, despite having once yielded three tonnes of the stuff from one hole, dug out by Dick Matutinovich and Andy Botica.

Pouto, down at the Kaipara entrance, has taken a nose dive from

This map, that the local member takes all the credit for, indicates that Flaxmill and Babylon had their own stations, despite the fact that Flaxmill was eventually absorbed into Babylon.
David McGill.

its proud days as a gum and port centre for the region, and headquarters of the harbour master and lighthouse keeper. Now it is just the end of the road. Its small lighthouse has gone to Dargaville, and vandals have done their best to sink the old main lighthouse. Road and rail finished it. At least it is a good place for birds to find sanctuary now, up over the hills where the marble sculpture stands of Maori chief Peter Kerua, carved by an Italian sculptor from a photograph of the dead dignitary sent to him in 1903.

Tangitiki had its gum days, with store and wharf, and later became a popular picnic spot. The *Wairoa Bell* advertised in 1909 that strawberries and cream were available from Mrs Blacklaw.

Maropiu was not only a gum centre, but it also provided trout from the Kaihu Stream. It even had a brass band to brag about. Its hotel went to Dargaville and its school became a shed. In its day, a local told me, it was a place where the foresters congregated on a Saturday to settle their differences in fisticuff fashion.

Aoroa had 300 gumdiggers as well as a milling industry and a busy port. It has at least retained a place on the map, which **Mangawhare** has failed to do, despite its former importance as a gum and timber-trading centre. In an attempt to keep up with the play, its butchery became a fish shop. The enterprising establishment of a gumoil factory there failed, apparently due to poor management. A cordial factory was also tried, but it was probably just too close to the determined burgeoning of Dargaville to survive.

Redhill had more of a gumtown to it than most, with shops, a school, a post office and hall in the 1880s. It still has the hall, and memories, such as the severity of a particular teacher, which provoked a hefty lass into breaking her slate over his head and observing that he framed well. And the spirits are still there of the forty or so horsemen pounding hellbent back from the Aratapu pub on a Saturday night. Even more speculative than Mangawhare's factory was the elaborate effort in 1922 to extract oil from peat — the north had its share of Heath Robinson inventors. One that did work was the washing-machine-type sieve of the kind that Tony Yelash has rusting away at Ahipara; A. H. Reed, himself once a gum-digger, called it a hurdy-gurdy, which has the right ring to it for this typical piece of backyard, ad hoc, Kiwi ingenuity.

Moving north to the Kaitaia area, the gumtown of **Mangatete** is now off the face of the map, but it was once near Awanui. Peria, east of Kaitaia, is a shadow of the gumtown that had a two-storey accommodation house seating seventy at table, a hall that travelling companies performed at, a saddler and harness maker and gum-merchant William Hazard, who manufactured Key Brand baking powder.

174

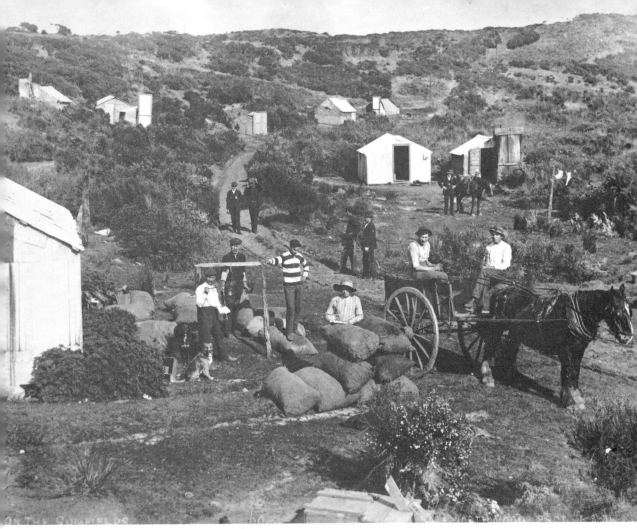

The nearest the Houhora gumdiggers got to a township. *Alexander Turnbull Library.*

The end of the road at Houhora Heads, part of the great Northland gumfield complex. *David McGill.*

In its heyday, gum was a bullish stockmarket commodity. The *Northern Wairoa Gazette* for 18 January, 1883, reported confidently: "The gum market remains in the same condition as last week, with perhaps a hardening tendency for better qualities."

Those who read the stock market reports also no doubt responded to the announcement in an 1886 edition of the *Wairoa Bell* that a lecture would be given on "Hell, Its Location and Its Absolute Certainty". Gum and Victorian respectability were both riding high — for those already at the top. The gumdiggers were closer to the have-nots. They would come into town to blow what little bundle they had. "You've cut her out, mate," the publican would say, and the digger would shoulder his pikau and be off back to his draughty shack and the back-breaking job of digging out gum.

Waipapakauri was a centre for the area in the digging days, with 1,000 of them, half Dalmatians. Joseph Evans was the patriarch, spreading out a sequence of general stores at Awanui, Waiharahara, Houhora and Te Kao in the 1880s, with enough sons to have one in charge of each store. In 1890 he established the Travellers Rest Hotel at Waipapakauri, but he did not rest himself, travelling over ninety kilometres a day to pay cash for gum. Not surprisingly he was known as the Gum King. His payments were often in gold, precisely weighed from 6s to 100s per hundredweight for grades ranging from sugar gum through block, good, brown, ordinary, white, rescraped white, bright amber and dial, altogether over 200 classifications.

From 1890 to 1920 there were around 7,000 diggers in the Houhora, Waihopo and Pukenui area. Roy Wagener of the museum at Houhora Heads points out that these were not townships, but rather one great field of diggers served every kilometre by a store. These areas have remained static, but **Parenga** most certainly declined from a population of 350 to zero. Farming and almost every known mineral was there, but gum provided its heyday, yielding 4,000 tonnes a year for forty years. At the turn of the century it was predicted in the *Cyclopedia of New Zealand* that Parenga would produce for another 100 years, a prediction that was about nine-tenths wrong. There were 150 Maoris, 150 Dalmatians and fifty Europeans, but Sam Yates, King of the North, was in charge of the land and all the beasts and men of burden who worked on it; in earlier times he had known Emperor Louis Napoleon, and had his autograph to prove it. After his death his wife carried on for a time.

When you fly over the area, the pilot will point out where the King of the North lived, down there, that little hut, see it? The soft startlingly-white sands are shifting in to bury the evidence of any human settlement. A squadron of godwits banks away to safety, and returns when the infernal flying machine has gone, for this is again where only the godwits fly.

This Herekino store is a sign of the depressing Northland times after the gumrush. *David McGill.*

176

20

Chop, chop, chop
The hewers and drawers of northern waters

On the occasion of the recent soiree at Aratapu,
Nemo, while noticing the decorations in the Public Hall,
could not help thinking what a miserable contrast the
hovel honoured with such an appellation in our own
township presented to that comfortable building.

Northern Wairoa Gazette, Dargaville, 29 February, 1884.

Aratapu was the capital of the Hobson County in 1884, and
Dargaville was the Pretender. Since the county council offices were
moved from Aratapu to Dargaville in 1908, Dargaville has ruled,
while Aratapu has declined into a flat field on the way to Te Koporu,
its hall and school massive skeletons of a milltown that once served
2,000 people.

It was known as Sawdust Town. Along with Te Koporu, it had the
biggest mills in New Zealand after Auckland, and the Kauri Timber
Company produced a total of 900,000 cubic metres sawn from these
two giants among kauri towns. The company spent forty years
working Aratapu into the ground.

In its heyday Aratapu had a board-walk up the main street like
something out of a Wild West town. There were butchers, bakers
and mattress makers, smallgoods manufacturers, drapers, station-
ers, hairdressers, picture framers, bootmakers, coach builders,
blacksmiths and gunsmiths, saddlers and gum spear makers,
tailors and chemists, restaurateurs and billiard saloon proprietors.
The watch and clock repairer was most important, for if the men
were late for work twice they were out of a job. It was the
intransigence of the millowners in trying to force workers to buy
only from their stores that led to the formation there of the Northern
Wairoa Workers Union.

This page: Aratapu's deserted hall and school. *David McGill.*

Facing page: Aratapu photograph and fixture preserved at Dargaville's museum. *David McGill.*

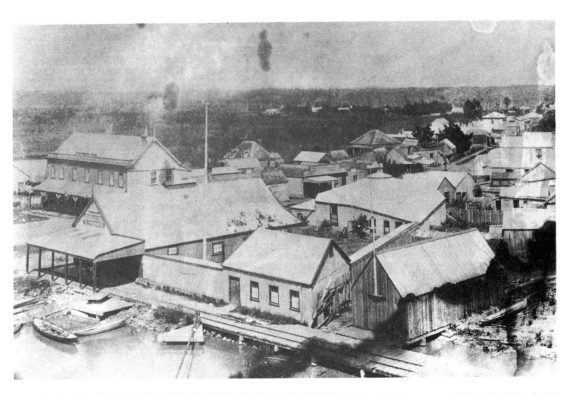

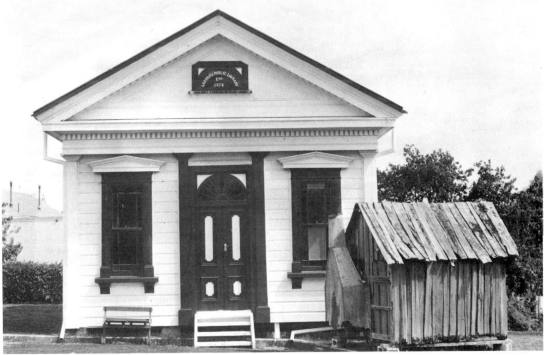

179

Aratapu got the Hobson County Council offices in 1866, and never looked back until the turn of the century. It even had the police station moved from Te Koporu in 1885. There was a Meredith canning toheroas, a milliner Miss Olsen to renovate hats and Mrs Souter's own preparation, Nimble Ointment which was guaranteed to cure man and beast. Mr Stallworthy, District Chief Ruler of the Rechabites, opened a North Tent there and organised local education. In 1886 he published the *Aratapu Gazette,* took over the *Koporu Bell,* shifted it to Aratapu and called it the *Wairoa Bell,* which prospered enough to buy out the *Northern Advertiser,* thus becoming the *Wairoa Bell and Advertiser.*

Entertainment included a local band, a choral society, rugby, cricket and tug-of-war and a skating rink that also served for showing movies, until it was burnt down. The hall did duty as a court. The district high school there (where parents demanded a thorough grounding in shorthand, bookkeeping, arts and sciences or they would take their custom elsewhere) actually kept going until 1965. Te Koporu got its Methodist Church and post office; Mititai its Church of England and Dargaville its library.

This was also the principal shipbuilding town of the north. Perhaps the country's most famous shipbuilder, James Barbour, worked here; the *Northern Wairoa Gazette* liked to refer to him as "our local artist", and indeed he was, for he could shape a piece of wood by the uncanny conjunction of eye, axe and adze.

Barbour's and the country's most famous home-hewn craft was the *Huia,* its thirty-two-and-a-half metre keel carved by him out of a single kauri. It still holds the record run of four days and sixteen hours from Newcastle to Kaipara under sail. After half a century of service this topsail schooner went down off Noumea in 1951.

Brown Town was another shipbuilding centre, up the road, at the base of Te Koporu, though it was more the Brown family's yard than a township. However, Hokianga Harbour to the north takes pride of port for shipbuilding in this country when the little English-style village of **Depthford** was created in 1827 at the waterside of an area now called Horeke. Depthford gave birth to one sweet little ship, the *Enterprise,* crafted from kauri and puriri and declared the most beautiful ship ever to enter Sydney; she had come, said the newspaper, from that "canniballic Elysium". The English were not amused, and grumpily refused to grant her registration, which put paid to the yard of Depthford in 1831, along with its sawmill and store.

In the 1840s resourceful missionaries built a ship at **Hoanga,** also known as **Grahams Fern,** where a sawmilling town developed and then dissolved. It was also where hothouse vineries became popular picnic spots, but there is nothing there today.

Whangape was a shipbuilding site in the 1870s, but it proved

more effective as a breaker than a builder of ships. After a steamer turned turtle there in 1880 with all hands lost, this milltown was also sunk. The harbour was known as the False Hokianga because it looked similar from the sea; four of the ships wrecked there were initially attributed to the Hokianga. Only the farmers remain at the end of a long and winding and dusty road. High upon a hill a classic white wooden chapel is framed splendidly against the skyline.

You are hard put to find anybody now at the millports of **Owhata,** in Herekino Harbour to the north, and **Koutu,** south at the mouth of the Hokianga.

Whangape Harbour has silted up, but Whangape still stands recognisably on the littoral. Many Wairoa River towns are now

181

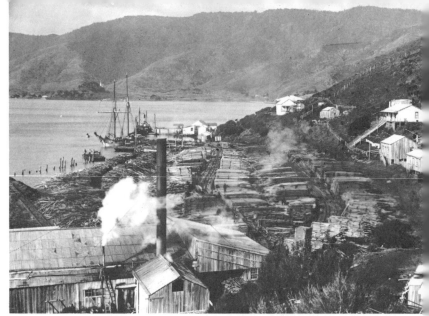

Whangape mill. *Northwood Collection, Alexander Turnbull Library.*

The church at Whangape is as isolated as you would find in a month of Sundays. The treacherous harbour bar wrecked its chances as a ship-building centre. *David McGill.*

inland and overgrown. The locals tell you it is because of the neglect of the authorities. Another reason is the unintentional success of the Manchurian rice grass that came here as ballast and now challenges the raupo for supremacy in an area that was once a wide, muddy mini-Mississippi. Take **Aoroa,** if you can find it. Once a dozen ships tied up at this port below Dargaville. There are rotting moorings and rusty boilers to be found, but of the timber port of **Paradise** or **Mapuna,** below Kirikopuni, there is nary enough kauri left to pick your teeth with.

Aoroa was one of the boom towns, milling nearly 500 cubic metres sawn weekly, and once putting on the Wairoa's biggest sports meet, with 250 entrants. Mrs Bennett of Ruawai recalls when you could walk across the Wairoa on the logs. Now you would be chancing your feet to try it, and there would be little anyway once you got to the other side, especially of the satellite milltowns like Tatarariki, which was too close to Te Kopuru to flourish. But these

182

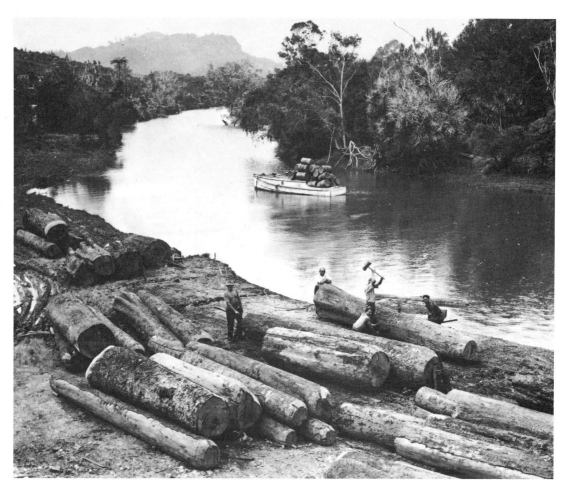

one-car places still have pride in their past. Aoroa is not alone in claiming the Southern Hemisphere's biggest sawmill, although the evidence has gone along with its board-walk, boarding houses and billiard saloon. Those not yet caught up in the new gospel of conservation tell you the kauris that are left in Waipoua were rejects, too small to bother with in the good old days. Saddest perhaps is **Mangawhare,** which lost its churches to Dargaville, its hall to a rugby club, and its accountant, bricklayer and bootmaker goodness knows where. No longer is its racing stand grand.

 Kaihu, like its kauris, has been brought low. This milltown really boomed in the 1900s, when its population rose to over 700, with 1,000 Dalmatian diggers in the vicinity. As well as a sawmill, it had stores, a barber, a dressmaker, two boarding houses, a National Bank, two bakers, three billiard saloons, two blacksmiths, a shooting gallery, a race course, Roman Catholic and Methodist churches, the Band of Hope Hotel and a post and telegraph office.

The bushmen tell a strange story of the death-throes of the kauri, closing in on the saw as they were part-way through splitting it: not that this stopped the industry being axed out of existence and taking with it the mysterious spirit that the Maoris recognised in the great kauri forests.
Northwood Collection, Alexander Turnbull Library.

183

Disastrous floods at the turn of the century broke the log booms and destroyed most of the mill and town.

Today Kaihu is down to a hotel and store. The train stopped running, but then it had got off to a poor start in the first place, when the Duke scheduled to cut the ribbon failed to arrive and the town drunk stepped in — with a pair of scissors. Sawdust still burns there, a rather eerie memorial to boom days.

Tangowahine may also serve as an epitaph for what the north was, for it means (in its earlier form, Tangiwahine) "weeping woman". It was one of the last mills to close. Spars for the British Admiralty had been taken from there in 1840 and by 1911 it had a population of 400, served by a store, post office, billiard saloon, hairdresser, butcher, stables and three boarding houses.

The Far North and the North-west share a history of false hopes with the Deep South of New Zealand. Here there is still talk of what could be if the Wairoa was unclogged; if only the east side did not get preferential treatment. In 1913 the Hokianga Chamber of Commerce was blaming the politicians for not letting them develop this reserve land, which was the best farming country in the Dominion.

The highest hopes with the lowest results were those of the English Non-conformists who planned the last great ordered colony in New Zealand, which was to spread from **Port Albert** up the Kaipara to Matakohe and Paparoa. Three Port Alberts were planned. The first was a speculators' clean-up that fooled nobody. The second was the founders' pipedream, planned on the way out in 1862; the *Albertland Gazette* was first published aboard ship. The third town was less ambitious, but it did include provision for a customhouse and other official buildings, for it was hoped that it would rival Auckland.

The first problem was the harbour, where over forty ships were lost before it was finally closed in 1947. At one time it saw 13,000 logs in the kind of kauri drive that would equal anything that Canadian lumberjacks have ever handled. Later problems were declared to be the lack of road and rail access from Auckland, and it was thought that once these were remedied the place would shoot ahead. But possibly the area was doomed from the beginning. Over 3,000 came out, and many almost starved there before shifting down to Auckland. There were also high development hopes for Batley and Pahi. Port Albert is so depressed today that there is not enough support for a museum, so artefacts are stored in the local football sheds. The spirit seems alive only in the centennial publication.

The Hobson County Centennial publication reproduced a 1916 Irish joke about one Mulligan who dropped sixpence down a crack in the floor and was observed pushing a £5 note after it.

In the early 1900s vigorous attempts were made to keep Northland steaming ahead. *David McGill.*

"Mulligan, what the devil are ye doin'?"

"Sh-r!" says Mulligan. "I'm tryin' to make it wort' my while to tear up this board."

Northland went about development somewhat the same way, tearing down and rooting up priceless assets for the sake of a few quick pence.

Certainly it has now reaped its whirlwind. The image of its decline is there in the deserted and overgrown railway station at Donnelly's Crossing, above Kaihu. Kauri was once king there; today the kingbreakers have also brought themselves low.

The *Wairoa Bell* of 1886, you recall, announced a lecture on the subject of "Hell, Its Location and Its Absolute Certainty". Nothing quite so grim for the north and north-west, more a limbo of vague hopes and Paradise Lost. Perhaps there are hopes of Paradise Regained; after passing through the nondescript remnants of the milltown of **Sweetwater** I chanced upon a grove of kauri seedlings, part of the kauri experimental-planting programme. Ka pai!

The train doesn't stop any more at Donnelly's Crossing. What kauri is left is here to stay. The station is mute evidence of boom to bust. *David McGill.*

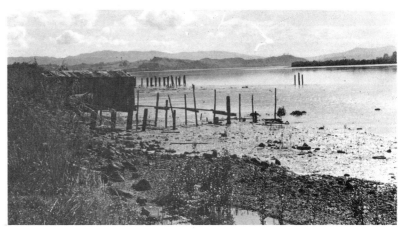

Kohukohu port, a fate so many Northland ports shared. *David McGill.*

186

21
After the kauri
Milltowns south and north

Some specimens of native wood are sent,
As portion of the tribute we present:
Vast belts of woodland clothe the mountain side,
And forest glades – where oft in towering pride
Stand lofty pines, of various form and hue,
Black, red, and white – and rarer silver too:
These in abundance on our Coast are found,
Whilst ferns of loveliest form are scattered 'round.

John Cross, Poet Laureate of Westland, Hokitika, 21 June, 1879:
Most respectfully inscribed to the Hon. Commissioner of the Sydney
International Exhibition, 1879.

Such Pakeha sycophancy and insensitivity stood in marked con-
trast to the Maori appreciation of the great forests. Maori forest
firebugs were punished in kind, with the burning of their huts. To
the Maori the forest was food, shelter, clothing and transport, and
therefore to be treated with the respect such an important provider
deserved. The Maoris restricted their cultivation to scrub areas.
When a great tree was to be felled, first the forest god Tane was
placated by an elaborate ceremony.

The Pakeha began his dedicated chopping out of the kauri about
1840; seventy years or one lifetime later, the mighty kauri forests
were gone.

Pakeha bushmen observed the curious "death throes" of the
kauri. When it had been toppled and was being sawn, at about one
third to halfway through the cut, the kauri would rise up from its
prone position and close on the cruel teeth of the saw!

It is a matter of little debate how much notice we took of this silent
protest: today there is no kauri twenty-five metres in circumfer-
ence. We are pausing in the polishing off of the other native woods,
the matai, rimu, totara, kahikatea, tawa, miro, maire, hinau and

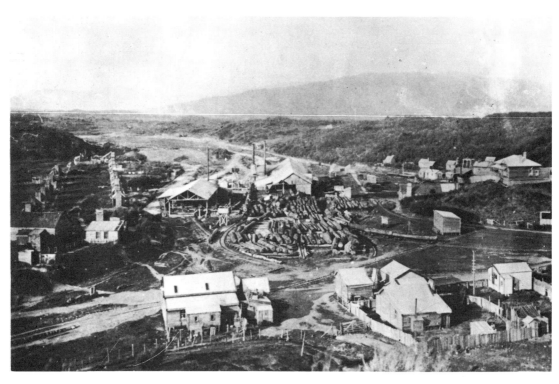

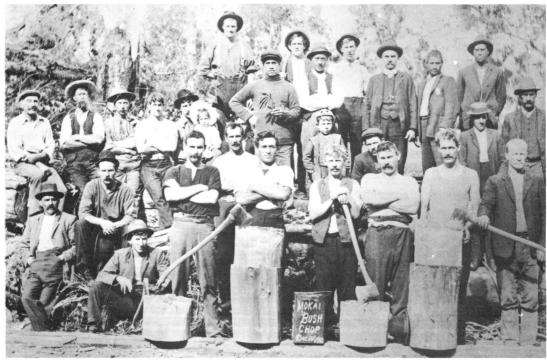

kawaka — but the spirit of the forest seems to have departed with the kauri. Those who have written on the timber industry, with the grand exception of Tom Hay, seem to lose their sap once they leave the kauri behind. Its death throes in the first decade of this century coincided with the pitch of native timber exploitation. We now know how unique it is, we regard it as our greatest wood, we mourn its passing and we pay much for its remnants second-hand.

It took so very few bushmen to reduce our native forest cover from three-quarters of the land when the white man arrived, to now less than one quarter. In 1907, just as we were getting into exotic planting, there were 411 mills in the country employing 7,139 men with dependents making a total milling population of about 25,000. Mills varied in size from three employees at Mangopai, to 120 at Te Koporu and over 300 at **Mokai,** above Lake Taupo. Mokai still has seventy folk in residence but they have moved up the road, leaving behind a perfect little village "brown", where once the Taupo Totara Timber Company ran its railway to its main mill, with general store, post office, butcher, hall and school.

Today a crescent of abandoned cottages have been taken over by a local with a sense of humour. He warns intruders in bold bush script that a toll will be required if they trespass, and the money will go to the unregistered Mokai Historical Society for the preservation of these wooden monuments to our axemen. And why not?

Few of the mill settlements deserved to be called towns. Those in the central North Island below Taupo are dealt with in a succeeding chapter on the Main Trunk Line. Te Whaiti, below Murupara, deserves a mention for having just closed, a local told me on my way through. **Barryville,** northwest of Lake Taupo, looks like many a postwar milltown with its plain weatherboard and corrugated iron-roofed houses, wooden fences and power poles, but its only inhabitants now are wild cats. Intensive conservation lobbying to halt logging in nearby Pureora forest in 1978 led to the closure of the two saw mills and the township was soon deserted.

South Island timber towns have in many cases kept going, but only by the bark of their trees, as with Nelson Creek or Rimu, the latter down from its gold days of 500 people to fifty-eight at the last count. Milltowns past their last gasp include **Onamalutu** above Kaituna, **Ferntown** opposite Collingwood, **Mangarakau** at the bottom of Whanganui Inlet, Golden Bay, and the Coast towns of **Kokiri, Bell Hill** and **Kaimata. Weld** was the Bruce Bay Sawmilling Company town in the 1930s, but today is no more than a few chimneys and foundations.

Kinloch, opposite Glenorchy, at the top of Lake Wakatipu, was a surveyed timber town that is now off the map.

Down in the Deep South **Waihoaka, Wakaputa** and **Longwood** have got the chop. There were fifty mills in Southland in the early

Mokai in the days when it ruled the native timber roost. *Alexander Turnbull Library.*

Mokai in boom times, 1910. *Houlihan Collection, Alexander Turnbull Library.*

Mokai milltown after the train stopped running, as it is today. The township moved up the road. The old town slowly rots towards oblivion. *David McGill.*

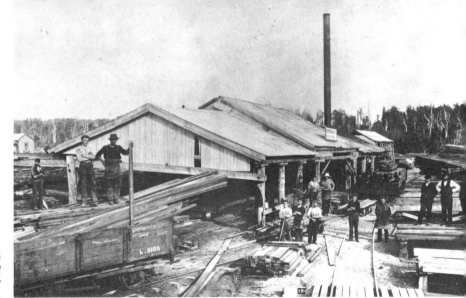

Kokiri sawmill. *West Coast Historical and Mechanical Society Collection, Alexander Turnbull Library.*

Bell Hill township in 1954. *New Zealand Forest Service, J. H. G. Johns.*

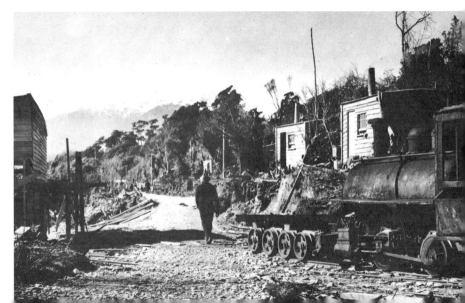

Bruce Bay sawmill. *Alexander Turnbull Library.*

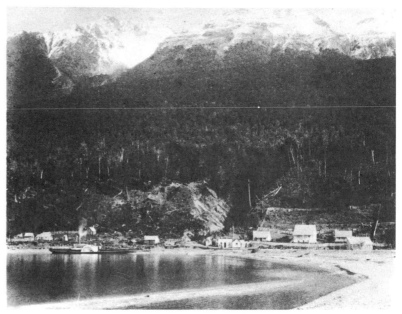

part of the century, the biggest number for any South Island
province. **Chaslands** had 150 folk in the 1900s, when there was
milling and also a cheese factory. The school had opened in 1895,
with two teachers. Conditions were grim for the sick or injured.
Tom Welsh died from appendicitis after an all-night journey by gig
and half-draught horse, with George Dewar riding ahead to rouse
settlers to make cups of tea. The isolation of the region bred intrepid
men like George Dewar's brother, Tom, who crossed the Andes on
foot.

George Dewar has written the Chaslands' story from its heydays
in the 1890s to its lowdays in the 1950s — stories of lobster feasts, of
eel for breakfast, dinner and tea, of mud up to your neck, the
awsome chopping of the Browdens and Jack Churchfield, and the
midwife Mrs Churchfield, who always knew the sex and time of
birth, something medical science has not yet bettered.

Niagara and Waikawa have held on better than Chaslands, but
not by a very long chop. Other Catlins Bush milltowns like **Tautuku**
and **Sixmile** have been felled. Waikawa relives its past port
splendour in its museum; the church and school bells now toll for its
past.

The famous cricketer Dan Reese helped exploit the **Port Craig**
timber with the same bold and uncomplicated enthusiasm he
brought to the whacking of the willow. Port Craig now rots
pleasantly around the inaccessible side of Te Waewae Bay, pro-
tected from the south-westerlies and bathed in the warm gulf cur-
rent. The timber is there, but it is a devil of a job to get it out, and
now Port Craig lies very much off the beaten track.

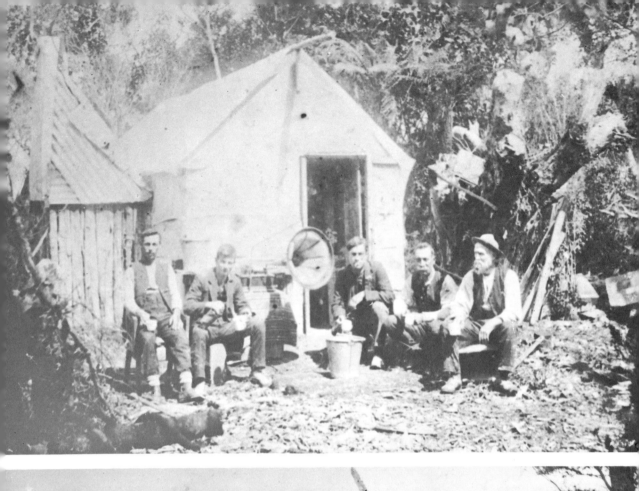

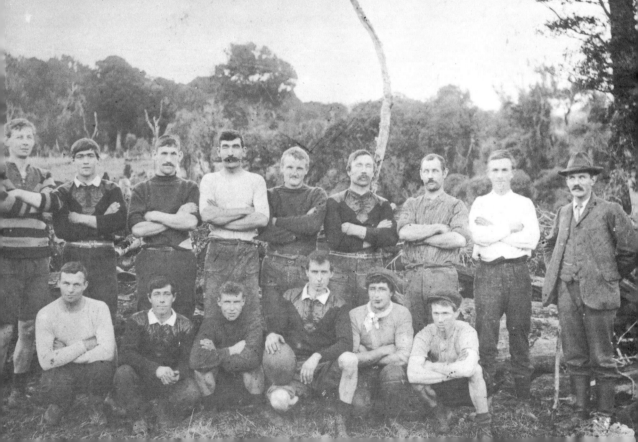

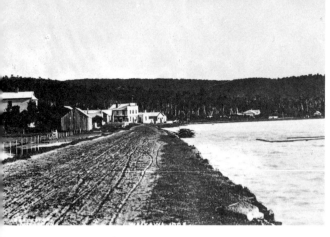

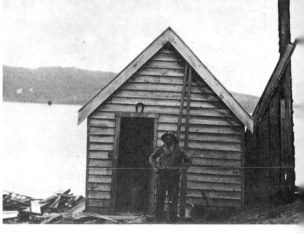

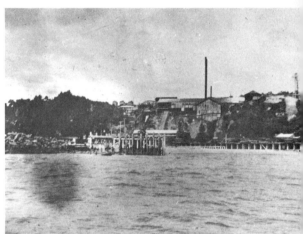

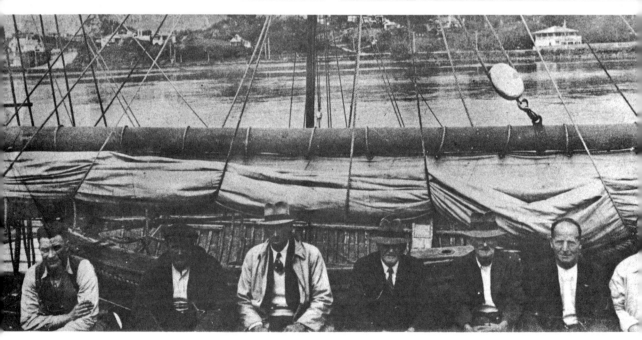

Tragedy marked much of its establishment. It was named after the manager, John Craig, who was drowned attempting to rescue his boatman, waterlogged in his gumboots among the treacherous breakers. Then his brother James died of burns following an explosion. Less serious was the problem of the sly-grogging, which Reese and his co-directors solved by allowing the men to bring in any grog they liked, so long as they waited until Saturday to drink it. On Saturdays there was a dance, where the ladies restrained the excesses of the bottle, and made the men available for work again by Monday. The mill made a fortune, peaking at 1,813 cubic metres of sawn timber for the month of May, 1928, New Zealand's highest take. A few years later the mill crashed, along with most other large enterprises unable to cope with their crippling overheads; at that time it paid to be a small businessman.

Jack Wilson of Orepuki had his first job with the sawmill at Port Craig. He remembers the twenty-four-metre-high derrick used to winch the timber on a pulley out to the ships. In his day about 130 men cut rimu, tot (his word for totara) and birch on the beach. The schoolhouse now serves as a hunters' hut while the wharf serves for nowt, and rots away.

Top left: Waikawa postcard, 1908.

Top right: Joe Clarke and his hut, Waikawa. *Southland Museum.*

Centre left: Waikawa today. *David McGill.*

Centre right: Port Craig. *Southland Museum.*

Bottom: Riverton estuary, servicing centre for long forgotten sawmilling settlements. *Riverton Museum Collection, David McGill.*

Port Craig. *Southland Museum.*

195

Stewart Island had its intensive period of logging earlier than most, from the 1860s through to the 1890s. Its biggest mill was at **Kaipipi,** over the hill from Half Moon Bay. The mill houses have gone from there, but even at the time most of the workers lived at Horseshoe Bay, later Half Moon Bay. They walked at a snail's pace to work, for they were then in the employers' time; they ran home in their own time. There was also milling at the north end of Horseshoe Bay, where there were about twenty houses with big wooden chimneys. Later there was also a mill inland at Murdoch's Stream.

Milltowns generally have a better record of survival than gold-towns or gumtowns. Wiltsdown, outside Tokoroa, is an example of a milltown that closed in 1971, but was open six months later, as a resort suburb for Tokoroa. The landlord bought the eleven-hectare town, lock, stock and sawdust mountain. A pity somebody does not buy Mokai, for the record.

Kaipipi, Stewart Island.
Alexander Turnbull Library.

22

A cuppa and a pie
The Main Trunk line

You can get to Taumarunui going north or going south,
And you end up there at midnight and you've cinders in your
 mouth.
You've cinders in your whiskers and cinders in your eye,
So you pop off to refreshments for a cup of tea and kai.

Peter Cape's *Taumarunui.*

The romance of the rail in the days when it had something to be
romantic about is dead; its ghosts still hiss and whistle around a
backroom siding in Paremata, north of Wellington. Here Bob Stott
puffs on his pipe and painstakingly pieces together his masterpiece
— a miniature railway station and attached sawmill.

"It's hard to say," he says through a clenched pipe, "which came
first — the station or the sawmill. Both came and went together in
the centre of the North Island on the Main Trunk line. The line
allowed wood to be milled here and sent to Auckland or Wellington.
There is nothing else here, no farming to fall back on or develop.
The opening up of the Main Trunk brought these towns to life, the
automation of rail signals and the cutting out of native timber
ended their days. Exotics may save some."

Stott began as a freelance enthusiast with the magazine *Rails,*
which was good enough to force the official railways publication off
the track. He has been building up a head ever since on the subject
of our rapidly-evaporating and so-recent history of steam loco-
motives. He went out and photographed everything that moved on
rail or was associated with it. That wasn't enough. He wanted still
to see it all. He had seen overseas the effect of three-dimensional
minature reconstructions and he has applied the lessons learned
around three walls of this backroom. Working with such materials
as balsa wood and brass, he has recreated the way the railways used
to be, including the original steam engine that was built in this

197

country (for which he could only find the plans for the boiler; the rest was extrapolation). Thar she blows, a bold brass beauty. To find out exactly how the old wooden stations looked in their time he has gone around what is left and talked to those who worked in them. The results are there in delicate ribbed roofs which lift out to show the filagreed balsa underwork. Same for the mill, a miniaturised model of obsolete timber yards.

Raurimu is probably the most famous of these central North Island station/sawmill townships, although its fame is largely due to the technological triumph of the rail spiral above. Its industries are flattened now, the school is closed and most of the shops shuttered and empty. In 1952 it had two teachers, a butcher, a tearooms, and the offices of the Kaitieke County Council.

The stations were located about every sixteen kilometres. A 1958 timetable shows three times as many stations as there are today; that was about the end of their run, for remote signalling began to be introduced around this time. Taihape to Te Kuiti would span these towns. The stations fell like ninepins — the one at Erua, the prison town, in 1954, Pokaka's in 1957 and Pakihi's in 1959. Tangiwai once had a mill too, but is remembered now only for its Royal disaster. Horopito is sinking fast; in 1929 it had mills, a butcher, draper, grocer, gardener, machinist, smithy, bootmaker, schoolmistress and postmaster. Mangapehi's two mills closed in the early 1960s; in 1929 it had two blacksmiths, a butcher, accountant, teacher, boarding house, carpenter, sawdoctor and a store that ran to an assistant, listed by Wise's Directory as simply "Hankers". In 1909 **Turangaarere** had a mill, a butcher, a teacher, a store, a smithy, a machinist and an engine driver.

Ongarue had a big mill a couple of kilometres from the station; the mill was bulldozed flat in the early '60s. Kopaki has little left. Waimiha had an old wooden building with a false frontage where you could make out the lettering "Waimiha Picture Palace"; the town has only one thriving aspect now, the hydrangeas that have always liked the climate. In the style so familiar throughout the country, Puketutu had been Mokau and Kopaki was Paratikawa. It was the problem of doubling up on names that later officials spotted and changed, although it didn't help Puketapu, whose nine citizens are not to be confused with the 292 in the Hawke's Bay Puketapu.

Pokaka was Pokako in its heyday just before the Depression, when it had mills, a smithy, two butchers and a teacher.

Now Horopito has nothing but the most famous vintage car-wrecker in the world.

The 107 kilometres from Taumarunui to Waiouru made up the last and most famous stretch of the Main Trunk line, notable for the spiral and the great viaducts. There were 1,000 men on the job there in 1908, working flat tack to get the line finished in time for the

Raurimu on its last legs.
David McGill.

Pokaka, Turangarere, Tangiwai, Horopito, Raurimu, Waimiha — it could be any one of these decaying Main Trunk Line settlements where the train doesn't stop much any more.
David McGill.

198

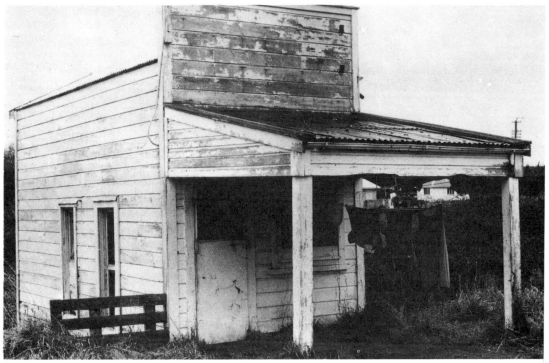

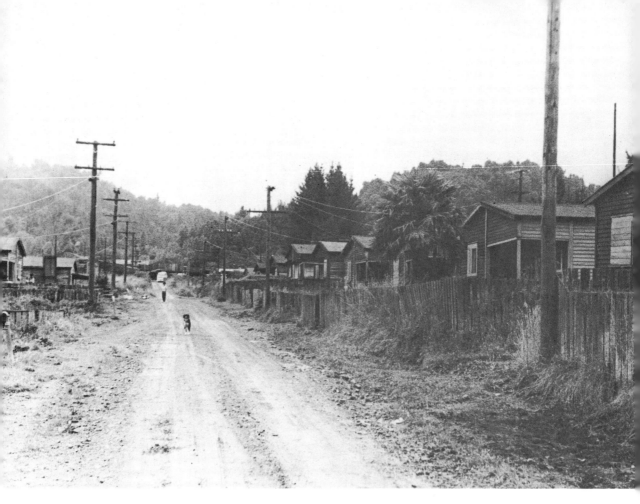

Ngaroma in 1969. *Bob Stott.*

politicians to get up to Auckland to greet the American Fleet. The men lived in temporary towns in the Upper Ongarue. Their slab and canvas whares were reminiscent of the first goldtowns, and the workers appreciated the similarity by scrawling across hut fronts such charcoal legends as **"Carson City"** and **"Angel's Rest"**, but undoubtedly the most popular sign in these settlements was "Hop beer sold here". This King Country brew was famous for its kick.

These men had no bulldozers and caterpillar tractors. They used picks, shovels, axes, saws, horses and wheelbarrows to cut down fifteen metres, build up twice that with fill, or burrow a kilometre through a mountain. The *1955 Engineers and Assistants Association Yearbook* paid them their due in the words of John R. (sic) Lee: "Bush beards, heavy moustaches, bulging muscles and bowyanged trousers mark them unmistakably as railway navvies — a now long extinct species, which before its passing left on the face of the land indelible monuments to its mighty efforts."

Moving north-west across to the Mangakino line, was **Ngaroma**, now an abandoned milltown. You need a narrow car to get in through the overhanging hedges.

200

Tangarakau after the trains stopped. *David McGill.*

Cross over to Putaruru and you would be hard put to find Bart's Siding, up to Bartholomew's mill six kilometres to the east. Further down, at the end of its own line, Te Whetu mill has closed.

Switch points right around and head over to Taranaki, where Whangamomona blossomed as the cuppa stop halfway between New Plymouth and Taumarunui. Its sawmill closed in 1926, and most of the town has now closed too.

The Whangamomona area was opened up to farmers with government assistance in the 1890s, but it was not really open until the New Plymouth railway went through. This was begun from that end about 1900, reaching Whangamomona by the First World War and Tahora a decade later. By 1934 thrice-weekly express trains were running to Taumarunui.

The Reverend Alexander has written an entertaining account of this milling and farming neighbourhood that was only truly accessible by rail. He did his best to humbly preach the message by horse, for which pains he was forever doing battle between the mud and his boots, extricating his horse, or playing Samaritan to some less lucky or less skilled wayfarer. One newly-wed waited until dark to take his bride back, so that she would not see the treacherous roads. The Reverend said many a service by candlelight, and he only ever occupied the front half of his Whangamomona whare, for the back was permanently flooded.

Sometimes the Reverend resorted to travel by jigger, a delightful open-air mode of transport that I recall well from my boyhood days when illegally jiggering miles along the Taneatua line. The train to

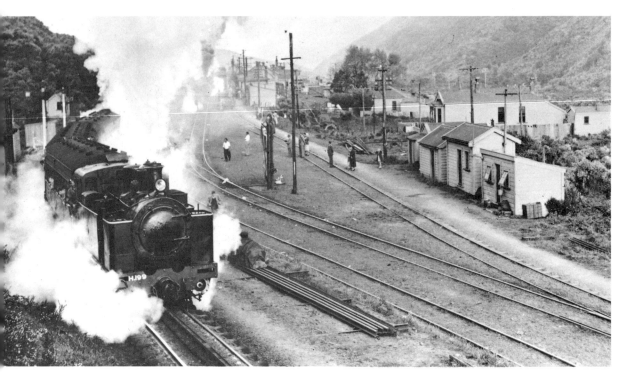

The last passenger train leaving Cross Creek on 29 October, 1955 — a special from the Carterton show to Wellington. *New Zealand Railways Publicity Department.*

Whangamomona, the Reverend observed, was an endless source of amusement to the "backblock dwellers" because of its slowness, earning it the cognomen of caterpillar. There were no lights in the tunnels, which naturally the lads loved; the minister recalls a Maori shouting as they came out of the tunnel, "It is tomorrow."

In his days there he lists an hotel, a post office, a bank with district nurse in residence, a baker, billiard room, hall, station and railway cottages and his Anglican, Roman Catholic and Presbyterian churches.

Tahoraparoa was reduced to Tahora. It once had stores, a hall, a school, railway station, railway cottages, post office, rifle and tennis clubs and a domain that provided sanctuary for pigeon and tui.

Further on was **Tangarakau,** a town of 1,000 public workers which lasted from 1925 until the railway was finished in 1932. It had stores, drapers, a hairdresser, tobacconist, bootshop, tearooms, confectioner and fruiterer, social rooms, post office and savings bank, police station, boarding house, pictures and social hall, lending library and reading room, school and sawmill. Coal was to be its great black hope, but now it is quite dead.

Cross Creek and its subsidiary upper settlement of **The Summit** are completely gone. They were the servicing settlements for the remarkable Rimutaka Incline, which opened in 1878 and closed in

202

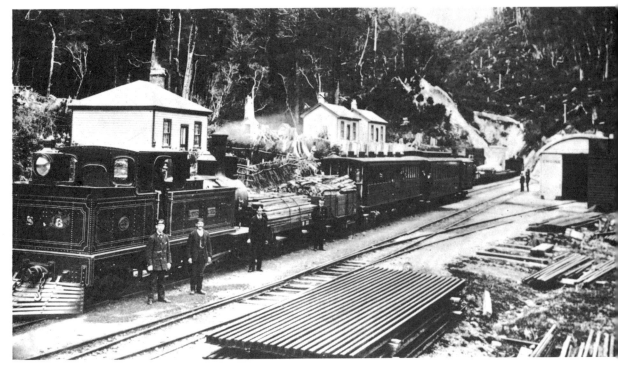

1955. Cross Creek got its stores from Featherston eleven kilometres away, but in every other respect it was a self-contained town.

Cross Creek was said to be the department's Siberian salt mine, where recalcitrant staff were sent to do penance. Cross Creekers did not agree. There were about thirty families there, and some single men, from stationmaster down through driver-in-charge, drivers, firemen, guards, cleaners, porters, coalmen, fitters and gangmen, all vital — the friction was so great that after every thirty-nine-tonner had passed over The Summit the blocks had to be replaced on the special-incline van, a type used in only one other place, Mt Cennis in Europe. Many a family volunteered to stay a generation and bring up their children there, under the expert tutelage of master-in-residence, Samuel Turkington of County Down, whose roll totalled thirty-four. There was the attraction of good hunting country, but also the close-knit community that isolation breeds, with card evenings, movies and dances in the social hall on Saturday nights.

The Summit did indeed have aspects of Siberia about it, with vicious prevailing winds — passengers were cautioned against leaving the carriages at this station. Then there was the 240 centimetres of rain per annum. On Saturday nights the townsfolk were brought down to share in the festivities. The descent from 400 metres above took twenty minutes, the return trip forty.

The Summit, about 1886. The passenger/freight train at the station is hauled by an "S" class single Fairlie steam locomotive. *New Zealand Railways Publicity Department.*

Cross Creek was supposed to have been named after local farmer Lot Cross. How he made out is not recorded, but there is nobody farming there now. The tracks were taken up and the land has reverted to blackberry and gorse, with only the magpies and the wind to make any noise about it.

Across the Strait, **Glenhope** is the misnomer for the dead end of the ill-fated rail project from Nelson to the west. The site of the former school is now a memorial to the district's pioneers.

The Catlins River Branch Rail in Southland is another example, like the central North Island Main Trunk towns, of a railway that was developed for timber. Work began from Balclutha in 1885, extending the fifty-one kilometres to Tahakopa in 1915. Only a railway could have taken out the quantities milled here; one mill in 1960 was estimated to have cut 2,500 cubic metres sawn a year for fifty years, enough to build 12,000 homes. The Catlins will never see milling to this extent again. Casualties of the Catlins Line included **Ratanui, Parae, Houipapa, Maclennan** and **Caberfeidh.** Houipapa, typically, had stores, a post office, a boarding house, school, dining rooms and a hall that served for church services too. Caberfeidh meant "Stags Head!", the war cry of the Seaforth Highlanders. It had three grocers and a chemist. Maclennan's railway station trebled as post office and Sunday School with an attendance of eighty; Kahuika was a settlement in the valley. Parae was known as Tahora until 1916, the name-change due either to its clash with a North Island station or a suspicion that it was a Maori vulgarity.

Bob Stott lives in the past. Not the dim distant, but the past that peaked in the '50s, when the Ks and KAs and Js thundered up and down our Main Trunk lines, when you tumbled sleepily out of a carriage at Taumarunui for a cuppa and a pie and walked briskly up and down the station shivering and unsure which was steam and which was your breath-clouds, as men tapped wheels and un-coupled and coupled, with much clanging and shunting, another great, hissing, iron dragon in readiness for the next breathtaking 150-kilometre dash through the night. Those were the days when travel was an occasion.

Bob has a gripe. We all know the names of the passengers who came out on the first four ships but nobody is bothering about this most recent and colourful chapter of our history that is cooling and evaporating before our very eyes.

> *Her whistle called and she was gone,*
> *And the winds of the plain blew free.*
> *And the Lord of the Ranges packed away*
> *To the smoky gloom of the sheds.*

Will Lawson on riding the express through the King Country.

23

An untimely doom
The coaltowns

He said he worked in pillars, where the place would creak and
* roar,*
And he also worked hard stentons, and could always fill a score.
At driving in back headings he would bet me ten to one
He'd beat any man at yardage, 'tween here and Millerton.

Hewing Coal on Burnett's Face, Dan Moloney.

Denniston is a working ghost town. Forty or so coalminers still take
the spiral road up into this deserted coaltown in the clouds to take
out 1,000 tonnes a week. But they don't want to live there anymore,
except for a very few weatherproofed spirits like Fred Todd.

"I've been here since 1926," says Fred, "so I must like it."

He pushes back the brim of his tartan balaclava and rolls a durry.
Across the road an alternative-looking chap with a beard is paint-
ing his roof red. Fred explains that he is a woodturner, one of the
new lads up here, the kind that folk in the valley call "hippies".
Fred doesn't mind him. In fact, he even considered copying
the woodturner's red roof, but in the end settled for green.

Fred keeps the reputation for hospitality alive. He ambles out to
meet you, greets you and settles back on his heels for a chat. Yes,
there are only three of the originals left. His wife and mother-in-law
are still with him, but his son and daughter have moved down
below, where all the miners went in the mid-'60s (and some took
their houses with them).

Once there were five hotels here, three stores, two butchers, a
bakehouse, a tennis court and a swimming pool even, though who
would swim up here on this raw and blasted heath beggars
thought. Fred points out where the hospital was, down by that pine
tree there, and there was a big garage opposite that. The school was
taken to Karamea for an assembly hall.

Today it is an eleven-kilometre drive up a winding road to this

Denniston is strictly for tourists outside office hours, because all the workers have moved down below the mist line (except for Fred Todd and a few others). *David McGill.*

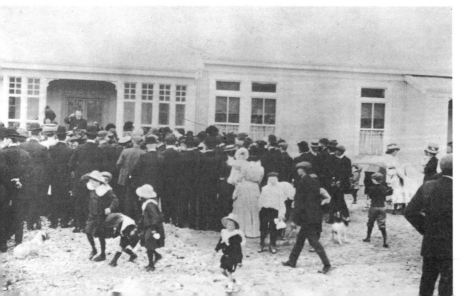

Denniston Hospital, opened November 1910, and now dead and gone. *Alexander Turnbull Library.*

Denniston, 1945. *Pascoe Collection, Alexander Turnbull Library.*

Westport Coal Company's Denniston Mine Rescuing Brigade. *Back row:* W. Brownlie, J. Oldham, F. Duffy, A. Smith, J. McCallum. *Front row:* W. Butler, J. McIllwain, E. Gould, A. Openshaw, W. Hewitson. *Standing:* A. Marshall. *Denniston Miners' Union Collection, Alexander Turnbull Library.*

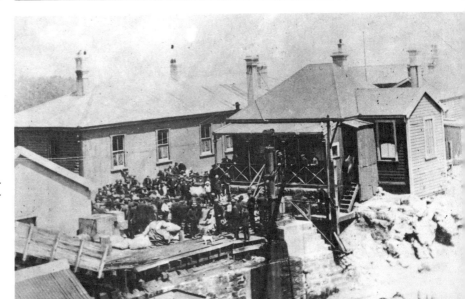

Denniston strike, 1913. *Alexander Turnbull Library.*

stony, barren plateau 600 metres above sea level. It is a pleasant drive past toetoe, flax and rock. The view, when available, provides a spectacular vista of green tableland and endless blue sea.

Denniston was famous for having the steepest self-acting incline railway in the world, falling its 600 metres in under two kilometres, a one to one-and-a-quarter pitch on a forty-seven degree angle, which is too steep to slalom. This one mighty big-dipper plunge closed in 1967 after eighty-seven years at the top. It carried 13,000,000 tonnes of coal, supplies, coffins, billiard tables and pianos and people, although the officious Dunedin officials charged and fined them for so doing.

Constant battering from violent winds, rains and mists bred a tough native. The recreation ground, blasted out of rock, necessarily created the conjunction of skin and sandstone, which was never to the liking of the lowland visiting football teams.

The Westport Coal Company was rash enough to try to block the establishment of liquor outlets up here. It failed. In recognition of their independence, these sturdy Knights of Labour called their first pub The Sons of Freedom.

Denniston had a population of 793 in 1901, with 111 in its suburban village of **Coalbrookdale,** and 212 at Burnett's Face, three kilometres up. By 1905 their combined populations hit 1,500.

Burnett's Face was so cold that the ink froze on James Burnett as he attempted to record its coal lode; he did manage to mark down eight degrees below freezing before his pen seized up. It was because of this atrocious weather that the Face kept on growing, with two hotels, a bakery, a butcher, a fancy goods shop and post and telegraph, and a population that rose to 627 in 1911. Rather than brave three kilometres of hail, sleet, fog, snow and wind, seasoned

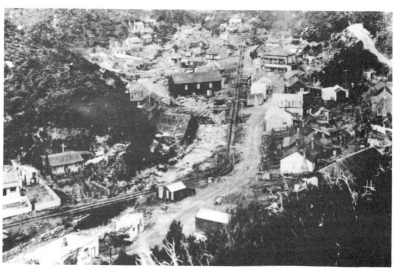

Burnett's Face before 1920.
*Miller Collection, Alexander
Turnbull Library.*

208

Mr and Mrs Charles Dusky and their son, David, at home, Burnett's Face. *Miller Collection, Alexander Turnbull Library.*

with 2,500 millimetres of rain per annum, miners preferred to live as close as possible to their work.

The Face had begun developing in 1886, but by 1916 industrial troubles began the decline. A report in 1919 on the coal industry attributed much of the dissatisfaction of the miners to "the sordidness of their living conditions and monotony of their home life". The report said there was no water supply, no drainage, and the surroundings were "dreary in the extreme".

The people rose above their lowly circumstances. They had two halls, two billiard saloons, a library, weekly card-game tournaments, dances, Cumberland-style wrestling (always guaranteed to get the circulation going), boxing, running, soccer, rugby, trots, whippets, in fact all the diversions that keep the adrenalin pumping and the spirits up.

Like many a town in those days they had a resident joker, who mimicked roosters late at night, who whinnied and stamped like horses to make the miners move aside and who called like the fishmonger so that the women ran outside with their plates to take advantage of this rare event. A trick in keeping with local Mother Nature's was to get under a sleeping man's bed and rock and bounce it to make him think another earthquake had struck. The tale was told of a man reeling home from the pub and responding to his wife's comment, "Drunk again" with, "So am I". And there was the lad who ran home to tell his mum that there was a new man in the two-up game called "Hugh Bugger".

The Face produced a Minister of Mines, but that did not save it.

Many inclined down to **Waimangaroa,** which itself moved down the line a couple of kilometres to Waimangaroa Junction, dropping the "Junction" for the sake of identity.

Granity has survived for much the same reason as Waimangaroa, because it is at sea level, although it is mainly now for the baching folk. From Granity up an inclined rail as high and inhospitable as Denniston is the remains of **Millerton,** its subtown of **Mine Creek,**

209

and, further up, **Stockton,** which never quite broke away to the extent that Burnett's Face did from Denniston. Millerton developed from 1896; Stockton from 1908. Stockton has generally had to settle for its population being lumped in with Millerton's, both reaching 279 in 1901, but now mustering a mere thirty-five.

Millerton was one of those towns with two of everything — two hotels, two butchers, two stores, two bootmakers and two fruiterers, the last named a rather rare business on the Mainland. The locally-managed co-operative managed one store and one butcher, as you would expect in the town where the Granity Creek Coalminers' Industrial Union of Workers was registered. There was a Roman Catholic church and a Primitive Methodist Mission hall, also draughts and rifle clubs.

Reefton has absorbed the coal and the towns around it, namely **Blacks Point, Crushington** and **Progress Junction.** Greymouth is performing the same service in its area. Coal may yet make a comeback, but it is unlikely that it would revive such derelict towns as **Wallsend** and **Brunner,** or Brunnerton, which are so near Greymouth. Brunner will always be remembered for its 1896 mining disaster, when the country mourned the sixty-five victims of an explosion. Thomas Bracken wrote:

At times like this the Great Eternal speaks
In tender tones. We hear Him through the gloom
Talking of sad, wet eyes, and pallid cheeks,
When strong men passed to an untimely doom.

The first Coast coal came out of this town which was named after explorer Thomas Brunner. That early entrepreneur, Reuben Waite, brought coal downstream in 1864. It was there that the State took over its first colliery, in 1868, necessary because of the haphazard and dangerous private development which was taking place. In its first century 7,000,000 tonnes came out of the Brunner mine; in 1883 it accounted for one sixth of New Zealand's coal production.

By 1887 both Brunner and Wallsend had three pubs each. Thirsts were generated by work and play (for Cornish wrestling in canvas coats was popular), and Brunner lad Harry Dunn was world champion in five styles. The Full Nelson hold that I remember being attempted in my playground days was banned after Harry applied it to beat Hannon, the world champion.

Brunnerites were no slouches at athletics either, despite their cramped profession (or maybe because of it) — consider the number of All Blacks today who are accountants and lawyers. The Australian champion sprinter Connors came over to Brunner and lost the 100 yards and the £100 prize to Tommy O'Loughlin. Connors was versatile and won his £100 that night on the smaller green billiard sward.

210

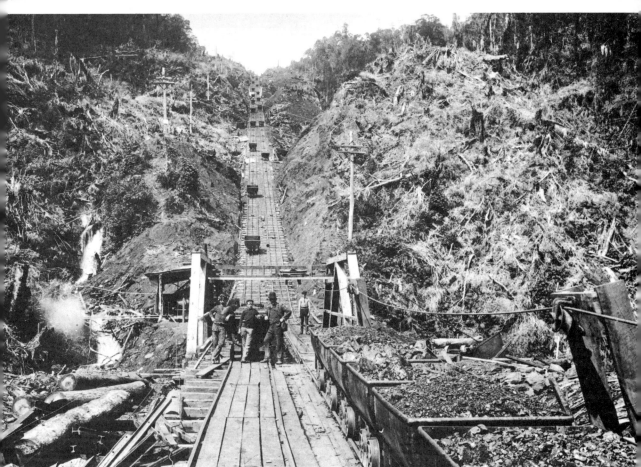

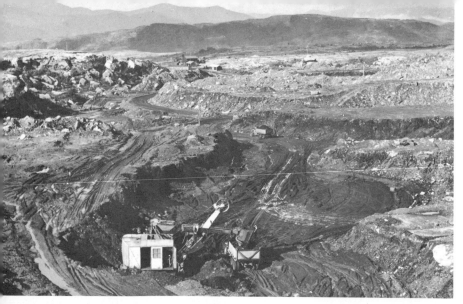

Stockton open-cast mining at the top of the Burma Road, May, 1948. *Alexander Turnbull Library.*

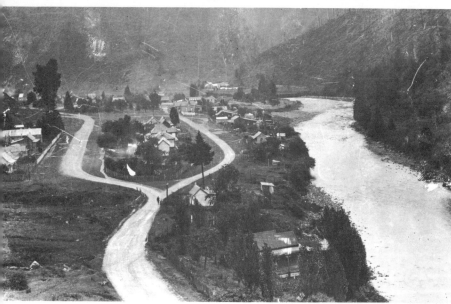

Blacks Point. *Alexander Turnbull Library.*

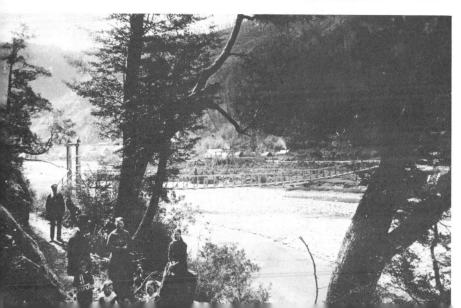

Crushington's suspension bridge. *Alexander Turnbull Library.*

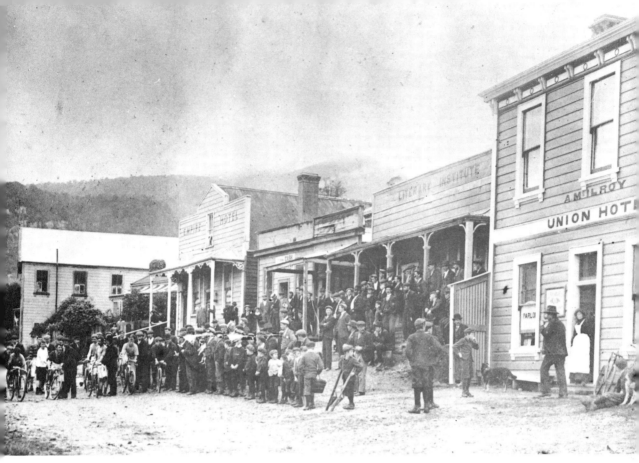

Start of a road race between Wallsend and Omoto about 1903, showing McIllroy's Union Hotel, the Literary Institute, the Billiard Room and the Empire Hotel, all destroyed by fire between 1928 and 1930. *Alexander Turnbull Library.*

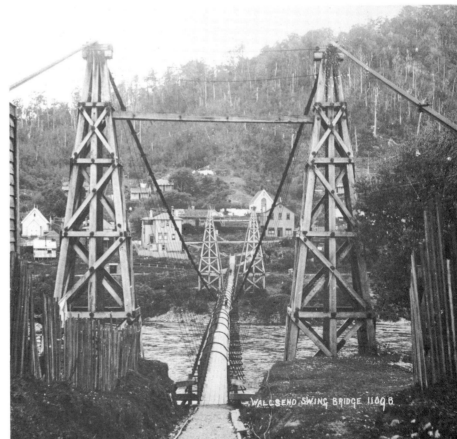

Wallsend swingbridge. *Price Collection, Alexander Turnbull Library.*

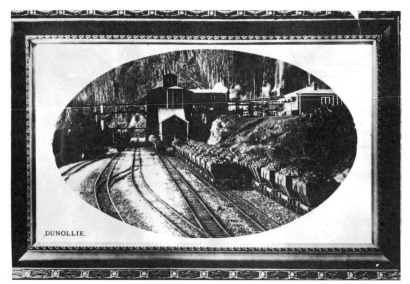

DUNOLLIE.

A cute way to dress up a coaltown. *Alexander Turnbull Library.*

The local ladies were tough too. One doughty dame gave birth and then walked off to do a day's washing.

In similar vein (!) to Greymouth, the Runanga borough has accounted for the coaltowns of **Dunollie** and **Rewanui,** and Blackball has killed **Roa,** where there were 103 people in 1951 and where there are now only nine. They may still be productive, but the car has finished them as townships.

Once there were 130 mines in the Greymouth area, today there is hardly a tenth of that number operating. About 30,000,000 tonnes was taken out of them, and there is as much again estimated to be remaining, not that that has stopped the authorities dismantling derelict towns like Brunner or the historic-minded from trying to save coke ovens and such.

Former state coalmine manager A. Openshaw summed up the fate of these coaltowns when he wrote in the *New Zealand Coal* magazine: "Ghost towns are caused by the means of livelihood having been worked out. But here we find a means of livelihood in abundance, a combination of circumstances having caused the exodus — industrial troubles, the depression of the 1930s, the law of supply and demand, better transport facilities to mines and, last but not least, the realisation that there are better and more congenial localities in which to live and rear a family."

Other declining coal localities are **Puponga** above Collingwood, the Shag Valley above Palmerston and **Kaitangata,** east of Balclutha.

Coal mining ceased at Puponga in 1917, when the mine was flooded. The shaky old wharf somehow survived until May, 1943, when the expected happened — a locomotive and its rolling stock took a vertical path through the wharf to the mudflats below. A

214

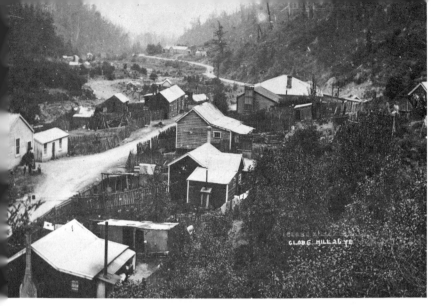

Globe Hill, later Progress
Junction. *Price Collection,
Alexander Turnbull Library.*

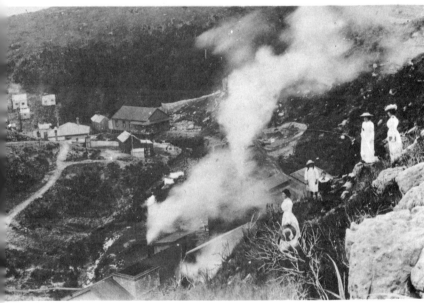

Mine Creek township on a
Sunday. *Miller Collection,
Alexander Turnbull Library.*

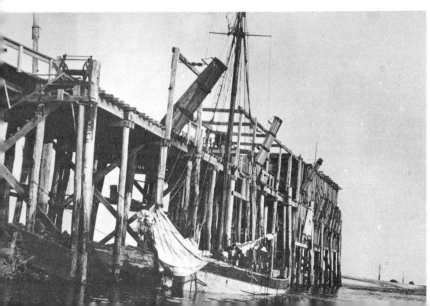

Puponga — the wharf
the train went through.
Alexander Turnbull Library.

feature of Puponga was its weighbridge office, which was the converted body of the railway tram which used to be on the Dun Mountain run from Nelson, the country's first railway line.

Shag Point was the centre of the Shag Valley coal mining. In the 1890s it had stores, a school, a pub and post office, three blacksmiths, two butchers, a brick and tile maker and a baker who did a fancy line in biscuits. Off the map is **Green Valley** which, in 1890, had a teacher and a store/post office, and Inch Valley, generally regarded as an outer limb of Dunback. Katiki, too, was seen in the 1900s as part of **Hillgrove,** a once-flourishing fishing village with several teachers and an hotel. Cook's misspelling of Kartigi was rectified, but Otago has stood for Otakou. Waihemo, which is only the county name today, was the original name for the Shag River and the settlement of **Waihemo,** which boasted two hotels in 1878, the year before the big strike.

The placenames in this area have enjoyed rather more than the usual mobility over the years. Kartigi was either Inch Valley or Dunback on an 1876 map, which showed no sign of Shag Point, but did list **Shag Valley,** just above what was then Kartigi. In the 1870s Shag Valley had a store, hotel and fellmongery. By 1900 it had a flour mill, blacksmith, boarding house and miners and farmers. Today it has fourteen folk.

Kaitangata, at the turn of the century, boasted four churches, two hotels, a hall, an athenaeum and a library. It is an area where gigantic coal reserves have been identified, but the coal is presently considered too poor to be economically recoverable. When oil becomes economically prohibitive, Kaitangata may then rival the wealthiest goldtowns, as indeed may many another slumbering coaltown.

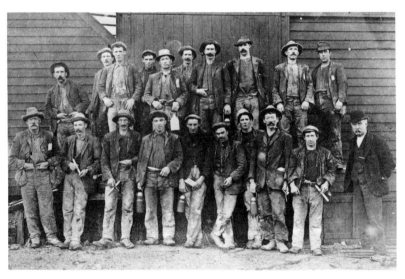

West Coast coalminers.
Alexander Turnbull Library.

24

A load of old rope
The flax boom

Whether by boiling with soap, retting and beating like the European flax, passing between fluted rollers, or other processes which the foolish inventors made it a point to keep secret, the expense of producing was too great, and the material produced was generally harsh and inferior in quality to the produce of native manufacture.

Adventure in New Zealand, Edward Jerningham Wakefield.

The Maori rejected most of the flax leaf as refuse, and made enough silky rope as he could use from the rest, whereas the Pakeha used all the flax leaf and made a coarse rope, which he tried to sell for profit. This clash of cultural attitudes was seen as much in the swamps as in the forests of New Zealand.

Wakefield wrote that flax was intended to become a major export and that it became fashionable to have an "idea" about flax. The ideas proved ultimately as worthless as Heath Robinson's, without intending to be so.

Marshlands above Blenheim may have been the last flaxmill from the early flaxflush to still keep going into the 1960s. There was one valuable spin-off historic industry which resulted from this activity in the local writings of the late Frank Smith, the Grand Old Man of Marlborough. He was in his mid-nineties, a few days from death, when he gladly agreed to talk about flax, which was his abiding interest. This upright old man with the thick black horn-rims and the striking white spade of Quaker beard was revered for his depth of local knowledge. He talked of the pride he took in having ploughed deep into his small regional furrow. He talked with affection of his three-kilometre walk to school, when he could hear five flaxmills at work.

"I well remember in the '90s depression," he said, "many a farmer paid his way on what he made from flax."

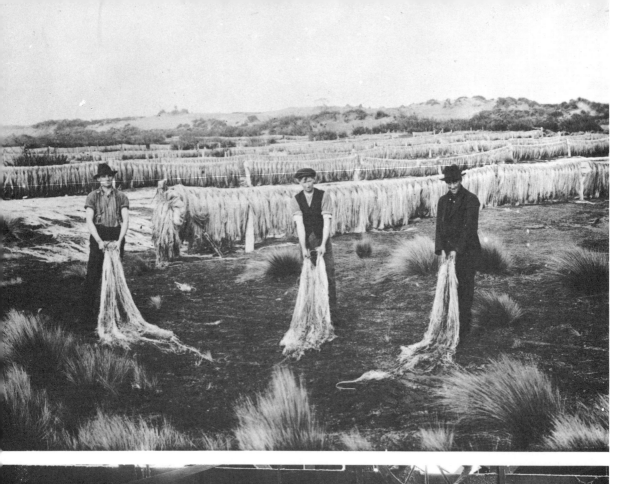

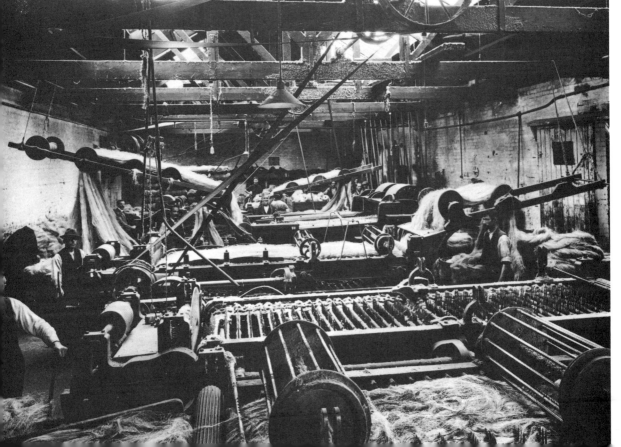

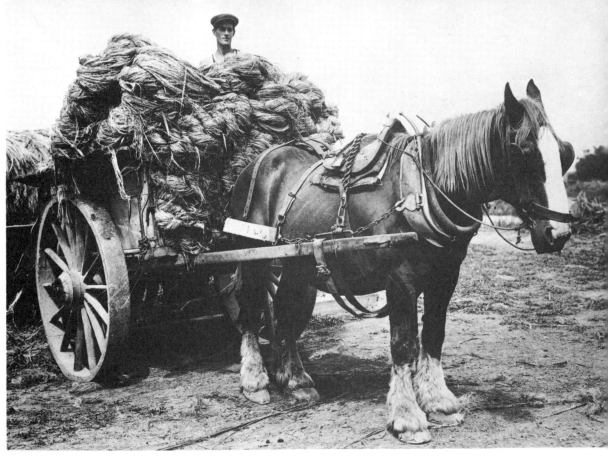

Flax in the days when there were high hopes for the industry's export potential. *Alexander Turnbull Library*.

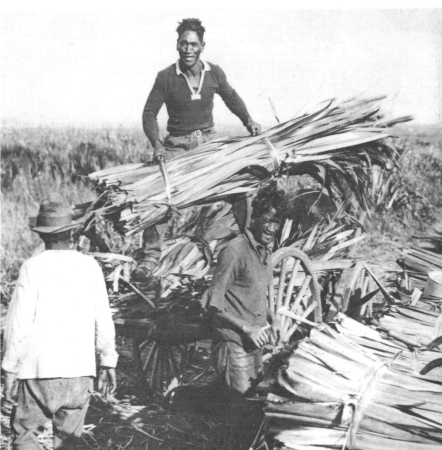

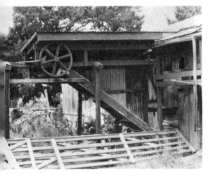

Marshlands provides its version of the ubiquitous Kilroy, and a little of the flax rope for which it was once so famous. The flax machinery lies unused now within the timber mill that replaced it. *David McGill.*

The catchment board drained the valley and that was the end of the flax. Marshlands was the last to fall and he believed it could very easily be revived.

Today Marshlands is as arid and empty as any well-worked gumfield. The whole area was once deservedly known as Wai-kakaho, after the kakaho or flowering stem of the toetoe which was so abundant there when the white man arrived. Fred Tuckett, New Zealand Company Chief Surveyor in Nelson, said the flax and bull-rushes limited progress to two kilometres per hour.

In 1843 land tenders were called for at 10d an acre and 6d a chain for cutting lines accepted. Cattle were run there until Sam Bowler took over in 1861. In 1870 he erected the Marshlands flaxmill and became a member of the Flaxdressers Association, which was designed to encourage an industry chaffing to exploit the country's new, abundant raw material.

One of Bowler's most valued employees was the Negro Arper Arthur Ailsworth, commonly known as Black Jack White; he liked to point out that White's Bay was named after him because he was the first "white" man to live there! The Marlborough press gave this droll fellow a 297-word obituary when he died in 1894 at the age of eighty-one, a native New Yorker who had come here as a whaler, aged sixteen.

Powick Brothers and Burroughs established a flaxmill in 1869, Seymour and Western set one up in 1870, David Boyes in 1872 and Jo and George Gledhill in 1880 on the bank of the Wairau, between Blind Creek Bridge and Thomas Road. By 1888 the Gledhill mill was processing a tonne of flax a day and employing fourteen hands. Chaytor took over from Bowler and employed twenty hands. The many fields of flax grew to a height of three-and-a-half metres and were rated, at least locally, as the best in the country. This was confirmed, perhaps, by a consignment being sent abroad to represent New Zealand flax at a trade fair. Revolution in the Philippines removed the competitive threat from the superior manila hemp, and the New Zealand flax industry boomed through the latter part of the century, with £100 a week circulating in the Marshlands area from flax production.

The industry hardly made it through the first decade of the twentieth century, and with it went the butchers, blacksmiths, brickworks, and other local businesses. Today Marshlands is comprised of four houses and the rusting remains of the flax chains and machinery which share big sheds with the timber industry that has replaced it. A local woman remembered from her childhood the flax being hung out to dry on fences like miles of washing. She warns that the floorboards are rotten for those who want to poke round. Her pre-teen daughter gallops by on a horse, coolly jumping it over a broken fence, wheeling the animal around to a halt with

220

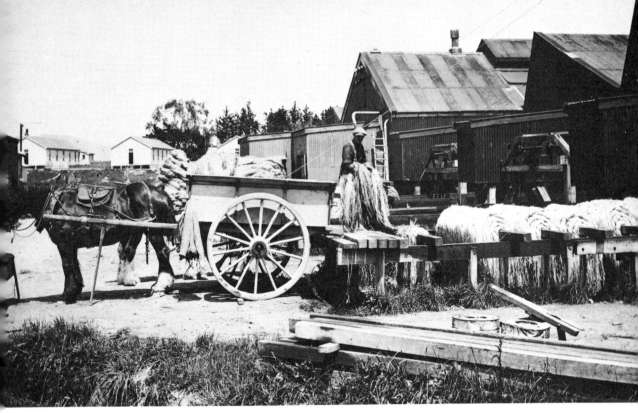

Miranui flaxmills, three kilometres north of Shannon, 1917. Fibre is being carted from the mill to the bleaching paddocks, in case you were in any doubt. *Adkin Collection, Alexander Turnbull Library.*

the correct panache of a potential Princess Anne and solemnly announcing that she was no longer afraid of the horse and might buy it.

Having questioned the visitor and discovered that he was from boring old Wellington, where she had been (she much preferred the country to that city), she spurred her horse off across the plain. Silence returned. A door creaked dryly. The white shed that was once the post office/store sagged from the heat and neglect. The brown and barren plain shimmered in the sunlight. The sky was high, wide and baleful. Agoraphobia could set in here.

Rauhuia, New Zealand flax, or *Linum monogynum* was the country's first indigenous export, if you don't count dried heads. The Port William, Stewart Island, exports peaked at 763.8 undressed tonnes in 1831, the same year that Kapiti Island was exporting the fibre. Wellington claims the first flaxmill in the country in 1846 — where Cuba Street is today. William Dunn had a tonne of flax dressed and dyed there and sent to England, where it was never heard of again. Later on England did not want to know about this load of old rope. Phormium tenax reached 579,000 tonnes in 1906, when there were 240 mills grinding around the country, most of them in the Manawatu.

Miranui, a few kilometres from Shannon, was the country's biggest flaxmill. In the mid '20s, 300 people worked there, almost half the Manawatu's flaxworkers. It ran for thirty years until 1933,

221

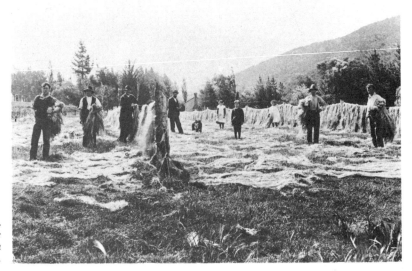

Flax drying at Evans Flat, about 1910. *Lawrence Museum Collection, Hocken Library.*

producing several million dollars' worth of the fibre. The "flaxies" had a store, reading room, billiard room and dining room which seated 130 and a rugby team. The 100 hectares of bleaching flax which was hung out to dry could have been mistaken at a distance for a tent-town hit by a hurricane. The industry was ruined by natural resistance rather than disaster, for the flax would not grow as fast as the managers required it, not even when it was mutated.

Northland was the other flax centre, with mills at Kaihu, Parore, Tangiteroria, Tangaihi (now Tangaehe), Tatarariki, Okahu, Raupo, Hoanga and Waihue; the last-named was the last to close, in the early 1970s. Further up there were mills at Whangape, Horeke, Mitimiti, Waima, Mangonui Bluff and **Wairohia,** the last settlement no longer in existence. **Flaxmill** on the Kaihu River lost its name to Babylon, and continued its losing streak with timber and gum, most engagingly in the spectacular 1928 failure of Dr Israel from Germany, who tried to boil gum out of kauri with a two-storey steel contraption.

At the top of the South Island, at the head of the Whanganui Inlet, **Kaihoka** had two flaxmills until it was abandoned in 1922.

On the West Coast **Poerua,** originally **Paerau,** had fifty or so government-settled flaxies in 1896, served by a school and post and telegraph office.

Southland had flax milling at Colac Bay, Pahia, Kaitangata and Fortrose, where there were six flax mills.

It seems unlikely that flax will ever be much more than a poi and pipi-basket industry, which is what it was perfectly happy to be before the grand profit-making proposals of the Pakeha.

222

25

Here, there and everywhere
North Island miscellany

Opepe, a clump of bush eighteen kilometres east of Taupo, must rate as the North Island's 22-carat uncategorised ghost town. In the 1870s it was a thriving community centred on an Armed Constabulary unit. It had been a traditional crossroads of tribal conflict and, in 1869, Te Kooti extended the engagement to the wiping out of nine of a fourteen-man contingent of Armed Constabulary.

Trooper Crosswell was perhaps the luckiest and certainly the most determined survivor. None but a sergeant made a fight of it, but at least Crosswell had the excuse that he was naked at the time, while his clothes were drying. He took his bare bottom off on an incredible journey of sixty-seven kilometres through rugged mid-winter terrain across the Kaingaroa Plains where bareness of foot was surely this footsoldier's greatest trial. He did it in two days.

The following year Opepe's Redoubt was completed, comprising a stockade with crow's nest to hold thirty men, and bark and slab huts for another 100. By 1873 the men had laid out good paddocks of English grass and private enterprise had occupied them in the shape of Smith and Mayo's store, a bakery and a wet canteen, replaced that year by William Cassion's hotel.

Races were on the card. A press report of the Christmas, 1871, races stated that they began on foot at 4 am, but there is no mention of Trooper Crosswell. The horse races were notable for the "splendid fencing of High Flyer in the hurdles, and fine staying qualities of the Sergeant's mare".

Opepe also ran to theatrical performances of such contemporary favourites as *Chops of the Channel* and Box and Cox.

Doubts about the Opepe Hotel were resolved on 21 May, 1875, when Sergeant James McE. Delaney reported that he found one dining room, two sitting rooms, six bedrooms, one store, one bar and one kitchen to be clean.

The town died with the departure of the Armed Constabulary in 1886. Today Historic Places buffs are restoring what they can find of

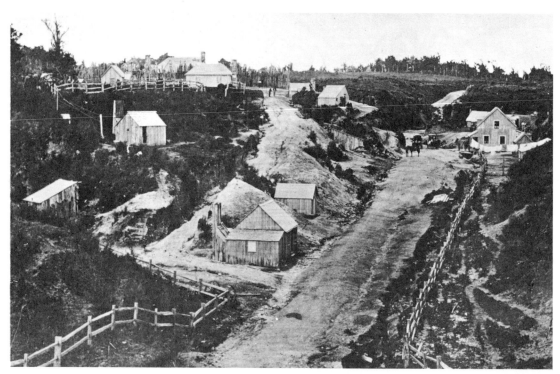

Opepe, about 1880. *Alexander Turnbull Library*.

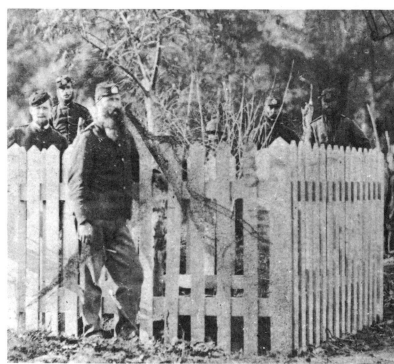

Graves of Te Kooti victims at Opepe, photographed in 1872. *Alexander Turnbull Library*.

224

Above left: The Opepe monument, curious for not identifying itself and for naming the survivors rather than the slain. *Alexander Turnbull Library.*

Above right: Main Street, Opepe, in 1959. *Alexander Turnbull Library.*

The water trough used by soldiers at Opepe, 1869 — a trough one particular soldier had to thank most heartily for helping him survive a Te Kooti ambush. *Alexander Turnbull Library.*

town and graves, which includes the water trough, once a three-kilometre journey west of the Redoubt to water the horses and bullocks. It was this scarcity of water that may have saved Trooper Crosswell's life. Many years later he was contracting on the Waioeka Gorge road when a Maori came up to him and said he knew him well. Crosswell drew a blank, until the Maori explained that he had watched the trooper at the old trough, but did not kill him lest a shot warned the other soldiers of the planned attack.

Opepe had an athenaeum, but it could not match the Temple of the Arts forty-two kilometres down the road at the second military post of **Runanga.** This was really an outpost or upper town, for it only mustered twenty or thirty men; they did once invite the Opepe regulars to an orchestral concert in their Temple, so clearly their lack of numbers did not militate against their savoir faire.

225

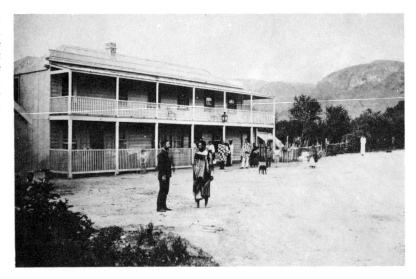

The popular Rotomahana Hotel at Te Wairoa, with proprietor McRae in the foreground. The first photograph was taken in the 1880s, before the eruption. The second speaks for itself. *Alexander Turnbull Library*.

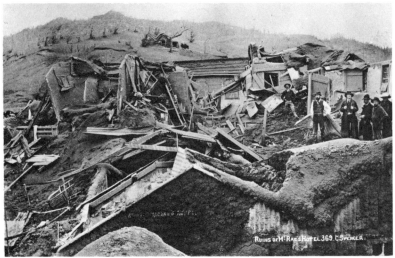

Much further down the road was **Kuripapango**, a summer hill resort for Napier officers and their families, a notion they rather impractically brought with them from India, for Napier was hardly a sweltering hellhole. No matter, the *British Medical Journal* advertised Kuripapango as the best place in the world, although it could not come up to the elitist standards of Poona.

Alex Macdonald ran the swish hotel at Kuripapango, and in getting folk to come there, confirmed his reputation as the country's crack coach driver. From 1893 Macdonald and George Rymer ran competitive coaching services for eight years between Napier and Kuripapango, over the ironically-named Gentle Annie. Kuripapango meant "wild dog", but its attractions were wild pig, wild

226

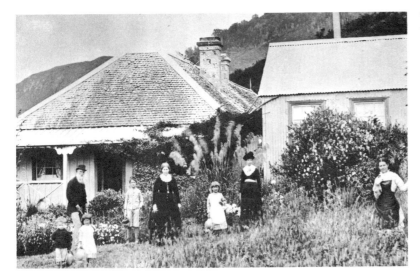

The Haszard family outside their Te Wairoa home, about 1880. *Alexander Turnbull Library*.

Ruins of the Haszard home after the Tarawera eruption. *Alexander Turnbull Library*.

pheasant and tame trout, plus all the mod cons of the day, not forgetting the bracing air at 600 metres above sea level. The hotel was burned down, but despite this people had caught on that there was nothing wrong with Napier, and that included Alex Macdonald's daughter, Rose.

A steel sewing machine driven through the trunk of a dead tree is the first evidence of **Te Wairoa**, the Buried Village, between Lakes Rotokakahi and Tarawera. Te Wairoa was an egalitarian resort town, the stopover for tourists visiting the Pink and White Terraces of Lake Rotomahana. It was the village of the Ngati Tuhourangi, of the Arawa Federation of Tribes, and Pakeha employees of the Rotomahana Hotel also lived there.

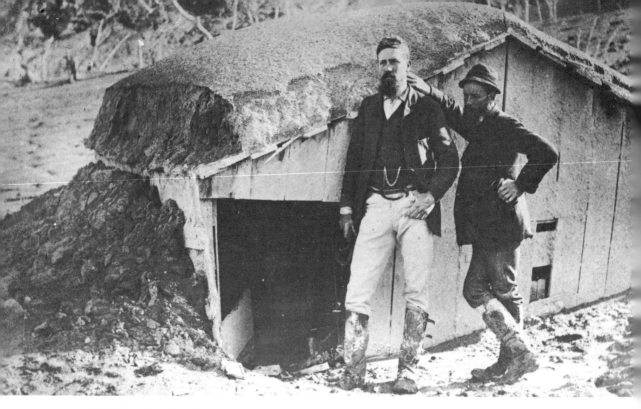

Te Wairoa, just after the eruption in 1886. Lundius is on the left and Blythe is on the right. *Alexander Turnbull Library.*

Petrified cat, Te Wairoa, 1901. *Thomas Collection, Alexander Turnbull Library.*

Facing page, top: Jerusalem in the 1890s. *Alexander Turnbull Library.*

Facing page, bottom: Jerusalem, 1921. *Alexander Turnbull Library.*

The village had a carved meeting house, a store, blacksmith, flour mill and another hotel, with orchards in the hills behind. Tourists were taken by whale boat across the lakes to view this Eighth Wonder of the World. That is, until Mt Tarawera erupted on 10 June, 1886, burying the Terraces and Te Wairoa. The Rotomahana Hotel collapsed under the weight of ash, killing a young Englishman. Tepaea, better known as Sophia Hinerangi, sheltered and calmed villagers and tourists in her whare.

Remnants of the village include the barman's hut and its iron bedstead, his shotgun and shaving gear and traces of the store and the great stone oven of the Rotomahana Hotel.

Port Awanui on the coast east of Tikitiki was a farmers' port early this century. It ran to two hotels, a shoemaker, a constable, a store, a teacher and a wharfinger. Floods before the last war speeded its demise.

Jerusalem renewed its mana in the early '70s under the influence of the Catholic poet James K. Baxter, but the heart-beat has almost gone again from this former headquarters of the Roman Catholic mission to the Maoris. Mother Mary Aubert lifted it to a spiritual height and a population of 200 in the late 1800s and the Queen of the Settlement also ministered to physical needs with a successful farm and orchard and a line in "cast-off clothing". Ranana, or London, below it and Pipiriki above have both survived somewhat better, although the latter's accommodation house was burned down in 1959.

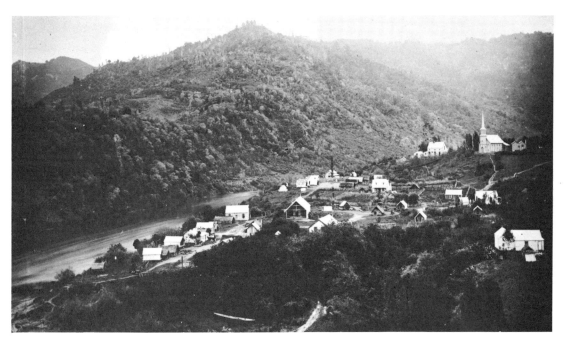

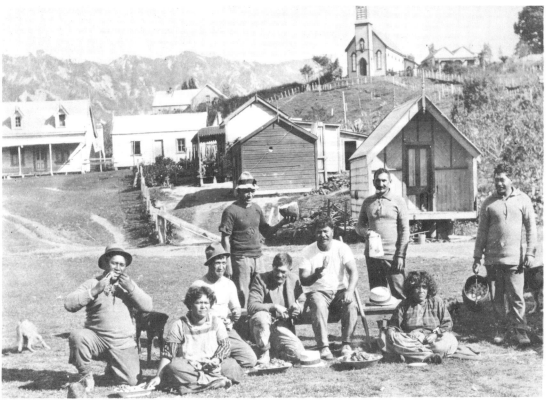

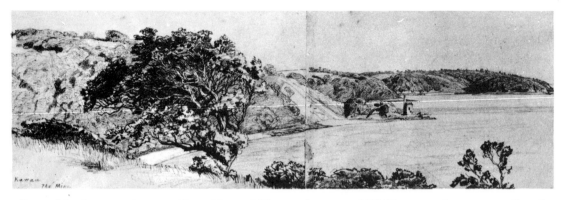

Kawau Island copper mine, a pencil sketch by James Grove Richmond, some time in the 1860s. *Alexander Turnbull Library Collection, Alexander Turnbull Library.*

Cape Terawhiti, south-west of Wellington, deserves noting for the goldminers who persisted there from the 1860s through to the occasional prospecting farmer in the 1940s, surely the nation's longest-sustained effort to extract the yellow stuff. It was almost certainly the biggest duffer, for $1,000,000 was spent for a return of $8,000. The peak came in the early 1880s, when twenty-six companies worked the area, living in huts and being serviced by Dorset's store. "Never Despair" was the ill-advised name of one of the companies that tackled this rugged outcrop. The mines are still there, in good condition, monuments to man's rash and virulent fever for gold.

Kawau Island in the Hauraki Gulf was mining of a different colour and altogether more successful. Once 400 men worked the copper mines and lived in huts nearby. Mining was so successful in 1842, the first year of operation, that a rival company tried to get in on the act. It had to settle for the nearby island of **Motuketekete** and managed to carry on for one successful year, 1846, when the two mines took out a combined total of 1,221 tonnes, up 474 tonnes on the previous year. The next year the take was down to 168 tonnes due to swamped mines, and, in the case of the Motuketeketeans, swamped lighters. The offshore islanders sold out, and the main islanders mined on until 1862.

Tikitikiora, a few kilometres below Russell, had its two decades of mining manganese from 1872, and was reputed then to be bigger than Russell. There is no evidence today of this singular venture.

Nor is there any evidence of the first organised European colony in New Zealand, set up on **Pakihi Island,** across the Firth from Thames, in 1826. Captain Herd brought the colonists in the *Rosanna* to cultivate flax, mill timber and maybe mine the island's minerals. This small conical island was a curious choice, unless defence was uppermost in the colonists' minds. That would appear not to be so, for when they were confronted by the Bay of Islands Nga Puhi fleet in close chanting hakas and holding up severed heads, they all took off for Sydney or Hokianga.

This deserted store is typical of the decline in trade by water on the east coast of the North Island. *David McGill.*

230

26

Faithful — for a time
South Island miscellany

Barrhill takes the biscuit for uncategorised South Island ghost towns. Today there is a farm house, a few holiday homes, and great avenues of oaks, sycamores and birches enfolding the little church of St John the Evangelist — all that remains of the most bizarre delusion of old world grandeur that this country has witnessed.

John Cathcart Wason was the eccentric Scot who recreated this village squirearchy. He was the Lord of the Manor, and he had an entire village built and peopled in the traditional forelock-tugging style. We have the unpredictability of the railway rather than any nascent egalitarianism to thank for the scotching of this reactionary model.

Wason purchased 8,000 hectares on the Rakaia River in 1870, and named it Corwar, after his Ayrshire ancestral home. He made it one of the best-farmed properties of the day; few could match the splendour of Corwar Castle, a twenty-room mansion which just naturally had to be high on a cliff, overlooking the Rakaia and his minions. In poetically just fashion the lodge has survived while Wason's folly has been consumed by fire, a warning perhaps to all importers of megalomania.

Trees were Wason's redeeming feature, and indeed his much more fitting memorial. Barrhill is crowned and enclosed in glorious avenues of oak, birch, poplar and sycamore. Streets named after these trees have little meaning now, for the twenty-eight village sections around Market Square are no more. He had the cottages built for his villagers, who included a carpenter, farrier, gardener and bricklayer. Buildings included a bakery, post office, smithy, the pretty stone church, a pub and a school opened in 1878 with twenty-three pupils. The church has survived as it was meant to, and the former school and schoolhouse and the pub remain in a manner for which they were not intended. All the other buildings have been removed.

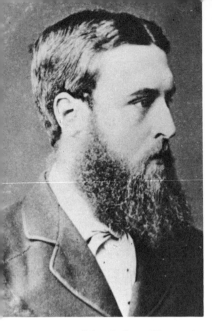

John Cathcart Wason, the man who wanted to be squire of his own medieval village in deepest Canterbury, but who had to return to the outermost reaches of his native Scotland to indulge his delusions of grandeur. *Alexander Turnbull Library.*

Church of St John the Evangelist, Barrhill — the only authentic survivor of John Cathcart Wason's dream of a medieval village in deepest Canterbury. *David McGill.*

In 1890 the new railway line to Methven was built several kilometres to the south, thus spelling the end of Squire Wason's dream. He had served on the local council, road and hospital boards and became a Member of Parliament, but none of these posts carried sufficient weight with the railway authorities to divert the train through Barrhill. The land belongs fittingly to descendants of the man who defeated Wason for his parliamentary seat of Ashburton in 1893.

Wason was not washed up. No man who could settle an argument by upending his opponent in a bowl of trifle was going to buckle at the loss of a mere village. John Cathcart returned to his native land and was duly returned as member for Orkney and Shetland Islands, as a Unionist or Conservative. In typical style he fell out with them and switched to Liberal, on which ticket he held the seat until his death. He may have been cantankerous, but he was also cunning, and no doubt the retention of his seat had something to do with his habit of knitting ostentatiously with Shetland wool in the House of Commons.

Those who have walked under the spreading branches and passed under the church portal, will surely bless the bad-tempered old bugger.

Cable Bay above Nelson only collapsed when the cable was shifted to Titahi Bay in 1917. From 1876 the cable supported a departmental community of staff and cadets, the Eastern Extension Cable Company staff and cadets and the Press Association agent and family. The agent's cottage remains there by the water, but the big institutional buildings were gutted by fire. The cadets are on record as spending some time fetching for themselves. Reports of rotten-egg explosions and rice boiled in red handkerchiefs persuaded the authorities to maintain a housekeeper there at all times.

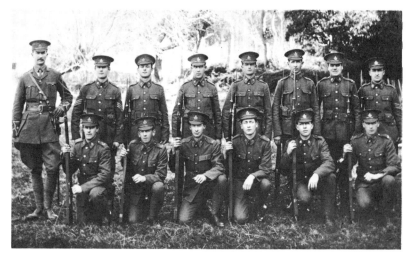

Cable Bay protectors, 1914, in the days when the cable was our only link with the outside world. It therefore had to be suitably protected from anarchists with bombs. *Jones Collection, Alexander Turnbull Library.*

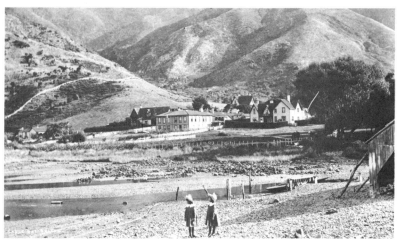

Cable Bay in the 1900s. *Tyree Collection, Alexander Turnbull Library.*

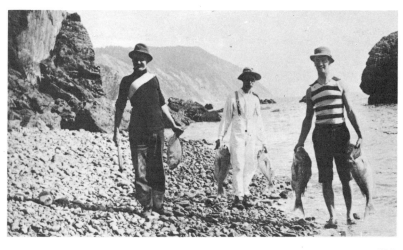

This proud trio have taken time off from telegraph duties at Cable Bay. *Alexander Turnbull Library.*

Supplies came from Wakapuaka by gig, bike and dogcart. In recent years Wakapuaka itself has been declining, losing its store, church, school and creamery, as well as the famous Black Horse Hotel. This was once run by an Annie Oakley-type of woman dressed as a man with a silver-mounted riding crop and .32 revolver. She rode two black horses. The area was a tough one, renowned for the bullockies' game of nose baiting, where you exposed one eye and tried to peel your opponent's nose with a bullock whip.

Port Robinson, below the mouth of the Waiau, is down from a population of sixty-three at the turn of the century to eight today. That is at least better than **Stanley,** a port that developed and disappeared in the space of one year. There were high hopes for this port at the harbour entrance to Invercargill, opposite Awarua. The Maoris had pronounced doom on the venture, and there was strong lobbying to develop Riverton instead. In their wisdom the local authorities voted £30,000 for Stanley. A year later it had silted up, and that was the end of that, money poured straight into the shifting sandy sea.

Port Robinson landing slip, about 1893. Alexander Turnbull Library.

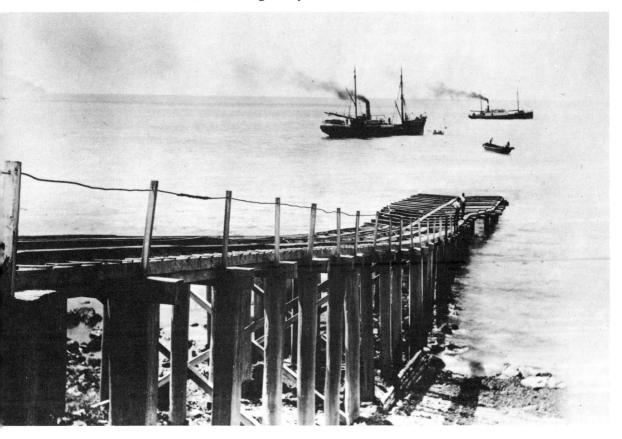

234

Public works have tended to be temporary in their settlements, but **Ranzau** and Sarau have the distinction of coming into existence because promised public works were not forthcoming. It all began back in the 1840s at the New Zealand Company office in Hamburg, where the promotion of the promised land was alluring and quite misleading. By the time the German settlers arrived the Company had collapsed and was no longer hiring immigrants for public works. Many headed for Australia, but some settled on the Kelling farm in Waimea East and others established Sarau at Moutere. Sarau became Neudorf, but the town of Ranzau soon had its Lutheran church, school, store, butcher, hotel, the usual makers of bricks, boots, buildings and beer and even an Oddfellows Hall. Facilities were shared with nearby Hope, which eventually absorbed Ranzau in the late 1870s.

Arawata, Jackson Bay, was a well-meaning but totally misleading government experiment of the 1870s. Official pamphlets lured 600 Britains, Poles, Germans and Italians to this unbroken wilderness where the malicious mosquito and the savage sandfly descended on all who dared set foot there, never mind the problems of a food

The opening of the Midland Railway Line at Jacksons about 1894, when the area anticipated boom times. *Alexander Turnbull Library.*

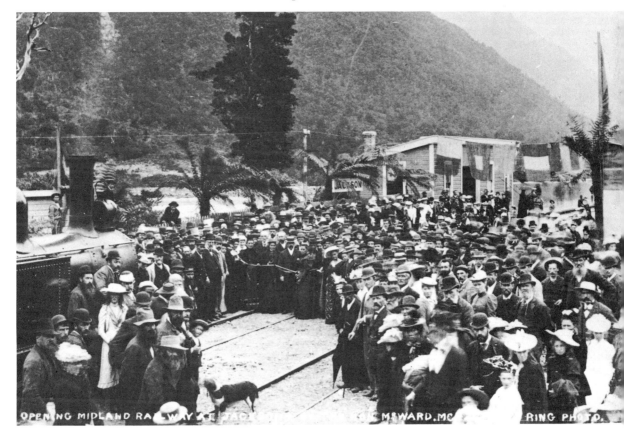

shortage and incessant rain. The government saw great prospects in milling timber to the extent of 19,000 cubic metres sawn, and in fishing, mining and farming. None were realised.

A Royal Commission in 1879 asked the locals to determine their first requirement. They replied with a request for a jetty.

Their second requirement?

Answer: a jetty.

"For want of a jetty," said James Robinson, "the settlement is dying." He knew, for he had a stack of sawn timber on land and a ship in harbour, but no way to meet the twain.

During this miserable period the pioneers did stage some race meetings. Perhaps typical of the feelings that this place engendered was the dastardly incident where the hot favourite was kidnapped by a rival and ridden all night long up and down the beach to tire the horse.

The Royal Commission got there in time to see the settlement collapse, timing, some might say, Royal Commissions have been noted for ever since. After it was abandoned, a landslide confirmed its demise.

The Marion and Homer public work camps housed 500 men, and a few brave wives in the 1930s, but the nearest shops were 160 kilometres away, and so would the men have been if there was any other job to go to. **Tophouse** was more of a town, for public workers cutting through the road between Marlborough and Nelson kept its school and hotel ticking over. Tophouse has seen them all: explorers, trackmen, diggers, drovers, roadmen, hunters, tourists, skiers, trampers and swagmen — it used to receive a small annual grant to feed and shelter the swagmen.

Tophouse was a moveable waystop. The first homestead was established there in 1840, smack on the boundary of the two provinces. This cob and thatch cottage became an inn. The second cob and thatch cottage went up across the valley in 1859, where mine host was variously spelt Adolf Wiesenhaven and Adolph Wisenhaven; he was said to have hands like frying pans, with which he delicately played a piano. In 1876 the telegraph station was established there, eight kilometres to the west of the present Tophouse which was built in 1887. Bullet marks can still be found in the verandah roof, evidence of the time when a jealous lodger shot a rival for the governess' affections. He then threatened her throat with a knife before he shot himself.

236

27

Hometown ghosts

Matata, twenty-seven kilometres north of Whakatane, was the compass of my boyhood world. Dad was the postmaster. We grew up in the house attached to the post office, and my brother Michael and I went to school with Gary Lees, son of the storekeeper. We went to church, where we served as altar boys, although my over-zealous arrival for this purpose at 4.30 one morning was not welcomed by a sleepy nun. We played in the lagoon and the hills, hunted for shipwrecks on the beach (and once found one), and kept away from the haunted house.

Today Matata is my ghost town, although there are now 522 people there, a few more than in my childhood days. Last time I was through, the Duck Inn was still there. This was once the scene of a memorable gorging on ice-creams, pies, sherbets and toffee which was financed by a delirious discovery of 10s in loose change in the golden sandhill that we often dug hopefully into.

Alas, the old, rusty, corrugated-iron picture show has been burned down. Granma only ever went there once. She sat upstairs in the dress circle, a sort of attic or choir loft, which was covered in dusty blue velvet drapes. She never went there again after a rat ran over her blue straw hat with the shiny artificial fruit on it. She kicked up almost as much fuss as Mum did the time she went to the outhouse and sat on a hedgehog.

My first memories were of huge summer bush fires raging over the hill behind and surely about to consume the post office; of winter seas crashing over the lagoon and surely about to cross the road and swamp the post office, and of great cracks of thunder and shafts of lightning threatening the end of the world when my little one was just beginning. Bedclothes, Mum's apron and Granma's lap came in handy on such occasions. Dad was usually busy looking for candles in the dark, saying things we weren't allowed to say.

When I came back from my first expedition, to the Devons next door, I had an armful of kittens for Mum and the rest. I had to take them back. Years later I met Georgie Devon in a Wellington pub, in white overalls and now the foreman of a glass company.

237

A lot seemed to happen very slowly — smoking stolen Capstans and First Lords, burnt black potatoes cooked in their jackets in our hut in the lupin field, golden pears shot down with our lancewood bows and arrows of applebox, Mike hitting me in the Adam's apple with a cricket ball up the footy field where they had hangis of pork and puha, the old kuias in long black dresses smoking pipes and lying in the sun against the iron fence next to Lees' store, no lollies for Lent and the incense, palm fronds and sadness of the Stations of the Cross. Putting mirrors under girls' dresses, fights down the Sandhill after school, White Island smoking, pipi feasts, going to the flics before Christmas Midnight mass and then the long wait for the presents. Having to help Dad in the garden and chop wood, going fishing with him, although he never caught anything — once a whale was washed up on the beach, down by The Cut, where Dad whitebaited, successfully. Sometimes the beach was covered with conch shells, sometimes with silver piper fish and mini-swords.

The author outside his childhood home, laying a few ghosts to rest.
Carol Cromie.

I won 700 marbles. A big boy took them off me. I got over it eventually.

Today Matata is very small.

238

28

Ghost-script

The farming industry looks likely to provide the next crop of ghost towns. Reasons for this include the current contraction of the economy and the current expansion of the monopoly-minded, while ease of travel makes outback settlements somewhat obsolete. A Country Calendar television programme in 1978 on Lyndhurst in the Ashburton County provided a graphic illustration of the decline and desertion of a farming township.

At this point in time Cromwell is about to be drowned in the name of hydro-electric progress, as the politicans have it. Perhaps they might consider reparation for this manmade Atlantis by following the lead of Nantgwrtheyrn in North Wales, an ex-quarry town that has been bought by an educational trust as a centre for Celtic studies. The stone cottages have been converted into residential accommodation, the manager's house into the warden's home and the chapel into a social and religious meeting place.

Here we have Wiltsdown as an example of one man's vision — the buying up of a deserted milltown and turning it into holiday homes for the citizens of Tokoroa. The preceding pages offer many possibilities, like Mokai above Taupo, Fruitlands in Central Otago — Macetown too — Waiuta on the West Coast and the Ahipara gumtown. All could be saved at a reasonable cost, and this is surely better, as the Wilsons of Orepuki put it to me, than the ersatz goldtowns you see on the Coast.

Ours may be the last generation with the opportunity to preserve these pioneering settlements. If we do, our children's children's children will surely thank us.

Bibliography

Adams, Cecilia. *The Hill, The Story of Denniston,* J. W. Baty, Christchurch, 1971.

Aitchison-Windeter, Susan N. *A History of Gold-mining at Cape Terawhiti, Wellington,* Department of Geology, Victoria University of Wellington, New Zealand, 1971.

Alexander, W. W. *The Experiences of the Reverend W. W. Alexander in Western Canada and in the Backblocks of New Zealand,* R. L. Lucas, Nelson, 1946.

Allan, Ruth. *Nelson: A History of Early Settlement,* A. H. and A. W. Reed, Wellington, 1965.

Andersen, Johannes Carl. *Place Names in New Zealand,* by direction of the Honorary Geographic Board of New Zealand, 1934, held in the Alexander Turnbull Library.

Anderson, Harold J. *Men of the Milford Road,* A. H. & A. W. Reed, Wellington, 1975.

Anderson, W. A. *Doctor in the Mountains,* A. H. & A. W. Reed, Wellington, 1964.

Appendix to the *Journals of the House of Representatives,* 1863, 1865, 1866, 1867, 1876, 1881,- 1884.

Ayson, B. *Miranui,* Southern Press, Wellington, 1977.

Bathgate, A. *Colonial Experiences,* James Maclehose, Glasgow, 1874, Capper Press, Christchurch, 1974.

BBC *Listener,* 1977-78.

Beaton, Eileen. *Macetown,* John McIndoe, Dunedin, 1971.

Beattie, Herries. *The Pioneer Explorers,* Otago Daily Times/Witness, 1947.

Beattie, Herries. *Southern Pioneers,* Mataura Ensign, 4 June, 1917 and 31 July, 1918.

Beattie, Herries. *Pioneer Recollections,* Mataura Ensign, 1909.

Beattie, Herries. *European Place Names in Southern New Zealand,* Mataura Ensign, 1912.

Begg, A. C. & N. C. *Port Preservation,* Whitcombe & Tombs, Wellington, 1973.

Best, Elsdon. *Forest Lore of the Maori,* The Polynesian Society/Dominion Museum, Wellington, 1942.

Bishop, Jane and Malcolm Walker. *Westland County Centennial Album,* Westland County Council, 1977.

Bradfield, A. G. S. *Forgotten Days,* Kerslake, Billens & Humphrey, Levin, 1956.

Bradley, E. K. *The Great Northern Wairoa,* published by author (2nd ed.), 1973.

Brayshaw, N. H. *Canvas and Gold,* published by author, Express Printing Works, Blenheim, 1964.

Brett, Sir Henry and Henry Hook. *The Albertlanders,* Brett Printing Company Ltd, Auckland, 1927.

Bruce, R. C. *Reminiscences of a Wanderer,* Whitcombe & Tombs, Wellington, 1914.

Buick, T. L. *Old Marlborough,* Hast & Keeling, Palmerston North, 1900, Capper Press, Christchurch, 1976.

Butler, Peter Scott. *Opium and Gold,* A. Taylor, Martinborough, 1977.

Cameron, W. N. *A Line of Railway,* New Zealand Railway & Locomotive Society Inc., Wellington, 1976.

Cape, Peter. *Kiwi Ballads,* A. H. & A. W. Reed Pacific Records, Wellington, 1975.

Carrick, R. O. *A Romance of Lake Wakatipu,* Government Printer, Wellington, 1892.

Carrick, R. O. Otago Place Names; *Otago Daily Times,* 1906.

Census of Population, 1874, 1878, 1901, 1976, Government Printer, Wellington.

Centennial of Albertland, 1862-1962, Campbell Printers, Wellsford.

Chandler, C. (Ed.). *Waiuta Ghosts,* privately printed, 1962.

Chappell, N. M. *New Zealand Banker's Hundred, A History of the BNZ, 1861-1961,* Bank of New Zealand, Wellington.

Charleston Herald & Brighton Times, 1870.

Church of St John the Evangelist, Barrhill, brochure, 1977.

Climie, Nell S. *Karangahake School & District 80th Jubilee 1889-1969*, Thames Valley News print, Thames, 1969.

Climie, Nell S. *Waihi Borough Council Diamond Jubilee, 1902-1962*, Hauraki Plains Gazette, 1962.

Climie, Nell S. (Ed.). *Ohinemuri Regional History Journal*, Historical Section WACMA (Inc.) and Paeroa and District Historical Museum, June, 1975.

Colonist, The, Nelson, 1863-64.

Colquhoun, N. & The Songspinners. *Songs of the Gumdiggers*, Reed Pacific Records, Wellington.

Colquhoun, N. & The Songspinners. *Songs of the Whalers*, Reed Pacific Records, Wellington.

Colquhoun, N. & The Songspinners. *Songs of the Goldfields*, Reed Pacific Records, Wellington.

Coromandel County Diamond Jubilee, 1937.

Cotter, M. J. *From Gold to Green*, Paeroa Borough Council, 1975.

Cowan, Janet. *Down the Years in the Maniototo*, Otago Centennial Historical Publications, 1948.

Cowan, James. *Romance of the Rail (North Island and South Island Main Trunk Railways)*, Publicity Branch, New Zealand Railways, Wellington, 1928.

Craddock, F. W. C. *Golden Canyon*, Pegasus, Christchurch, 1973.

Crawford, James Coutts. *Recollections of Travels in New Zealand and Australia*, Trubner & Co., London, 1880.

Cromwell *Argus*, 1870.

Cyclopedia of New Zealand, 1897-1906, Cyclopedia Co. Ltd (1897-1908), Wellington and Christchurch.

Dewar, G. E. *Chaslands*, A. H. & A. W. Reed, Wellington, 1953.

Dieffenbach, Ernst. *Travels in New Zealand*, John Murray, London, 1843.

Don, Alexander. "Early Central Otago: A Ballarat Miner's Reminiscences", Otago *Witness*, 1931 (?).

Downey, J. F. *Gold Mines of the Hauraki District*, Government Printer, Wellington, 1935.

Dunedin Evening Star, 1865.

Dunstan Times, 1866-67.

Dyer, P. F. (Ed.). *Jubilee Selections from the New Zealand Railway Observer*, New Zealand Railway & Locomotive Society Inc., Wellington, 1969.

Eaton, E. M. *Probing the Nelson Creek Area*, S. Eaton, Nelson Creek, 1976.

Echo, The, Dunedin, 1869.

Elder, J. R. *Goldseekers and Bushrangers in New Zealand*, Blackie & Son, London, 1930.

Evans, Allister. *Waikaka Saga*, Waikaka Historical Society, 1962.

Evening Star, The, Hokitika, 1867.

Field, T. A. *Relics of the Goldfields*, John McIndoe, Dunedin, 1976.

Forest and Bird, Journal of the Royal Forest & Bird Society, 1977-78.

Fulton, Robert Valpy, *Medical Practice in Otago and Southland in the Early Days*, Otago Daily Times/Witness 1922.

Gabriels Gully Centennial Booklet 1861-1961, Lawrence Borough Council.

Gabriels Gully Jubilee Reminiscences of Early Goldmining Days, Otago Daily Times/Witness, 1911.

Garcia, James (Ed.). *History of Whangamomona County*, Daily News Company Ltd, New Plymouth, 1946.

Gerard, Eric Stephen. *Strait of Adventure*, A. H. & A. W. Reed, Wellington, 1952.

Gilkison, R. *Early Days of Central Otago*, (3rd ed.), Whitcombe & Tombs, Wellington, 1958.

Glasson, H. A. *The Naseby & Mt Ida Goldfields Centennial 1863-1963*, Naseby Centennial Committee.

Glasson, H. A. *The Golden Cobweb*, Otago Daily Times/Witness, 1957.

Glover, Denis. *Arawata Bill*, Pegasus, Christchurch, 1953.

Grayland, E. & V. *Coromandel Coast*, A. H. & A. W. Reed, Wellington, 1965.

Greif, Stuart W. *Overseas Chinese in New Zealand*, Asia Pacific Press, Singapore, 1974.

Greymouth Evening Star, 24 July, 1957.

Grey River Argus, 1866, 1868.

Gumdiggers Gazette, Northland Tourist Publications, 1968.

Gumtown/Coroglen 75th Jubilee Committee, 1896-1971.

Hall, David. *The Golden Echo*, Collins, Auckland, 1971.

Hall-Jones, F. G. *Historical Southland*, Southland Historical Committee, H. & J. Smith, 1945.

Hall-Jones, John. *Early Fiordland*, A. H. & A. W. Reed, Wellington, 1968.

Handbook of New Zealand Mines, Government Printer, Wellington, 1887.

Hargreaves, R. P. *Nineteenth Century Otago and Southland Town Plans*, University of Otago Press, 1968.

Hargreaves, R. P. *Former Town and Locality Names*, University of Otago Geography Department, 1967 (?).

Harmon, D. I. *Yesterdays of Seddonville*, privately published, 1976.

Harrop, A. J. *The Romance of Westland*, Whitcombe & Tombs, Wellington, 1923.

Harper, G. S. *Gold Diggings and the Gospel*, Wesley Historical Society, Auckland, 1964.

Hassing, G. M. *Pages from the Memory Log of G. M. Hassing*. Southland Times, 1930.

Havelock Mail, The, 1 January, 1864.

Heberley, James. *Diary*, Alexander Turnbull Library manuscript, Wellington.

Heinz, W. F. *New Zealand's Last Gold Rush*, A. H. & A. W. Reed, Wellington, 1977.

Heinz, W. F. *Prospecting for Gold*, Pegasus, Christchurch, 1952.

Heinz, W. F. *The Story of Shantytown*, Pegasus, Christchurch, 1972.

Heinz, W. F. *Bright Fine Gold*, A. H. & A. W. Reed, Wellington, 1974.

Hindmarsh, W. H. (Waratah). *Tales of the Golden West*, Whitcombe & Tombs, Wellington, 1906.

Hobson County Centennial 1876-1976, North Auckland Times, Dargaville.

Hokitika Evening Star, 1867.

Horn, C. F. *My Golden Century*; Thames Valley News, Thames, 1973.

Hosking, T. M. *Opepe*, Taupo County Council, 1968.

Hoskins, R. *The Life and Times of the Celebrated Charles R. Thatcher*, Collins, Auckland, 1977.

Howard, Basil. *Rakiura: A History of Stewart Island*, A. H. & A. W. Reed, Wellington, 1940.

Illustrated New Zealand Herald, 1868-69.

Inangahua Herald, 1872.

Inangahua Times, 1875.

Insull, H. A. H. *Marlborough Place Names*, A. H. & A. W. Reed, Wellington, 1952.

Isdale, A. M. *History of the River Thames*, published by author, 1967.

Isdale, A. M. *Coromandel Historical Sidelights*; Gold Centennial publication, 1952.

Isdale, A. M. *Thames Gold Fields Centennial Motel Magazine Co. Ltd.*, Manurewa, 1967.

Isdale, A. M. Unpublished notes held by author.

Irvine, Jean. *Historic Hokianga*, Northern News Print, Kaikohe, 1965.

Jenkin, R. *New Zealand Mysteries*, A. H. & A. W. Reed, Wellington, 1970.

Kaikorai Valley High School. *The Ghosts of Waipori*, Otago Daily Times, 1970.

Kay, R. A. (Ed.). *Westland's Golden Century*, Westland Centennial Council.

Keene, Florence. *To the Northward*. The Northern Advocate, Whangarei, 1970.

Kelly, W. A. *Thames: The First Hundred Years*, Thames Star, 1968.

Knudson, Danny A. *Road to Skippers*, A. H. & A. W. Reed, Wellington, 1974.

Lake County Press, The, 1884.

Larasse, C. *Westland's Wealth*, New Zealand Forest Service Information Series No. 29.

Loughnan, R. A. "The First Gold Discoveries in New Zealand", reprinted from the *New Zealand Mines Record*, monthly journal of the Mines Department, Government Printer, Wellington, 1906.

Lovell-Smith, E. M. *Old Coaching Days in Otago and Southland*, Lovell-Smith & Venner Ltd, Christchurch, 1931; Capper, Christchurch, 1976.

Lush, Vicesimus. *The Thames Journals of Vicesimus Lush, 1868-82*, Pegasus, Christchurch, 1975.

Lyell Argus, 1875.

McArthur, G. & J. *The Golden Lure, 1862-1962*, Central Otago News, 1962.

Macdonald, C. A. *Pages from the Past*, H. Duckworth, Blenheim, 1933, originally published by the Marlborough Express.

McDonald, K. C. *White Stone Country*, North Otago Centennial Committee, 1962.

McGavin, T. A. *A Century of Railways in Taranaki, 1875-1975*, New Zealand Railway & Locomotive Society, Inc., 1976.

McInnes, Gay. *Castle on the Run*, Pegasus, Christchurch, 1969.

MacIntosh, J. *Fortrose*, Times Printing Service, Invercargill, 1975.

McKenzie, Mrs Alice. *Pioneers of Martins Bay*, (3rd ed.), Whitcombe & Tombs, Wellington, 1970.

McLemmon, K. E. *North Island's Main Trunk Golden Jubilee, 1908-58 Souvenir Booklet*, Railway Enthusiasts Society, Wellington, 1958.

McLintock, A. H. (Ed.). *A Descriptive Atlas of New Zealand*, Government Printer, Wellington, 1960.

McNab, R. M. *The Old Whaling Days*, Whitcombe & Tombs, Wellington, 1913.

NcNeil, A. R. *Memories of Early Coromandel*, Coromandel School of Mines, 1964.

MacNeish, James. *Tavern in the Town*, A. H. & A. W. Reed, Wellington, 1957.

Macnicol, Terry. *Echoes from Skippers Canyon*. A. H. & A. W. Reed, Wellington, 1967.

Macnicol, Terry. *Beyond the Skippers Road*, A. H. & A. W. Reed, Wellington, 1965.

Mabbett, H. *Rock and Sky*, Wilson & Horton, Auckland, 1977.

Marks, R. *Hammer and Tap*, Tuapeka County Council, 1977.

Marlborough Express, 1866.

Marlborough News, 1865.

Mason, F. Van Wyck. *Harpoon in Eden*, Hutchinson, London, 1969.

Masters, L. *Tales of the Mails*, Hawke's Bay Centennial Year, Hart Print, Hastings, 1959.

May, Philip Ross. *Hokitika: Goldfields Capital*, Pegasus, Christchurch, 1964.

May, Philip Ross. *Gold Town*, Pegasus, Christchurch, 1970.

May, Philip Ross. *The West Coast Gold Rushes* (2nd ed.), Pegasus, Christchurch, 1970.

Mayhew, W. R. *Tuapeka, The Land and the People*, Otago Centennial Historical Publications, 1949.

Maynard, Dr Felix (in collaboration with A. Dumas, Sen., translated by F. W. Reed). *The Whalers*, Hutchinson, London, 1937.

Menzies, L. R. *A Gold Seeker's Odyssey*, John Long, London, 1937.

Meyer, R. J. *Coaling from the Clouds*, New Zealand Railway & Locomotive Society Inc., Wellington, 1971.

Millar, J. Halket. *Westland's Golden Sixties*, A. H. & A. W. Reed, Wellington, 1959.

Millar, J. Halket. *Gold in New Zealand*, A. H. & A. W. Reed, Wellington, 1956.

Miller, F. W. G. *History of Waikaia*, Waikaia Historical Society, 1966.

Miller, F. W. G. *Beyond the Blue Mountains*, Otago Centennial Historical Publications, 1954.

Miller, F. W. G. *History of Goldmining in Central Otago* (newspaper clippings 1938-40).

Miller, F. W. G. *Golden Days of the Lake Country*, Otago Centennial Historical Publications, 1949.

Miller, F. W. G. *Historic Central Otago*, A. H. & A. W. Reed, Wellington, 1970.

Miller, F. W. G. *Historic Wakatipu*, A. H. & A. W. Reed, Wellington, 1970.

Miller, F. W. G. *Front Page Verse*, R. Folley & Sons, Invercargill, 1945.

Miller, F. W. G. *There Was Gold in the River*, A. H. & A. W. Reed, Wellington, 1946.

Miller, F. W. G. *Gold in the River*, A. H. & A. W. Reed, Wellington, 1969.

Miller, F. W. G. *The Story of the Kingston Flyer*, Whitcoulls, Wellington, 1975.

Miller, J. McK. *Blue Spur Centennial Reunion 1861-1961*, Blue Spur Centennial Committee, Dunedin, 1962.

Miller, W. *Coal in the Buller*, privately published, Westport, 1973.

Moffat, Harry L. *A Nelson Digger*, Nelson Evening Mail, R. Lucas & Son, 1896.

Moloney, Dan. *The History of Addisons Flat Gold Fields*, Westport News, 1923.

Money, Charles L. *Knocking About in New Zealand*, Samuel Mullen, Melbourne, 1871, Capper, Christchurch, 1971.

Mooney, K. L. *History of the County of Hawke's Bay*, Hawke's Bay County Council, 1973-77.

Moore, C. W. S. *The Dunstan*, Otago Centennial Historical Publications, 1953-54.

Moorehead, Alan. *The Fatal Impact*, Hamish Hamilton, London, 1966.

Morrell, W. P. *The Gold Rushes*, Adam & Charles Black, London, 1940.

Mt Ida Chronicle, 1864.

Munro, J. R. *Gabriels Gully Centennial, 1961*, Otago Daily Times.

Nelson Evening Mail, 1866 and 1900s.

Nelson Examiner, 1864-65.

Nelson Examiner & New Zealand Chronicle, 1865.

Newport, J. N. W. *Footprints*, Whitcombe & Tombs, Wellington, 1962.

New Zealand Department of Mines Report on the Goldfields in New Zealand, 1887.

New Zealand Listener, 1977-78.

New Zealand Songster, No. 3, c.1875, No. 5, c.1878; Joseph Braithwaite, Dunedin.

New Zealand Times, 1861-65.

Nicolson-Garrett, Gladys. *St Bathans*, John McIndoe, Dunedin, 1977.

Noble, W. S. *The Gold of Wetherstons*, Otago Daily Times/Witness, 1932.

Nodwell, F. L. *Shore Whaling in Early Marlborough*, University of New Zealand thesis for MA, 1947, (held in the Alexander Turnbull Library).

Nokomai Herald, 1871.

Nolan, M. A. *Gold Trails of the West Coast*, A. H. & A. W. Reed, Wellington, 1975.

Nolan, M. A. *Gold Trails of Nelson & Marlborough*, A. H. & A. W. Reed, Wellington, 1976.

Nolan, M. A. *Gold Trails of the Coromandel*, A. H. & A. W. Reed, Wellington, 1977.

O'Neill, L. P. *Thames Borough Centennial Souvenir*, Thames Star, 1973.

Otago Centennial, The, October, 1861 and April, 1862.

Otago Colonist, The, 1861-63.

Otago Daily Times, 1862-65.

Parcell, J. C. *Heart of the Plain*, Otago Centennial Historical Publications, 1951.

Park, Ruth. *One-a-pecker, Two-a-pecker*, Angus & Robertson, Sydney, 1957.

Pfaff, Carl J. *The Diggers' Story*, West Coasters' Association, 1914.

Pope, Diana and Jeremy. *Mobil New Zealand Travel Guide, North Island and South Island*, A. H. & A. W. Reed, Wellington, 1974.

Preshaw, G. O. *Banking Under Difficulties,*

Edwards, Dunlop & Co., Marlborough, 1888, Capper, Christchurch, 1971.

Pyke, Vincent. *The Story of Wild Will Enderby,* George Robertson, Melbourne and R. T. Wheeler, Dunedin, 1873.

Pyke, Vincent. *History of the Early Gold Discoveries in Otago,* Otago Daily Times and Witness Newspapers, 1887.

Pyke, Vincent. *The Adventures of George Washington Pratt,* George Robertson, Melbourne, 1874.

Reed, A. H. *The Story of the Kauri,* A. H. & A. W. Reed, Wellington, 1959.

Reed, A. W. *The Story of Northland,* (Facsimile ed.), A. H. & A. W. Reed, Wellington, 1975.

Reed, A. H. *The Gumdiggers,* A. H. & A. W. Reed, Wellington, 1972.

Reed, A. H. *The Gumdigger,* A. H. & A. W. Reed, Wellington, 1948.

Reed, A. H. *Place Names of New Zealand,* Alexander Turnbull Library files, Wellington.

Reed, A. H. *Coromandel Holiday,* A. H. & A. W. Reed, Wellington, 1952.

Reese, D. *Was It All Cricket?* George Allen & Unwin, London, 1948.

Reeves, H. J. *In the Years That Are Gone,* John McIndoe, Dunedin, 1947.

Reeves, W. P. *The Long White Cloud* (4th ed.), George Allen & Unwin, London, 1950.

Reid, R. C. *Rambles on the Golden Coast of the South Island of New Zealand,* Reid & Co., Greymouth, 1884.

Rickard, L. S. *The Whaling Trade in Old New Zealand,* Minerva, Auckland, 1965.

Robson, James and J. O. P. Watt. *Bits and Pieces,* Whitcombe & Tombs, Wellington, 1967.

Roebuck, Margaret and Els Grims. *Karangahake Gold Town,* Club Printing, Onehunga, Auckland.

Roxburgh, Irvine. *Jacksons Bay,* A. H. & A. W. Reed, Wellington, 1976.

Roxburgh, Irvine. *Wanaka Story,* Otago Centennial Historical Publications, 1957.

Salmon, J. H. M. *A History of Goldmining in New Zealand,* Government Printer, Wellington, 1963.

Sam Chapman's Coromandel in the Golden Days, Times Commercial Printers, Hamilton, 1975.

Sansom, Olga. *The Stewart Islanders,* A. H. & A. W. Reed, Wellington, 1970.

Shaw, M. S. and E. D. Farrant. *The Taieri Plain,* Otago Centennial Historical Publications, 1949.

Sheffield, C. M. *Kawau Island,* Whitcombe & Tombs, Wellington, 1962.

Simpson, R. A. *This Is Kuaotunu,* Thames Star, 1955.

Simpson, Thomas E. *Kauri to Radiata,* Hodder & Stoughton, London, 1973.

Skinner, Eric. *Waitahuna Memories,* A. H. & A. W. Reed, Wellington, 1948.

Small, Joe. *New Zealand and Australian Songster and Goldfields Diary,* Tribe, Mosley & Caygill, Christchurch, 1866, Nags Head Press, Christchurch, 1970.

Smith, Frank. *Tua Marina Settlement, 1859-1959, A Centennial Review,* Express Printing Works, Blenheim, 1959.

Smith, Jim. *Round Hill Reminiscences* (unpublished notes).

Soil and Health. *Journal of the Soil Association of New Zealand, 1976-78.*

Somerville, H. *The Story of Komata Reefs,* published by the author, Auckland, 1969.

Sparrow, G. S. "The Growth and Status of the Phormium Tenax Industry in New Zealand", *Economic Geography, Vol. 41, No. 4,* October, 1965.

Stallworthy, J. *Early Northern Wairoa,* Wairoa Bell and Northern Advertiser, 1916.

Startup, R. M. *New Zealand Post Offices Past and Present,* Laurie Franks, Christchurch, 1960.

Startup, R. M. *Early Days of the New Zealand Post Office,* Laurie Franks, Christchurch, 1960.

Stewart, G. G. *The Romance of New Zealand Railways,* A. H. & A. W. Reed, Wellington, 1951.

Sumpter, G. Hugh. *In Search of Central Otago,* Whitcombe & Tombs, Wellington, 1948.

Sunday Times, The, London, 1978.

Taylor, Nancy (Ed.). *Early Travellers in New Zealand,* Clarendon Press, Oxford, 1959.

Tenquist, J. D. *Rails over the Ranges,* Featherston Jaycee Inc., 1975.

Thames Advertiser & Miners' News, 1875.

Thames Star, 1879.

Thatcher, Charles T. *Lake Wakatipu Songster,* Mills & Hopcroft, Dunedin, 1863.

Thompson, Helen M. *East of the Rock and Pillar,* Otago Centennial Historical Publications, 1949.

Timms, Joe. *Conversations with Gilbert Perano, Bill Parkes, Norm Judd and Cappy Harris,* 1977 (unpublished).

Tracy, Mona. *West Coast Yesterdays.* A. H. & A. W. Reed, Wellington, 1960.

Trask, E. E. *The End of the Line: A History of the Catlins River Branch Railway,* Catlins Historical Society, 1971.

Tuapeka Times, 1868.

Turner, Andrew (Ed.). *Gumfield Rhymes and Practicalities,* Andrew Turner, Whangarei, 1900.

Voice from Westland, New Zealand, A. *Miscellaneous Verse from Australia and New Zealand,* 1879 (held in the Alexander Turnbull Library).

Waihi Miner & Hauraki Goldfields Gazette, 1895.

*Waikouaiti Herald,*1869.

Waite, Reuben (W. H. L. Leech Ed.). *A Narrative of the Discovery of the West Coast Goldfields,* J. Hounsell, Nelson, 1869.

Wakefield, E. J. *Adventure in New Zealand,* John Murray, London, 1845.

Wards, Ian (Ed.). *New Zealand Atlas,* Government Printer, 1976.

Wastney, P. V. & N. L. *Early Tide to Wakapuaka,* Nelson Historical Society, 1977.

Watt, J. O. P. *Preservation Inlet,* Times Printing Service, Invercargill, 1971.

Wayte, Edward, set by. *Thames Gold Field Miners Guide 1868,* Capper, Christchurch, 1975.

Webster, A. H. H. *Teviot Tapestry,* Otago Centennial Historical Publications, 1948.

Weekly News, The, 1950s.

West Coast Times, 1866-67, 1880, 1890s.

Westport Evening Star, 1876, '79.

Westport News, 1874.

Westport Times & Star, 1867, '69, '70.

Western Star, Riverton, 1876.

Wheeler, "New Zealand Goldfields Report", *Melbourne Argus,* 1861.

Wilson, Eva. *Orepuki: A Hundred Years of Memories;* Orepuki & District Centennial Committee, Craig Printing Company, Invercargill, 1971.

Wilson, Geoffrey. *Linkwater,* Linkwater Settlers Association, Express Printing Works, Blenheim, 1962.

Wilson, J. G. *The History of Hawke's Bay,* A. H. & A. W. Reed, Wellington, 1939, Capper, Christchurch, 1976.

Wise's New Zealand Guide; Wises, 5th edition, Auckland, 1972.

Witness, The, 1861-65.

Woodville School and District Jubilee Booklet, 1937.

Wright, David McKee. *Station Ballads and Other Verses,* J. G. Sawell (Wise's), Princes Street, Dunedin, 1897.

245

Index

Brackets denote an alternative name, except where inclusion of "area" distinguishes identical placenames. Figures in bold refer to photographs.

248

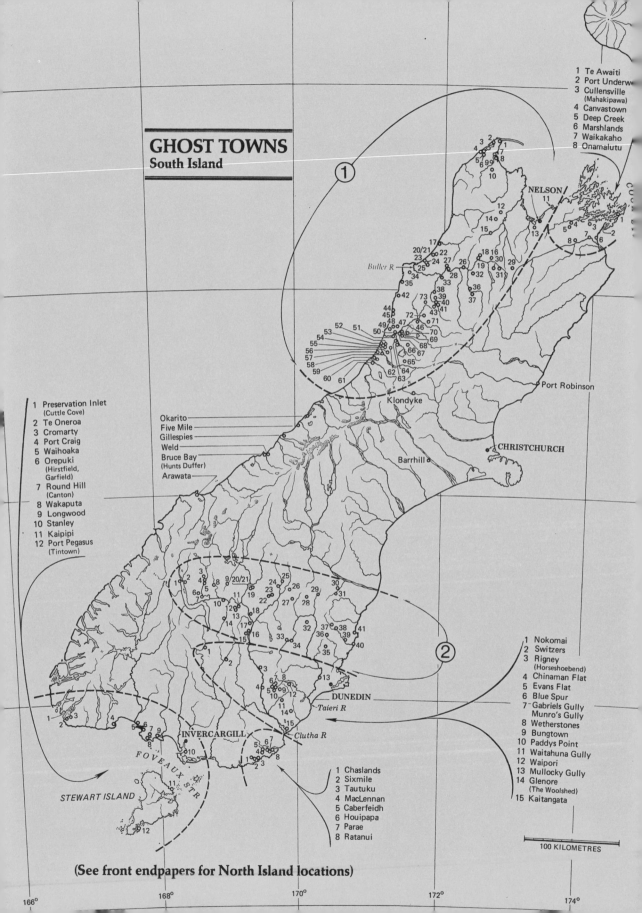

GHOST TOWNS
South Island

①

②

NELSON

CHRISTCHURCH

DUNEDIN

INVERCARGILL

STEWART ISLAND

FOVEAUX STR.

Buller R.

Port Robinson

Barrhill

Klondyke

Taieri R.

Clutha R.

1 Te Awaiti
2 Port Underwood
3 Cullensville
 (Mahakipawa)
4 Canvastown
5 Deep Creek
6 Marshlands
7 Waikakaho
8 Onamalutu

1 Preservation Inlet
 (Cuttle Cove)
2 Te Oneroa
3 Cromarty
4 Port Craig
5 Waihoaka
6 Orepuki
 (Hirstfield,
 Garfield)
7 Round Hill
 (Canton)
8 Wakaputa
9 Longwood
10 Stanley
11 Kaipipi
12 Port Pegasus
 (Tintown)

Okarito
Five Mile
Gillespies
Weld
Bruce Bay
(Hunts Duffer)
Arawata

1 Nokomai
2 Switzers
3 Rigney
 (Horseshoebend)
4 Chinaman Flat
5 Evans Flat
6 Blue Spur
7 Gabriels Gully
 Munro's Gully
8 Wetherstones
9 Bungtown
10 Paddys Point
11 Waitahuna Gully
12 Waipori
13 Mullocky Gully
14 Glenore
 (The Woolshed)
15 Kaitangata

1 Chaslands
2 Sixmile
3 Tautuku
4 MacLennan
5 Caberfeidh
6 Houipapa
7 Parae
8 Ratanui

100 KILOMETRES

(See front endpapers for North Island locations)

Key to South Island locations

Map 1

1	Puponga
2	Kaihoka
3	Mangarakau
4	Paturau
5	Dogtown
6	Pennyweight Town
7	Ferntown
8	Gibbs Town
9	Bedstead Gully
10	Washbourns
11	Cable Bay
12	Balloon
13	Ranzau
14	Baton
15	Upper and Lower Wangapeka
16	Kynnersley
17	Wakatu
18	Glenhope
19	Owen River
20	Millerton
21	Mine Creek
22	Stockton
23	Waimangaroa
24	Denniston and Coalbrookdale
25	Burnetts Face
26	Fern Flat
27	Zalatown
28	Lyell
29	Tophouse
30	Howard
31	Maggie Creek
32	Mangles Vally
33	Kynnersley
34	Addisons Flat (Waite's Pakihi)
35	Charleston
36	Matakitaki
37	Upper Matakitaki
38	The Landing (Emmanuels Flat)
39	Capleston (Georgetown and Boatmans)
40	Blacks Point
41	Crushington
42	Progress Junction (Globe Hill)
43	Brighton
44	Canoe Creek
45	Barrytown
46	Half Ounce / Nobles / Granville / Duffers
47	Roa
48	Rewanui
49	Dunollie
50	Wallsend
51	Brunner
52	Welshmans (Upper & Lower)
53	Lagoontown
54	Rutherglen
55	Marsden / Nemona (No Name)
56	Greenstone
57	Chesterfield and Lamplough
58	Dillmanston / Larrikins and Cousin Jack
59	Stafford
60	Goldsborough
61	Blue Spur
62	Maori Creek (Dunganville)
63	Kokiri
64	Kaimata (Arnold)
65	Poerua (Paerau)
66	Bell Hill
67	Twelve Mile (Kamaka) / Moonlight Gully
68	No Town
69	Red Jacks / Chinaman Flat / Welshmans
70	Lower Nelson Creek / Try Again Terrace / Orwell Creek / Callaghans / German Gully / Fenians / Sunday Creek / Bald Hill / Dogtown / Deadmans Creek / Camptown / Kangaroo / Napoleons / Adams Town
71	Waiuta
72	Blackwater
73	Maimai (Squaretown)

Map 2

1	Kinloch
2	Glenorchy (Tahuna)
3	Bullendale
4	Skippers Point
5	Maori Point (Charleston)
6	Moke Creek (Zephirtown) and Moonlight Creek
7	Arthurs Point
8	Macetown
9	Cardrona and Lower Cardrona
10	Gibbston
11	Bannockburn
12	Carricktown
13	Quartzville
14	Nevis
15	Gorge Creek (Chamonix)
16	Fruitlands / Bald Hill Flat / Speargrass / Limerick
17	Conroys Gully
18	Muttontown Gully
19	Bendigo
20	Logantown
21	Welshtown
22	Drybread
23	Matakanui (Tinkers)
24	Cambrians
25	St. Bathans (Welshmans)
26	Blackstone Hill- (Hills Creek)
27	Garibaldi Diggings
28	Hogburn Gully
29	Kyeburn Diggings
30	Maerewhenua
31	Livingstone
32	Hamiltons Diggings (Flatcap)
33	Serpentine Flat
34	Paerau (Styx)
35	Nenthorn
36	Macraes Flat (Fullartons)
37	Green Valley
38	Waihemo
39	Shag Valley
40	Shag Point
41	Hill Grove